Amanda Hopkinson, the daughter of a writer and photographer, was born in London in 1948 and now works as a writer and picture editor. She attended schools in London as well as a 'progressive' Quaker boarding school, and went on to read history at Warwick University. Her doctorate, on the political theatre of the French Revolution, was researched in Paris and she has travelled extensively inside and beyond Europe, working as a journalist and translator and for international aid agencies. She has been involved in establishing and running the first all-women photographic agency, *Format Photographers*. *Julia Margaret Cameron*, an assessment of the pioneering Victorian photographer, is Amanda Hopkinson's first book. She has four children and lives in East London.

VIRAGO PIONEERS are important reassessments of the lives and ideas of women from every walk of life and all periods of history, re-evaluating their contribution in the light of work done over the past twenty-years or more – work that has led to important changes of perspective on women's place in history and contemporary life.

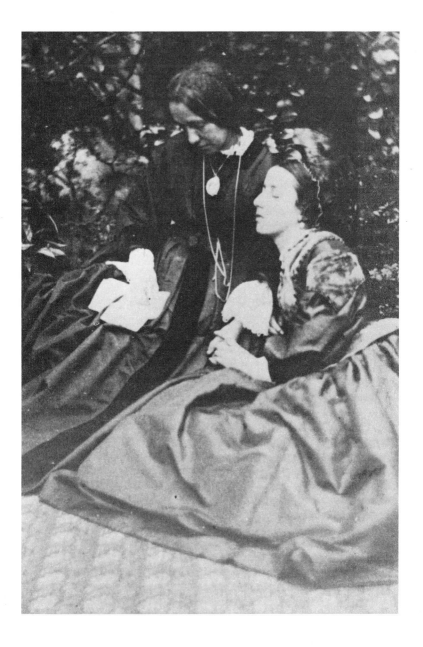

JULIA MARGARET CAMERON

Amanda Hopkinson

To Bob Gilbert

Published by VIRAGO PRESS Limited 1986
41 William IV Street, London WC2N 4DB

Copyright © Amanda Hopkinson 1986

British Library Cataloguing in Publication Data

Hopkinson, Amanda
 Julia Margaret Cameron. – (Virago pioneers)
 1. Cameron, Julia Margaret – Criticism and
 interpretation
 I. Title
 770'.92'4 TR140.C27
 ISBN 0-86068-726-0

Typeset by Rowland Phototypesetting
and printed in Great Britain by St Edmundsbury Press
both of Bury St Edmunds

Frontispiece: Julia Margaret Cameron with her daughter.
See Notes, page 163, for full caption

Cover illustration: based on a photograph of Julia Margaret
Cameron by her son, Henry Herschel Hay Cameron

CONTENTS

ACKNOWLEDGEMENTS

Thanks are due to Colin Ford, Margaret Harker, Val Williams and especially to my father Tom Hopkinson, for discussing my research into Julia Margaret Cameron with me and offering their opinions and recommendations. Many of their views are well known, and where I have differed this has been at least partly a consequence of talking things through in order to reach an independent conclusion. I hope the discussion still has long to run, for there can be as many responses to a picture as people looking at it.

Thanks also to the staff of the major institutions housing Julia Margaret's work for their time and patience; in particular to Pam Roberts at the Royal Photographic Society, Bath; Gaby Porter at the National Museum of Photography, Film and Television, Bradford, and Terry Pepper at the National Portrait Gallery, London; also to Lindsay Stewart at Christie's of South Kensington, for providing access to a considerable amount of 'Cameronabilia' before it went on sale, and for supplying photocopies and copy prints. I am also indebted to Alison Foster at the Royal Photographic Society, to John O'Grady who took copies of prints in Eric Sommer's private collection, and to Eric Sommer himself, who contributed much time and hospitality in showing me his extensive collection, including the 'Mia Album' and the *cartes-de-visite*.

Finally, I would like to thank the friends who read and reviewed the text and those who helped to amuse and care for my children while I was working on it. And of course to thank the children themselves, who proved so tolerant when at least three of them expressed their incredulity that I could abandon a 'proper

CONTENTS

ACKNOWLEDGEMENTS

Thanks are due to Colin Ford, Margaret Harker, Val Williams and especially to my father Tom Hopkinson, for discussing my research into Julia Margaret Cameron with me and offering their opinions and recommendations. Many of their views are well known, and where I have differed this has been at least partly a consequence of talking things through in order to reach an independent conclusion. I hope the discussion still has long to run, for there can be as many responses to a picture as people looking at it.

Thanks also to the staff of the major institutions housing Julia Margaret's work for their time and patience; in particular to Pam Roberts at the Royal Photographic Society, Bath; Gaby Porter at the National Museum of Photography, Film and Television, Bradford, and Terry Pepper at the National Portrait Gallery, London; also to Lindsay Stewart at Christie's of South Kensington, for providing access to a considerable amount of 'Cameronabilia' before it went on sale, and for supplying photocopies and copy prints. I am also indebted to Alison Foster at the Royal Photographic Society, to John O'Grady who took copies of prints in Eric Sommer's private collection, and to Eric Sommer himself, who contributed much time and hospitality in showing me his extensive collection, including the 'Mia Album' and the *cartes-de-visite*.

Finally, I would like to thank the friends who read and reviewed the text and those who helped to amuse and care for my children while I was working on it. And of course to thank the children themselves, who proved so tolerant when at least three of them expressed their incredulity that I could abandon a 'proper

job' in order to write. (The baby just *looked* incredulous.) A special debt of gratitude is owed to my agent Anne McDermid, and to Ursula Owen, Ruthie Petrie and Harriet Spicer at Virago, for their finely-balanced patience and encouragement. And to Jane Havell who, when time and health ran short, overhauled the last draft to produce the book you now see. Any mistakes, as they say, remain my own and are in defiance of the myriad skills of all the above.

The photographs in this book are reproduced by kind permission of the following: Ashmolean Museum, Oxford – Plates 1, 7, 14, 19, 26, 39; Christie's, South Kensington, London – frontispiece; National Museum of Photography, Film and Television, Bradford – Plates 9, 15, 16, 17, 23, 24, 25, 31, 33, 38, 46, 47, 51; National Portrait Gallery, London – Plates 3, 28, 29, 34, 35; Royal Photographic Society, Bath – Plates 4, 5, 10, 12, 13, 18, 20, 21, 22, 27, 36, 37, 40, 41, 42, 44, 45, 48, 49, 50, 52; Eric Sommer – Plates 2, 6, 8, 30, 32; Victoria & Albert Museum, London – Plates 11, 43.

CHRONOLOGY

11 June 1815	Julia Margaret Pattle born in Calcutta to James Pattle of the East India Company and Adeline, *née* de l'Etang, daughter of French royalists.
1820–34	She makes repeated journeys to Europe, receiving most of her education with her maternal grandmother at Versailles. She is especially close to her eldest sister, Adeline.
1835	Convalescing after an illness on the Cape of Good Hope, she meets the astronomer and photographer Sir John Herschel and her future husband Charles Hay Cameron, distinguished politician and liberal reformer.
1836	Her sister Adeline dies, aged twenty-four.
1838	She marries Cameron, who serves on the Council of India as a jurist, and becomes the leading society hostess in Calcutta, on close terms with the Governor General, Lord Hardinge.
1843	She helps to raise £14,000 towards relief of the Irish potato famine. Cameron becomes President of the Council of Education.
1847	Her translation of Bürger's romance *Lenore* is published in London, with illustrations by Daniel Maclise.
1848	Cameron retires and he and Julia Margaret leave India. They settle at Ephraim Court, Tunbridge Wells, but gravitate to Little Holland House, the London home of Julia Margaret's sister Sara Prinsep.
1850	They move to East Sheen, to be near their new friends the playwright Henry Taylor and his wife Alice.

1850–56	Julia Margaret's main concern is with family matters, including the birth of her youngest sons. Cameron publishes an open letter on the admission of Indians to the Indian Army and Civil Service and *An Address on the Duties of Great Britain to India.*
1857	They move to Putney Heath, to a cottage which they intermittently share with Alfred Tennyson and his family.
1860	Julia Margaret visits Freshwater on the Isle of Wight to see the Tennysons' new home, Farringford. She buys the house next door and calls it Dimbola.
December 1863	She is given her first camera by her only daughter Julia and Julia's husband Charles Norman. She sets determinedly to work, realising the concepts she had discussed with Herschel nearly thirty years before.
January 1864	She achieves what she calls her 'first success', a portrait of Annie Philpot. She works avidly, starting on two albums for Herschel and her younger sister Mia, and preparing photographs for exhibition and for sale. She becomes a member of the Photographic Societies of England and Scotland.
1865	She exhibits in Scotland, Berlin and at the International Exhibition in Dublin, as well as in London, which she does annually. Berlin awards her a bronze medal, but other judges and critics dismiss her work for technical deficiencies and unconventionality. She rents Colnaghi's for a one-woman show.
1866	She gives further showings at Colnaghi's and at the French Gallery, London. She wins the gold medal at Berlin.
1867	She exhibits in Paris, winning an Honourable Mention. She begins to work with a new lens and larger plates.
1868	She rents the German Gallery, London, for an exhibition, selling through Colnaghi's and from home.
1873	Her daughter Julia dies in childbirth. The Prinseps

	move to Freshwater, with the painter G. F. Watts. Julia Margaret largely abandons exhibitions, to concentrate on picture sales, especially of portraits and allegories.
1874	She works feverishly, at times despairingly, on illustrations for Tennyson's *Idylls of the King*. Disappointed at the quality and reduced size of the woodcuts, she brings out her own limited edition with a dozen full-sized plates. She begins *Annals of my Glass House*, an unfinished account of her photographic career.
1875	She creates the second volume of the *Idylls*, together with illustrations to other Tennyson poems. Again she produces her own larger edition, and a smaller compilation of the two volumes.
October	The Camerons emigrate to Ceylon to be close to their coffee-farming sons. They stay first at the fishing village of Kalutara, and then in the mountains at Lindoola.
1877	The painter Marianne North visits the Camerons and sits for Julia Margaret. Julia Margaret takes her only pictures of crowds and a landscape in Ceylon, but her work of this period fails to establish itself in a new context.
1878	The Camerons make a short, and unhappy, visit to England.
26 January 1879	Julia Margaret Cameron dies after a short illness, aged sixty-three, and is buried in the country between Colombo and Galle. Charles Hay Cameron dies just over a year later, aged eighty-five.

LIST OF PLATES

Abbreviations used

ASH	Ashmolean Museum, Oxford
NMP	National Museum of Photography, Film and Television, Bradford
NPG	National Portrait Gallery, London
RPS	Royal Photographic Society, Bath
Sommer	Private collection of Eric Sommer
V & A	Victoria & Albert Museum, London

INTRODUCTION

Julia Margaret Cameron was a pioneer photographer of multiple significance, who came to photography at a critical stage in both its technical and ideological development. She was active between 1864 and 1875, at a time when photography was in its infancy, the equipment extremely cumbersome, and processing an intricate and sometimes hazardous operation. She was rare in her determination to become a *professional* photographer, despite the patronising disdain of photographic societies and commercial exhibitors, and a press that was quick to mock her. She defiantly photographed outside set conventions, rejecting both the voguish 'landscape artist' style and the formal family groups mass-produced by the new photographic studios.

She differed from the great numbers of 'lady amateurs' by the seriousness with which she worked and the eminence of many of her subjects. These were drawn from her own social circle and included the writers Tennyson, Longfellow and Carlyle; the actress Ellen Terry; the artists Holman Hunt and G. F. Watts; and the scientists John Herschel and Charles Darwin. Their portraits were taken in a wholly original style – instead of the writer with his pen and desk, or the painter with his palette and easel, she took life-sized images of their faces, forcing an immediate and powerful confrontation between the viewer and the viewed. The term 'close-up' could have been invented for her, for she was the first to employ it to such dramatic effect. Like many other amateurs, she also photographed women and children; unlike them she developed a form of allegorical representation intended to bestow a translucent relevance on her compositions.

Her techniques and her subjects were often so out of the

ordinary that they defied categorisation even by her peers. Other amateurs, if they happened also to be women, were similarly accounted eccentrics, but they generally kept their eccentricities closer to home, photographing their families and estates, and were considered less outrageous than a woman apparently determined to disregard the few firm convictions that had been established in the new art form. The photographs that remain are a unique testimony to an indomitable woman. Despite her determination to succeed professionally, she refused ever to compromise the principles on which her art was based.

Julia Margaret Cameron is at once an immensely popular and an intensely unfashionable photographer. Her popularity is a measurable response to the enormous publicity generated by the campaign to 'save her pictures for the nation' in 1975, at a time when few people other than photographic specialists were aware of her work. The campaign prevented the sale of the Herschel album to America and, since funds had to be raised by public subscription, involved the production of numerous exhibitions, catalogues and articles. Yet a significant proportion of her pictures remain distinctly unfashionable to twentieth-century eyes. While her portraits will stand the test of any amount of time,[1] her illustrations of mythical, biblical and poetic themes appear to modern eyes at best sentimental, at worst embarrassing.

Such themes were as characteristic of the mid-Victorian heyday as was Julia Margaret Cameron herself. It was a period that combined extreme conformity with as extreme individualism: one had to know the rules in order to have the confidence with which to break them. Julia Margaret had the security that went with being born into the ruling class, and a panache all her own. She was born in Calcutta in 1815, the second of seven daughters of a senior officer of the East India Company, James Pattle, otherwise known as 'Jim Blazes' or, alternatively, 'the biggest liar in India'. Whether to protect the children from their father's outrageous behaviour, or simply to further their education, Mrs Pattle sent them back and forth to Europe, sometimes to English relatives, but mostly to their French grandmother in Versailles. Virginia Woolf, writing in 1913 about her great-aunt, recalled her

paternal inheritance of 'indomitable vitality' mingled with 'her mother's love of beauty'.[2]

This 'love of beauty' became the hallmark of Julia Margaret Cameron's working life. She began it late, having married young, raised five children of her own, another whom she adopted and numerous others she fostered. She met her husband, a Benthamite jurist named Charles Hay Cameron, when they were both convalescing away from Calcutta's steamy humidity on the Cape of Good Hope. They married in 1838 and were back in England within ten years, Charles Cameron having taken early retirement from the Law Commission of the Supreme Council of India. It was only when their extensive household, after moving repeatedly around London and Surrey, had finally settled in Freshwater in the Isle of Wight in the 1860s, that Julia Margaret found her vocation.

The gift of a camera came as a complete surprise to Julia Margaret Cameron. It came from her oldest child and only daughter, also called Julia, to whom she was deeply attached and who was to die young. The present was made with perfect timing and subtle understanding: Julia Margaret, forty-nine years of age, was suffering from acute loneliness. Her husband was abroad attending to his overseas investments, her sons grown up or at boarding school, and her daughter newly-wed. It was as she too was about to move away that Julia, in a spirit of light-heartedness, introduced her mother to the latest London craze, with the comment, 'It may amuse you, Mother, to try to photograph during your solitude at Freshwater.'

Julia might have known better. Although the camera was little more sophisticated than a couple of sliding boxes large enough to accommodate giant glass plate negatives ($9'' \times 12''$), and had to be awkwardly balanced on its steadying tripod, Julia Margaret was not a woman to be daunted, nor to undertake things by half-measures. All the abundant energy and much of the enthusiasm she had poured into her family, house-guests and friends, her cookery and home entertainments, her sporadic bouts of gardening and home decorating, was now re-directed. Her years of variegated literary endeavour, her appreciation of the beautiful,

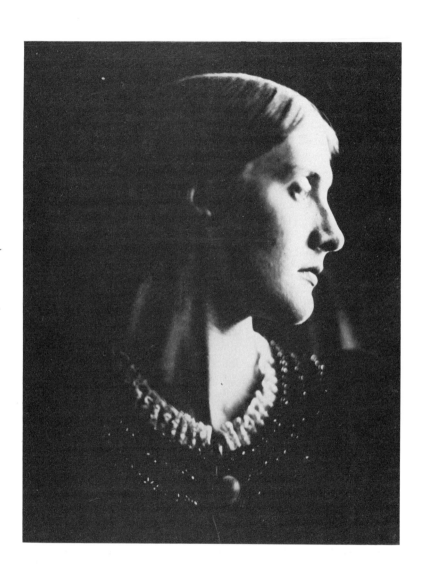

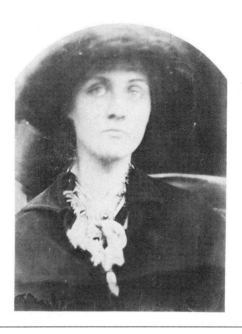

Three portraits of Mrs Herbert Duckworth (Julia Jackson): *Left*: **1.** in 1867; *above*: **2.** c. 1866; *overleaf*: **3.** in the garden with children, 1866. The child on the left is Florence Fisher, her niece; the one on the far right possibly Esme Howard. Julia Jackson was commonly asserted to be the most beautiful daughter of the Pattle sister whose looks gained most with time. Thomas Woolner, the Pre-Raphaelite sculptor, 'worshipped' Mia's delicate bone structure, and did not balk at proposing marriage to her youngest daughter, as Holman Hunt also did. In similar vein, James Russell Lowell and George Meredith revered the lovely Julia. The writer George Meredith commented (to Julia's daughter, Vanessa Bell) that Leslie Stephen 'was the only man in my knowledge worthy of being mated with your mother' – an ironic statement in view of the existence of a still unpublished account of that marriage written by Stephen himself, and called, bitterly, 'The Mausoleum Book'. One friend hinted at a characteristic of Julia that no conventional paeans to her bring out: 'She would say something so unexpected from that Madonna face, one thought it *vicious*.' A lengthier analysis of the marital role her Madonna mother filled is explored by Virginia Woolf in *To the Lighthouse*.

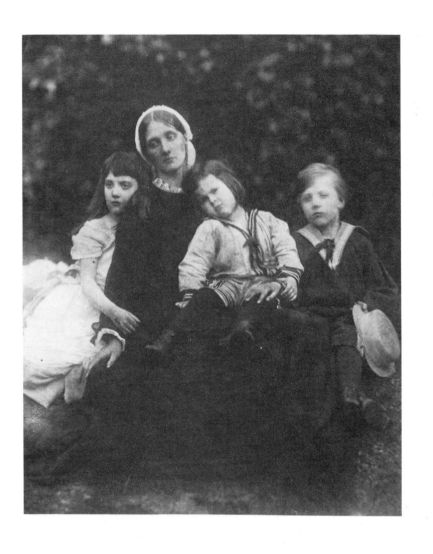

and – most imperiously of all – her considerable array of friends, neighbours and servants, were all pressed into the service of the new art that Julia Margaret was determined to raise to heights hitherto achieved (in her estimation) only by poetry and painting.

First, however, she had to grasp the rudiments of the complex chemistry that was essential, in 1863, for the production of her large prints. Thirty years earlier she had corresponded with John Herschel concerning his early photographic experiments, experiments to which he had never been free to devote himself fully. In 1839 two simultaneous, but coincidental, discoveries on either side of the Channel had led to the invention of the daguerrotype in France and the calotype in England. Both inventions overcame the formerly insuperable problem of 'fixing' an image so that it would not fade on being exposed to light. (Not that there weren't always unscrupulous practitioners, even in the 1860s, willing to turn an all-too-common mistake into deliberate practice by failing to wash the hyposulphate adequately from their prints so that, as one of them put it, 'they look well enough now, and the sooner they fade, the sooner will they have to come to me for another set.'[3]) These two techniques were rapidly replaced by the wet collodion process, invented by Frederick Scott Archer in 1851.

To learn the wet collodion process, Julia Margaret first had to acquire, as one manual had it, 'a knowledge of photo-chemistry and a degree of manual dexterity in addition to an eye for a good picture'. First the large glass plates had to be chemically sensitised. The exposures were necessarily very long, with sitters required to remain absolutely still, in her case sometimes for as long as ten minutes. Then developing and fixing solutions had to be poured over the plate from heavy and unwieldy bottles, before an intensive washing process. The image thus fixed had to be dried and varnished.[4] It was then printed by direct contact onto albumen paper sensitised with silver chloride; the frames had to be exposed to sunlight for several hours for the picture to appear 'as if by magic'.

This was a complex and intricate process, and one which depended on the careful manipulation of light and dark. It is astonishing that Julia Margaret created her wealth of intermedi-

ate tones with nothing more sophisticated than an old greenhouse (her studio) in which she blanketed out certain panes to direct the available light; a coal-hole (her darkroom) in which she processed her plates; and the uncertain daylight in which they were printed, mostly out of doors.

- Photography as art, science and witchcraft

Julia Margaret Cameron's burning desire was to make photography a branch of High Art. She was unusual in not having started out – like David Octavius Hill and Oscar Gustav Rejlander – as a painter who took to photography. She was surrounded by a côterie of artists and writers who unstintingly followed the 'whispering muse' (portrayed in one of her pictures as a young girl whispering in the ear of the painter G. F. Watts; see Plate 43). Julia Margaret spelt Art with a capital A and Photography with a capital P.[5] She believed her vocation to be the equal of any of the foremost painters and poets in her circle, a belief in which they encouraged her, drawing to her attention such articles as that which offered tips on 'Photography in Oil Colours'.[6]

Photography was, inevitably, a more 'democratic' medium than painting (certain types of photographs were affordable by the working classes in a manner in which paintings never were), but Julia Margaret Cameron did not wish her work to come within the general 'democratisation of the image' debate. As one of the early matriarchs of the Bloomsbury dynasty, she anticipated the exclusion of politics, social reform and commerce from their work. A professional photographer she would be, but a commercial one – mass-producing for a mass-market – never. Many of her contemporaries were aware of, and discussed, the basic problem of what photography should aim to achieve. The editor of *The British Journal of Photography* wrote on 19 October 1866 of the conflicting demands of his rôle:

He has all sorts of readers to please; the one a practical photographer, the other a chemist, the third an artist, the fourth an optician, the fifth an amateur who does not understand anything, and all these have to be

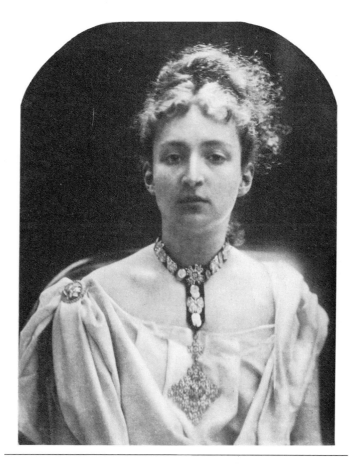

4. Miss Isabel Bateman, c. 1874. Isabel Bateman was an actress and theatre manager during the 1870s, one of the du Maurier set who worked closely with Henry Irving and Ellen Terry. We do not know whether Julia Margaret managed to persuade her to join 'the strange train of people ascending and descending the staircase in odd states of apparel' for one of her evening performances. But whether or not she made it from the glasshouse to the impromptu stage, she accomplished the journey to India and paid a visit, in 1875, to the Camerons' bungalow in Ceylon.

satisfied. The practical photographer fancies nothing but formulae; he does not read theoretical essays, which are of interest to the chemist, who, in turn, looks in contempt on art studies that are fancied by the artist and on mathematical problems or chemical formulae as he would on the signs of the Cabbala.

This reference to the Cabbala reflected the earlier debate that had raged around the issue of whether photography was an art or a science or, more sinisterly, a 'black art' or some form of alchemy. The term 'black art' could be tamed by being ascribed simply to the wet collodion process, which stained hands and garments inky black, yet there remained the intrinsic mystery of conjuring up an image onto an ostensibly blank piece of paper or glass. In one of the earliest commentaries on the calotype (published in *The Spectator* of 2 February 1839) it was called 'the self operating process of Fine Art', and the term 'calotype' was itself derived from the Greek 'kalos' for beautiful. Fox Talbot, its inventor, himself linked the process more to nature than to art, describing photography as 'Sun Pictures' or 'The Pencil of Nature' – suggesting the origin for Julia Margaret's picture entitled 'Cupid's Pencil of Light' (Plate 41). An early picture by Hill and Adamson comes inscribed 'Sol fecit', meaning the sun made it.

Whether by the incomprehensible action of light or still more devious means, photography allowed what appeared to be a magical transcription from life into art. And before we scoff at the Victorians for their quaint superstitions, we should review our own photographic language. We still talk of 'taking' photographs or of 'shooting' people, as though the subjects are forever passive and the photographer alone has the power to take the initiative and control the image. In the few regions of the world still unfamiliar with the camera, people still resist having their photograph 'taken', for fear that a little bit of their souls might be captured and regenerated as the photographer's own.

This magical dimension, with its hint of witchcraft, was one Julia Margaret chose to invoke only in order to silence the more recalcitrant of her child sitters. Laura Gurney, a frequent model, recalled 'Aunt Julia as a terrifying elderly woman, short and

squat, with none of the Pattle grace and beauty about her. Dressed in dark clothes, stained with chemicals from her photography (and smelling of them too), with a plump eager face and piercing eyes, and a voice husky and a little harsh, yet in some way compelling and even charming'.[7]

Julia Margaret herself made light of the often inconvenient and occasionally frightening aspects of her art. She wrote of her habit of sharing her latest triumph with her husband, and that 'running into the dining-room with my wet pictures has stained such an immense quantity of table linen with nitrate of silver, indelible stains, that I should have been banished from any less indulgent household'.[8] And the chemicals were indeed dangerous, their effects not always predictable. One friend recalls entering the house to find Julia Margaret being marched up and down between her sons, fearful that some deadly potassium cyanide might have entered a cut in her finger and be poisoning her bloodstream.

To the Victorians photography was additionally a new toy. They wanted to discover not only how it worked but what it could do. The field was wide open and the potential applications apparently limitless. The idea of visually recording members of one's family and one's friends *as they really were*, as opposed to how some artist thought best to visualise them, was its most popular attribute. The contemporary magazine *Macmillan's* recounted the craze – based, it was believed, on equal parts of vanity and novelty – for linking photography to that other important Victorian invention, the penny post. Families could stay in touch not only by letter-writing but by sending photographic portraits back and forth. It is therefore perhaps entirely natural that Julia Margaret, who wrote copious daily doses of letters to catch the post even if it meant sending boys on donkeys or holding up trains to do so, should have been so strongly attracted to portraiture.

Yet she stayed completely above the twin assumptions that photography was about representing reality and at the same time improving on it. She was much more taken with the magical properties of her camera – 'become to me as a living thing, with voice and memory and creative vigour' was how she described it. She exploited its ability to do more than record, even represent:

she wanted to draw out the *inner* essence of her subjects, to epitomise them in a picture. What took her pages of marginless scrawl to describe in words, she wanted to reveal in a single image, in itself a form of magical transformation, drawing art out of reality.

It was not realism but representation that Julia Margaret intended, and where she so brilliantly succeeded. In *Annals of my Glass House*, the unfinished account of her photographic career, she expressed her inspiration and intent in the following terms: 'When I have had such men [as Carlyle] before my camera, my whole soul has endeavoured to do its duty towards them in recording faithfully the greatness of the inner as well as the features of the outer man.'[9] The list of the men she thus sought to capture include Longfellow, Trollope, Browning, Holman Hunt, G. F. Watts, Darwin; her close friends and neighbours Henry Taylor and Alfred Tennyson and, of course, John Herschel. To Herschel she dedicated her most justly famous album, containing arguably the finest photographic portrait ever taken – that of Herschel himself.

● Julia Margaret's women, men and children

Every book on the subject of 'Pattledom' (as the hegemony of the indomitable Pattle sisters came to be known) makes the same claim: that of all the strikingly unconventional sisters, Julia Margaret was the only one lacking in beauty. Although family and friends were at pains to advise her that what she lacked in looks was compensated by talent elsewhere, it must have seemed something of a consolation prize, for her sisters were not without talents themselves. Even the description of Virginia, Sara and herself as 'Beauty, Dash and Talent' left her till last, although she was the eldest of the three. A number of portraits of her still exist: in nearly all of them she is, typically, doing something. All show her in mature years at Freshwater, one has her playing the piano, another writing a letter, still another reading a book. All were favourite pastimes of hers, and even those taken as set-pieces are indicative of the things that were important to her. There is a little

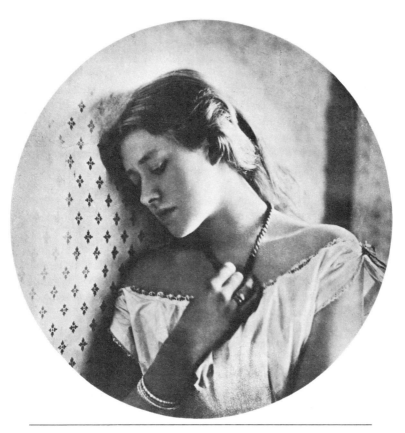

5. Ellen Terry, 1864. Taken when Ellen was sixteen, on the eve of her marriage to G. F. Watts, this picture personifies the sweetness and tenderness Watts himself chose to emphasise in his oil portrait of her, entitled *Choosing*. Nevertheless, Ellen's strong features and sensually bared shoulder slightly belie this image – not surprisingly since, far from being 'simply' a child bride, she was already an accomplished Shakespearean actress and surrogate parent to her numerous younger brothers and sisters. O. G. Rejlander also photographed her, and there is some confusion over whether this portrait, although ascribed to Julia Margaret, may not have been taken by him (the wallpapered background is one he frequently used).

series, perhaps something of a family joke given her near-obsession with letters, called 'The Post' which shows her and all her assembled household receiving and giving mail to the post-man with his fringed beard and large leather satchel. And there is another family photo, taken outside the parlour door, illustrating a bit of elaborate charade with her performing a deep curtsy to her young son's sweeping bow.

If one compares the famous portrait of her, taken when she was in her fifties by her photographer-son Henry Herschel Hay Cameron, with that painted by her close friend G. F. Watts (now in the National Portrait Gallery), the gap of twenty years between the two portraits cannot adequately explain the difference be-tween the two women. The photograph (see cover) shows an unconventionally dressed woman, her hair shrouded in a lace mantilla and her arms in a heavily brocaded kaftan, gazing intently past the camera. Watts's painting, on the other hand, removes the prominent wart from beside her left nostril, straight-ens her nose, widens her eyes, gives her a fashionably oval forehead rather than the square one she actually possessed, and dresses her all in white. The only feature he did not manage to smooth was the definite set of her chin. Neither portrait can bear the weight of defending Julia Margaret against the charge of plainness, though both refute the frequent accusation of ugliness.

Whether the beautiful young women Julia Margaret repeatedly photographed represent her idealised self at the same age, herself as she would have liked to appear, or an outward expression of an inner truth, we can only speculate. She certainly liked to be surrounded by them, and since she owned five sons to one daughter, she additionally fostered another five girls. Once she turned from raising children to taking up a career, it was the grown young women as much as the camera who 'added more and more impulse to my love of the beautiful'.[10] Perhaps the young women were those to whom she felt strongly attracted. There is certainly a passionate extravagance of style in the profusion of her notes to Emily Tennyson, her eulogies to the young Mrs Hambro, and descriptions of Alice Taylor as a 'frail magnolia blossom'. Her quip that 'no woman between the ages of eighteen and eighty

should allow herself to be photographed' was belied over and over again as she chose young women in their twenties as models. She was unable to photograph them other than as individuals or as allegories: attempts to recognise them as types – for example, as wives or mothers – failed and looked forced unless made to conform with some religious parable. (The portrait of Julia Jackson with her three children is a rare exception, both in being taken out of doors and in its naturalness.)

Julia Margaret approached the photography of women and men very differently. Apart from pictures of relatives and a few close friends, her women do not bear names, for they are not famous. Still less is there an equivalent to 'The Astronomer', for women did not have, or were assumed not to have, vocations by which they could be described.[11] Had she labelled a picture of a woman 'The Artist' or 'The Musician', it would have been counted as a symbolic pose or a dilettante indulgence. Where she gave her photographs such names as 'The Letter Writer' or 'The Gardener's Daughter', these were references to the poems which had inspired the illustrations, and were not meant primarily as descriptions of the photographs.

Many of the titles Julia Margaret gave her pictures were intended to endow their subjects with a significance they did not have in real life. The titles were often devised afterwards, drawn from a variety of biblical, classical, Shakespearean and Romantic writings. Julia Margaret was well-read, and much more interested in literature than most of the upper-class women of her day. Her photographs abound with literary references,[12] as one might expect from a woman who considered herself an accomplished poet; who had completed at least half a novel[13]; and who was on affectionately familiar terms with two of the greatest literary lions around – the epic poet and playwright Henry Taylor and the Poet Laureate, Alfred Lord Tennyson. In choosing women models, she frequently sought types to represent the wistful loveliness of Tennyson's tragic heroines; the exotic mystery of 'The East' (who might also double and treble as Rebecca and Zoë); or the youthful plaintiveness of Ophelia and Juliet.

Fantasy characters like these paradoxically allowed female

models greater scope for individual expression than they had in being themselves, in much the same way that play-acting did. It was no coincidence that many of Julia Margaret's literary subjects transferred directly from the amateur theatricals in which the whole household enthusiastically participated. Only through acting other parts could women give at least symbolic expression to their own aspirations and emotions, at a time when simply being someone else's relative – a wife, mother or sister – was intended to be a woman's self-fulfilment. A clear expression of this double standard occurs in Julia Margaret's photographs of her niece, Julia Jackson. On the one hand Julia is regularly photographed under her own name, with all the attention to dramatic lighting and imposing costume that is afforded the 'lionised men'. On the other, she is also presented successively as Mrs Herbert Duckworth and Mrs Leslie Stephen, as though her own powerful personality were entirely subsumed within her husbands' identities.[14]

In all, Julia Margaret photographed at least as many children as men, but twice as many women as either – unless the remaining collections of her work are wholly unrepresentative.[15] Whether this was more to do with availability than choice we can't be sure, though we do know that a dearth of willing conscripts from within her extensive domestic circle never prevented her from hauling in passers-by or local farm-workers to come and 'play a part' for a few hours and a few shillings. Much of her illustrative photography is reminiscent of the amateur theatricals enjoyed by the Camerons, as by so many large Victorian families, in which everyone participated, including servants, children and old people. These were so popular within Pattledom that the tradition continued down through the family into its Bloomsbury heyday. In the mid-1920s, Virginia Woolf started composing her version of 'Freshwater', one of her 'sublimely obscene' comic satires, and in 1935 it was privately staged in Vanessa Bell's London studio with Vanessa herself playing that 'imperious woman . . . Aunt Julia'.[16]

Through the chosen constraints of allegorical illustration, Julia Margaret returned over and over to her favourite subjects: a

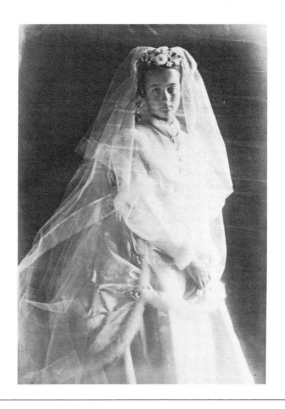

6. My Ewen's Bride of 18th November 1869 (Annie Chinery). This is one instance where flaws in Julia Margaret's technique (in this case, streaks on the negative irremovable by subsequent retouching) actually enhance the picture. Annie Chinery was Julia Margaret's first daughter-in-law, and she was seized by her new mother-in-law both photographically and maternally. Unfortunately, when Julia Margaret most craved both female companionship and familiar photographic subjects, in Ceylon, their closeness was brought to an end by Annie's determined resistance to Julia Margaret's demands upon her eldest son, Ewen. Nevertheless, Annie had for a long time consented to sit for her domineering new relative. This portrait captures her sweet seriousness of expression, while the white lines, blending with those of the veil, give it an ethereal quality.

young woman and a much older man. To me, of all her theatrical creations, the Shakespearean ones work best, precisely because her selections grant scope to that particular relationship. Juliet confiding in Friar Lawrence, Cordelia turning away from Lear, Miranda beseeching Prospero – all convey an intensity as indicative of Julia Margaret's strength of feeling as of the ostensible story. The reason for her fondness for this theme, and the emotion behind her treatment of it, we can only guess at. How was she affected by her rumbustious and largely absentee father? By a childhood devoid of brothers and male companions? Did it 'just happen' that she found herself surrounded by some of the most commanding – and by then elderly – men of her time, with whom she struck up powerful friendships? Or did her husband, who at forty-three was twice her age when they married, form the unconscious as well as the actual model for so many of her males?

Julia Margaret certainly had her share of ridicule and suffering at having her work wilfully misconstrued. Certainly her subjects frequently lent themselves to suggesting other still more interesting, powerful or historically significant personages. The men she admired tended, naturally enough, to put her in mind of kings (David, Cophetua, Ahasuerus, Lear, etc.) or magicians (Merlin and Prospero), and the women of great beauties or tragic heroines (Ophelia and Juliet from Shakespeare; Esther and 'Mary Mother' from the Bible; a Neapolitan peasant or a Greek goddess from popular fancy dress). She was aware of how easily all this could be made fun of even by her contemporaries, for she wrote warmly of how 'our chief friend, Henry Taylor . . . regardless of the possible dread that sitting to my fancy might be making a fool of himself . . . consented (to pose for me)'. Tennyson held out against her cajoling and bullying for several years, and finally succumbed only to playing *himself*, in a fine series of seven portraits taken over as many years.

In order to preserve her own brand of truthfulness, Julia Margaret minimised the most salient differences between photography and painting. She overcame the lack of colour by an unusual richness and depth of tone, created by lighting only from one side or from the top in order to maximise shadows, and

enhanced by the plush garments she encouraged her sitters to wear. By restricting the angle and amount of light, she had to increase correspondingly the exposure time at maximum aperture, to at least four and sometimes to as much as ten minutes (satisfactory images could be obtained with exposures of as little as 20–40 seconds). Her refusal to accept the inherent limitations of the medium made her minimise its technicalities in order to allow the pure artistic inspiration to shine through unaided.

In this respect, as in so many others, she was an original spirit, working outside the mainstream of her time. She rejected the bread-and-butter of the commercial studios, their interminable series of formal families, each looking more like the last while attempting to outdo them in worldly attributes. She rejected too the popular version of childhood, that of posed groups of rigid dolls, dressed in velvet and flounces, exposed in all-round lighting which diminished still further any uniqueness of feature or expression. Julia Margaret was as incapable of reducing anyone to this level of nonentity as she would have been at forging the Barnardo's urchins:[17] neither in any way corresponded to her vision of the beautiful. Her pictures of cherubs and angels may seem saccharine to us now, but were in fact less so than the fussily-dressed and stiffly-posed real children. She knew that her version, with the bare body, loose hair and the attempt to capture with light the translucently ethereal quality of a young child, was at least as valid as the vastly overproduced and formal *cartes-de-visite* that were the current fashion. Indeed, her pictures of children, which have generally achieved far too little attention, bring out all Julia Margaret's skill with lighting and setting, and are an enduring and unique contribution to our understanding of her work.

Through photographing children and, to a lesser extent, young women in Grecian robes, Julia Margaret was able to 'model' bare flesh as a sculptor would. In this she was startlingly different from her photographic contemporaries, even those who were renowned for their child pictures, such as Lewis Carroll. Even Rejlander fell into stereotypes, photographing children as he

might have photographed members of the lower classes or foreign 'natives', as though they were another species.

But what most of all alienated photographic societies and exhibition judges and brought down cries of 'bungling amateur' was Julia Margaret Cameron's refusal to retouch. Yet she was employing a technique in which every blot and stain spread like ink, every speck of dust trapped under the collodion or varnish became magnified, and every finger-print showed like a fine forensic specimen. It was because she saw herself as a professional artist rather than a commercial photographer that she steadfastly refused to compromise and, as she earnestly advised anyone who would listen, she was backed in her opinions by such artistically sound colleagues as G. F. Watts and Dante Gabriel Rossetti. Beside the flourish of her long signature, many of her mounts bear the affirmation 'untouched' and 'from life' – as opposed to the more common 'from nature' used by other photographers. For she desired not only to create artistically but to capture an unrepeatable experience: those crucial minutes of that sitter's life. To wait until the print emerged, and then to tinker with it and prettify it was to falsify that reality and, incidentally, to bow to the fashion that rendered so many contemporary portraits as unreliable as the decorative painted miniatures they replaced. Although Julia Margaret chose occasionally to dabble, to peel off a bit of collodion film and obtain a darker background here or to sketch in a little half-hearted improvement there, these meagre attempts tended only to confirm her reluctance to change in any way the product to which she had already made her artistic contribution.

This contribution lay above all in her artist's eye, what she called her inner vision. She visualised what she wanted, inspired either by a theme or by an individual – it did not matter which, for however grand a piece of theatre was chosen for her *tableau vivant* it nearly always lacked background (i.e. context) and the emphasis was on characterisation. It might be that she combed the Isle of Wight to find her perfect Arthur working as a porter; or it might be that she assailed some white-haired Freshwater resident to be brought home to play Father Time. Either way, she knew in her

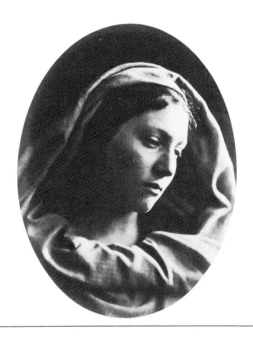

7. 'Mary Mother' (Mary Hiller), 1864. The 'Raphaelesque Madonna' sequence, as Julia Margaret herself called it, was entered for her very first photographic competition, along with a head of Henry Taylor. Neither won any prizes, which called forth Julia Margaret's furious repudiation of the judges' competence. They replied with the following comment, published in the *Photographic Journal* of 15 May 1865:

> The Committee much regret that they cannot concur in the lavish praise which has been bestowed on her productions by the non-photographic press, feeling convinced that she will herself adopt an entirely different mode of reproducing her poetic ideas when she has made herself acquainted with the capabilities of the art.

The Committee was not passing artistic criticism, merely finding technical fault with her method of working, which they assumed to be due to incompetence rather than an underlying philosophy that precluded tampering with the 'truth' even of a blemished picture. But at least they agreed that they were operating within the parameters of 'art' rather than of 'science'.

mind's eye what she wanted, and the more she worked with certain subjects, the more she saw their possibilities. Boccherini's maxim, 'Everything which does not correspond to the rules of composition should be forgiven for the truthfulness of what is represented', could well have been her own.

Discussion continues over whether or not Julia Margaret was short-sighted, as though her 'artist's eye' could be physiologically defined. She herself was predictably dismissive about the obsession with focus. 'Who has a right to say what focus is the legitimate focus? . . . My aspirations are to ennoble Photography and to secure for it the character and uses of High Art by combining the real and Ideal and sacrificing nothing of the Truth by all possible devotion to Poetry and beauty.'[18] She decried the commonplace 'map making and skeleton rendering of feature and form'[19] in order to concentrate on achieving 'that roundness and fullness of face and feature that modelling of flesh and limb which the focus I use only can give though called and condemned as *out of focus*'. It is also small wonder that, whatever her protestations about deliberate 'soft focus', many of her pictures were out of focus due to the involuntary movements of her sitters. Holding oneself completely still for such lengths of time is simply impossible. It is interesting that when she had a professional artist's model – if that is who 'Iago'/Alessandro Colorossi indeed was – she produced one of her sharpest, most direct and powerful images; Plate 31.

In one sense it is curious that the only art-form we do not know of Julia Margaret dabbling in is painting. The whole of English photography was intimately related to painting. D. O. Hill, prolific perfectionist of the calotype, transferred from watercolour to photography at its inception, and the majority of his successors sought to 'use the camera as a paint-brush'. Within the field of painting, debate continued on the ways of seeing and portraying the world. The Pre-Raphaelites' reference back to a halcyon Middle Ages where man was in his place and the world was at rights implied a clearer vision of things, reflected in their paintings with a meticulous attention even to far-distant detail as though all about one could be perceived with equal clarity. To

Turner, however, all was awash with light and subtle colour, human handiwork insignificant against the sweeping majesty of the elements, with even the grandeur of the Roman Colosseum eaten away by the gaping sky and encroaching slopes. Ruskin's famous quotation opposing Millais and Turner – 'the one quiet in temperament with a poor memory but keen sight' and the other 'impatient, imaginative and relatively short-sighted' – was a division which set Julia Margaret apart from, rather than with, the Pre-Raphaelites. She was certainly given to the grand scale of a 'short-sighted' Turner rather than to the meticulously even detail of Millais. Yet when she wrote to Ruskin for his views on photography in general and hers in particular, she received only the disappointing assertion: 'Fifteen years ago, I knew everything that the photograph could and could *not* do . . . I have long since ceased to take the slightest interest in it.'[20]

Whereas Julia Margaret's intention was to represent that age-old artistic vision – the Truth as she saw it, Beauty in an individual as an incarnation of the Divine – the expectations of the Photographic Society were more in tune with the ordinary person's view of photography, as a medium that was more 'naturalistic' than painting. And yet, paradoxically, it was often the naturalness of their appearance that most shocked Julia Margaret's sitters: Tennyson complained about the bags under his eyes that she refused to retouch out (Plate 24), and Daisy Bradley's mother found her daughter unrecognisable, despite what seems to us a portrait quite modern in its straightforwardness (Plate 35).

It is impossible to be certain whether it was always the poetry itself that inspired Julia Margaret, or the man she associated it with. Not only did she choose to illustrate verses by poets she admired, but also those admired by her husband, as, for instance, in the case of 'The Dream' (Plate 14). Yet beauty was to her a generalised artistic vision, into which she drew all previous and surrounding experience. After a lifetime of dilettantism (one translation, a few poems, the domestic accomplishments of a good hostess), Julia Margaret was ready to distil all her drama and delight into her late-found medium of self-expression. Although

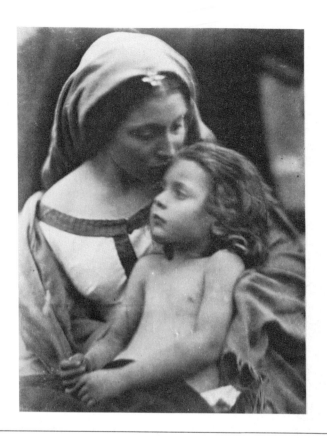

Above: **8.** 'Divine Love' (Mary Hillier and Freddy Gould), c. 1865 and *right*: **9.** 'The Return after Three Days' (Mary Hillier, Freddy Gould and unknown models), registered 1865. Freddy Gould was obliged to play both the infant and the 'twelve-year-old' Christ for these pictures, although in 1865 he was just four. Mary Hillier continued the role of Mary Mother she played in 1864, the link provided by the decorative flower she wears in her hair. The bouquet of fresh roses and lilies features also in 'The Flower Girl' – an example of the overlap of sacred and profane in Julia Margaret's world-view, or just a desire to maximise the use of favoured props, along with a casualness in thinking up titles afterwards?

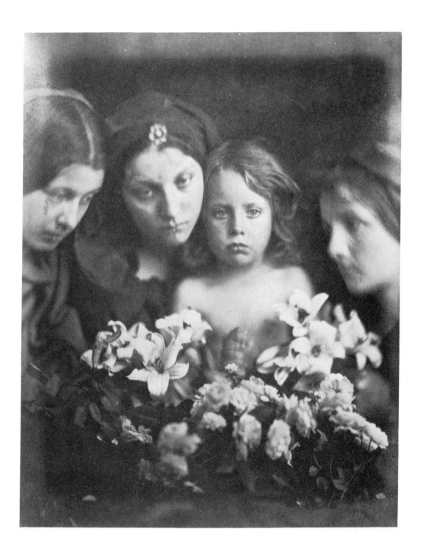

so supposedly typically Victorian, Julia Margaret was very much an individual. To say that she was eccentric, which she certainly was, does not actually explain anything about her photographs.

While Julia Margaret scorned conveyor-belt styled operations, she was not above desiring to practise professionally in terms of earning a living. The income on which the Camerons depended from their coffee and rubber plantations declined steadily while they were living in England, and Julia Margaret's lavish hospitality and famed generosity served to diminish reserves further. Yet there was always a tension between her high standards and ambitions, and her ability to render them commercially viable. She chose to prepare her photographic paper herself, sensitising it with silver chloride in preference to the more easily-yellowed albumen, and carefully controlling the extent of its coloration. It was an expensive as well as a laborious process, and in one mood of despair Julia Margaret rushed a wagonload of the residual silver to a fellow-photographer in London, imploring him to turn it to cash on her behalf. The poor man found himself obliged to return the lot, with the courteous explanation that she had been misinformed, silver chloride was not the silver of which money could be made.

Julia Margaret was persistent, if not consistent, in her attempts to derive an income from photography. Within a year of starting, she had entered into an arrangement with the West End print-sellers, P. & D. Colnaghi, and with the Autotype Company, lending them her most popular glass plates to print from. They mounted the prints and retailed them to meet an impressive demand at between half-a-guinea and one guinea each. The costs, however, were considerable: the best paper and card had always to be used; Julia Margaret wished to autograph as many as possible, and where practicable to add a famous sitter's signature. (Favourable comments, too, were welcome: G. F. Watts was prevailed on to copy out an originally spontaneous 'Quite Divine!' so often that he must have regretted writing it in the first place.) All of this took time and profits away from sales.

Julia Margaret was also aware of the value in establishing an international reputation, particularly in the face of hostility from

critics at home. Time and money had thus to be expended in crating her large and heavy prints around Britain and Europe and, where necessary, hiring a gallery to exhibit them. When a photograph proved popular she felt indebted to her models, and showered them with further copies. She even lapsed into the craze for *cartes-de-visite* but, knowing how ill they suited her style, had them made larger than usual and with gold-deckled borders. She gratefully acquiesced to Tennyson's suggestion that she should illustrate his Arthurian romance, *Idylls of the King*, but for the two dozen prints she supplied for two giant volumes issued in 1874 and 1875, she claimed to have destroyed two hundred in the making.[21]

To be one's own marketing and distribution manager, financier and auditor, was a hefty task to take on in addition to achieving an estimated total of some three thousand photographs. That Julia Margaret felt it to be so is evident from the rather desperate missives she kept firing off containing price-lists and details of orders and sittings. Although it seems clear that she undertook her own developing and printing while at Freshwater,[22] one is tempted to wonder if her poor assistant Mary Hillier was not landed with a considerable amount of the donkey-work while Julia Margaret attended to her ruling passion for dressing up and artistic arrangement. And even when the load became too much, and work had to be farmed out to the Autotype Company for mass-reproduction, Julia Margaret still supervised the shading of the carbon prints, detailing which should have yellowy, red or rust-coloured tones, which should be silver-tinted, and insisting that customers should be advised of the options. All of which, like the gilt-edged cabinet cards, added to costs and made the entire enterprise even more financially precarious.

● The image and the package – whose beauty and what truth?

Despite the controversy she very swiftly aroused, Julia Margaret Cameron achieved fame rapidly – if not, quite, as 'Priestess of the Sun' then as an exponent of the High Art movement. In the space of little more than a decade, she carved the niche she desired for

herself in the annals of photography. Her own *Annals* make plain the extent to which she felt most at home with her 'great men' and warmed to reflecting their eminence in her work, suggesting at least a desire to identify with their success and to enter into their world, more than that of fantasy (largely suggested by other people's poetry), or that of her 'fair women' or young children.

Furthermore, a typical press report congratulated her on 'the realisation of a method of focussing by which the delineations of the camera are made to correspond with the methods of drawing employed by the great Italian artists' and also for 'the introduction of an ideal pictorial element'.[23] This was the sort of comparison of which she would have approved. But one crucial difference, of course, between a work by a 'great Italian artist' and a 'great High Art photographer' is the matter of reproduction. The fact that Julia Margaret refused to attach any particular rarity value to her pictures – except when, inadvertently, a plate broke or became irreparably damaged – made her, despite herself, something of a democrat. She capitalised on photography's facility, that of mass-production, to make her work as accessible as possible. The more galleries that would hang it, the more papers review it, the more prints Colnaghi's could sell of it and the more books and albums that might include it, the wider it would be disseminated and the more contented she would be. And however haphazard her record-keeping may seem to us, she was in fact unusual in the care she exercised not only in dating and labelling her prints, but in ensuring that the copyright remained in her own name. The photographs were not intended as records in the way a family album might be, and she was at no pains to keep a chronology of daily or family life at Freshwater. She viewed her photographs as works of art in their own right.

The re-establishment of her reputation in this century was initiated by the artist and critic Roger Fry who collaborated with Virginia Woolf in devising the album *Famous Men and Fair Women*, published in 1926. It contained some thirty of her finest portraits, already indicating the modern preferences among her work, along with some of her own favourite groups of children and young girls (such as 'Paul and Virginia' and 'Summer Days').

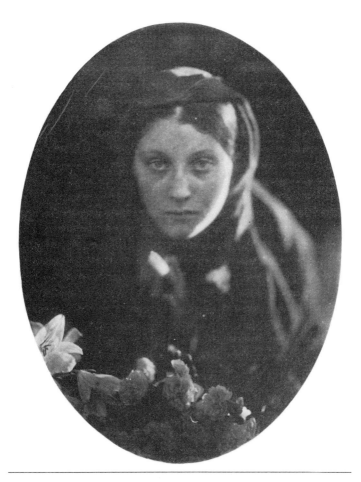

10. 'The Flower Girl' (Mary Hillier), 1865. Julia Margaret loved flowers, both wild and cultivated, although those she grew were mainly to please her most cherished guests and relatives. To please her husband, who had expressed a passing wish for more lawn, she had the vegetable allotment converted into one overnight. The symbolism of flowers was something she would have assimilated with her taste for Italian art – white for purity, roses for love, and lilies for Mary's message to the world.

Virginia Woolf supplied an animated monograph on her great-aunt's character and life that failed to avoid the familiar exaggerations, but captured the warm enthusiasm with which she believed the Pattles 'generally brought their eccentric undertakings to a successful end'.[24] Roger Fry revived the Victorians' problem with 'placing' photography as a specific discipline: he described its position as 'uncertain and uncomfortable. No one denies its immense services of all kinds, but its status as an independent art has always been disputed. It has never managed to get its Muse any proper representation on Parnassus, and yet it will not give up its pretensions altogether'.[25] Fry concludes, in apparent distinction to Virginia Woolf's individualisation of her 'eccentric' great-aunt, that Julia Margaret's work shows her to be typical of the artistic élite of the 1860s and 1870s. He regards her as among her peers in undertaking the portraiture of great men.

Roger Fry believed that Julia Margaret's work 'bid fair to outlive most of the works of the artists who were her contemporaries'. Two decades later, J. B. Priestley included the portrait of Ellen Terry in a volume of essays as one of his 'delights'. To him it was not the individual, whom he knew only in old age, who was conjured forth, but:

Woman herself, her soul withdrawn behind those heavy eyelids, the mystery, the challenge, the torment, the solace. Yet it would not be at all the same if this were not a photograph but a painting or drawing, some other man's vision. That would be art but this, however artfully the sitter has been posed and the camera handled, is an objective record. This is how she was on such a day, and not how she sung in some man's brain.[26]

At about the same time, the Gernsheims were preparing their enormously influential rehabilitation of Julia Margaret Cameron, and of Victorian photography in general. First published in September 1948, their *Julia Margaret Cameron* went through numerous reprints before being revised and republished (with considerably better reproductions than were possible soon after the war) in 1975. While unhappily playing the numbers game, and finding only sixty 'masterpieces' amongst her work as against 1,500 (or the entire contents) in the Hill–Adamson collection,

Helmut Gernsheim characterises her 'successes' as the 'land-scapes of a life. . . . Imbued with her peculiar style, these photographs are among the most beautiful and remarkable pictures in the history of photography.'[27]

To the Gernsheims it was always Julia Margaret's portraits that bore the hallmarks of 'work of a strong personality, and they are the most vigorous and expressive documents we have of the Great Victorians, faithfully revealing the minds of those who were the dominating figures of that period'. Like Roger Fry, Alison and Helmut Gernsheim compare Julia Margaret's 'great men' with the versions of Tennyson, Carlyle, Browning and Darwin created by the leading portrait painters of the day, and conclude: 'the photographer scores in every case against the painter'.[28] The Gernsheims paid due respect to Julia Margaret's unique capacity for 'piercing through outward appearance to the soul of the individual', a characteristic that was not the result of photography itself but of her own considerable talent.

There is, however, another dimension that comes into play that does have to do with the choice of a particular medium. Photography allowed its practitioner not to care what the sitter thought of the result; he or she could always blame it on the fact that, supposedly, 'the camera cannot lie'. Julia Margaret certainly invoked this cliché when it suited her, as when, for example, she objected to retouching out some physical flaw the subject had hitherto been unaware of. But, more than this, she made full use of the artistic licence it allowed her, in striking contrast to the commercial portraitists of her time, who had to care what their subjects thought, and so prettified them, taking full-length shots that gave maximum attention to dress (that important emblem of status), and flattening features into insignificance with all-round lighting, which pleased clients by allowing for shorter exposures.

These commercial techniques followed hard on the heels of the tradition of miniatures, based on flattery and consequent misrepresentation. One can see from Watts's oil portrait of Julia Margaret (in the National Portrait Gallery) just how far he was prepared to take his idealisation of his friend and patron in order to please, presumably her. In contrast, the numerous portraits

she took of the artist whom she cherished, admired, pitied and looked both after and up to, present just that range and wealth of feeling. He is represented now as the grand old 'Signor' leaning on his cane; now turned almost misanthropically away from the camera's eye, his hair ruffled and expression miserable; and yet another time posed in a poetic composition for 'The Whisper of the Muse'. All these portraits show Watts very much as Julia Margaret herself knew him, and in doing so they allow us to enter what was a very important and artistically creative relationship in her life.

The Gernsheims hit on this crucial element in the power of Julia Margaret's portraits: what they tell us about the inner life of their subjects, and the way that Julia Margaret felt about them: an intense reverence often combined with warm affection, and a deep relationship based on both. She could use the camera's reputation for veracity as a pretext for her own brand of truth, and she unerringly exploited what the camera could, as a safely 'neutral' implement, so effectively reveal. But she was closer to our age than her own in recognising that there is no such thing as holding up a neutral 'photographic mirror' to the outside world without it at once becoming a window onto the photographer's as well as the subject's own soul. The story of her array of powerful portraits is not that of technical perfection (as with so many of her contemporary photographers), any more than it would be with an accomplished artist. It was rather the story of the dynamic between the artist who is 'seer' and the subject who is himself or herself 'seeing', rather than the so-called objectivity of the 'seer' viewing the 'seen'.

The Gernsheims' growing interest in Victorian photography led them to publish increasing numbers of books on the subject and to establish a unique collection of early photographs, which was publicly exhibited during the 1950s and 1960s. Their efforts during this period to create a national collection were, however, frustrated – largely by lack of government interest – and the bulk of their extensive collection, including numerous Camerons, is now in the University of Texas. But they were largely responsible for reinstating Julia Margaret in the public eye, and for making

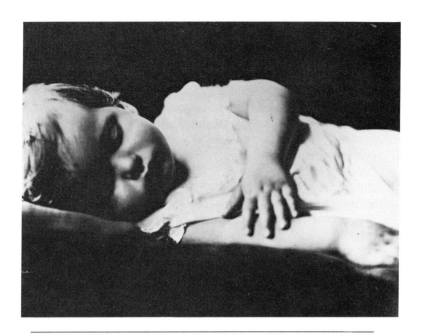

11. 'My Grandchild', 1865. This picture – as startling in its starkness as either 'Daisy' or 'Annie, My First Success' – was one that Julia Margaret toyed with in attempting to create a composite Madonna and Child. The difficulty of finding, dressing and setting a suitable Madonna next to the child could be overcome by taking advantage of her sleeping grandson, and attaching his Mother as part of the background later on. She experimented with several Mary Hillier Madonnas and one Mary Ryan one, but finally settled on one of the former for exhibition.

Colin Ford's job slightly easier when he took over responsibility for photography at the National Portrait Gallery. Ford's writings on Julia Margaret over the last dozen or more years have provided a lucid and researched commentary on the many exhibitions and catalogues he has put together.

The Gernsheims' emphasis was on the great men at the expense of Julia Margaret's range of other portraits. Yet her virtual invention of the close-up was also applied particularly to the younger women members of her family – Julia Jackson, Annie Chinery, May Prinsep – leaving the impression that the famous elderly men and the beautiful young women were those she most wished to be close to. Unfortunately, evaluations and comparisons between the different aspects of her work cannot easily be made until a permanent display of it is mounted. It is surely odd, when so many of our national museums have Camerons secreted in upstairs drawers or back offices, that the only permanently hung ones should be a small selection of her Sinhalese prints – surely among her least representative work – on a staircase at the National Museum of Photography. To find others of her pictures on display, one must look in such esoteric nooks as the Victorian Society's headquarters at Sandbourne House or Darwin's former home at Down in Kent.

If this book serves to interest readers in Julia Margaret and her work, and to encourage them to go and look at the original prints – four times larger than any of the reproductions here, with a depth to match their scale – then a major intention has been realised. For Julia Margaret longed 'to arrest all beauty that came before me', and it is only by looking at the originals that one can concur that 'at length that longing has been satisfied'. Single-handed, completely cast in her own mould, she did more to make photography an art-form than any other nineteenth-century photographer. In this she was an impressive and intrepid pioneer. Her pictures are, quite simply, beautiful.

THE LIFE

Julia Margaret Cameron's life is poorly documented in terms of chronological facts, over which there are frequent disagreements, but richly embroidered in contemporary anecdotes. We know relatively little of her first thirty-two years in India or the last five years in Ceylon, but have endlessly corroborated stories of her time on the Isle of Wight between 1858 and 1875. She was one of a circle that included many of the most famous writers, artists, scientists, musicians and politicians of the time. She and her six sisters were the forerunners of the matriarchs of Bloomsbury, strong women who made a determining impression on their numerous descendants, among whom were numbered what Quentin Bell has called the 'artistic' Stephens.

If 'Bloomsbury' has provided lavish pickings for critics looking to establish links, repeat gossip and trace allegiances, then so did 'Pattledom' in its own heyday. It was in India that Lord Dalhousie, despairing of the family ever conforming to expected codes of conduct, divided society into 'men, women and Pattles'. The seven sisters were a formidable team, amongst whom the bond of kinship overrode differences of lifestyle, opinion and personality.

Julia Margaret was born in Calcutta in 1815. She remained all her life devoted to the Indian sub-continent, although her olive complexion and dark hair need not denote the mixed blood that has sometimes been ascribed to her. She was not, however, a straightforward descendant of the British age of imperialism, for her ancestors were French immigrants, self-exiled from France after the Revolution. She was proud to be directly descended from the aristocracy of the *ancien régime*. Her grandfather was the Chevalier de l'Etang, a page of honour to Queen Marie-

Antoinette. He was exiled to a regiment of Spahis in Pondicherry sometime in the late eighteenth century. Depending on the version one picks, this was either in the wake of the mass exodus of young nobles that took place at the onset of the 1789 Revolution, or on account of the increasingly intimate nature of his services to the Queen to which Louis XVI objected.

However genuine either explanation may have been, the establishment of a French republic afforded a substantial reason for a royalist to remain overseas. Another was soon added by the Chevalier's marriage to a fellow French settler, Thérèse Josephe de Grincourt, and the rapid addition of five children to the family. The Chevalier supported them by working as a vet, training horses, running a riding school; finally he began his family's long contact with the East India Company by working as an assistant supervisor at one of their studs. Despite the recent lapse in military hostilities between England and France, in 1814 the then Governor General, the Marquis of Hastings, described de l'Etang as a 'man of exemplary manners and moreover . . . most highly qualified for superintending a stud farm, having held such an office under Louis XVI in France'.

The Chevalier continued in this line of work until his death in 1840. His wife outlived him, surviving well into her ninety-ninth year amidst the 'retirement' of a busily elegant social life in Versailles. It was to her house, 1 Place St Louis, that her daughter Adeline Pattle and her numerous offspring made frequent perilous visits from India. Her grandchildren, Julia Margaret and her sisters, received a major part of their admittedly haphazard education in Versailles.

'Home', however, was clearly understood by the Pattles to be England, despite the Versailles connection, and despite the fact that Adeline's husband, James Pattle, had been born in Bengal. He had been sent to school in Battersea, and joined the East India Company in 1792, bearing a guarantee of proficiency in 'Lating [sic], Writing and Accounts'. It is not known what use he made of the first of these, but the latter served him in considerable stead throughout his fifty-three years' service, and brought him a respectable fortune in consequence.

James Pattle died in 1845, and his wife survived him for only two months. Rumour had it that she died as a direct result of the macabre experiences surrounding the shipping of her husband's body back to England. The corpse, preserved in alcohol, burst its cask, and Adeline, drawn by the noise of the explosion in the next room, was the unhappy discoverer of the half-emergent body of her lately dead husband. 'The shock sent her off her head then and there, poor thing, and she died raving.'[1]

So in 1846 Julia Margaret found herself effectively the head of the family. Two children senior to her had died as infants. Adeline, her eldest sister to whom she had always been especially close, had died tragically at sea at the age of twenty-four, leaving three small daughters to be raised by their paternal aunt. Sophia, the youngest of her five remaining sisters, was just sixteen. The neo-classical villa in extensive grounds that had been the family's Calcutta home was sold, although the girls used a small portion of their inheritance to erect a Dispensary in Garden Reach Road for 'relieving the wants of the poor', dedicated to the memory of their mother. Garden Reach was where Julia Margaret had been born; it was so called after the adjoining Botanical Gardens, a favourite site for picnickers by virtue of its spreading shade and the cool of the River Hooghli running through it.

Julia Margaret's childhood, along with that of her sisters, had been unconventional even by the axioms of the day. Their time was split three ways between India, Europe and, connecting the two, the sea journeys that could last six months in either direction, during which the passengers' cabins became just as much home to them as their berths were to the sailors. The instructions provided by the shipping companies always invited passengers to 'board adequately equipped with furniture and servants'.

It was presumably thanks to some of these servants, the nursemaids and governesses, that the Pattle girls grew up as accomplished as they did, and as devoted to reading, writing, the fine arts and music. Their grandmother Mme de l'Etang primarily valued the social graces, and while running a household and playing bridge were writ large in the daily routine of life at Versailles, little formal education was provided. Perhaps the

repeated travel told against consistent instruction since any English tutor, once settled in India, might have objected to being returned to Europe. In addition to the inconvenience, very real hazards were involved; Julia Margaret underwent her first ship-wreck at the tender age of only a few months.

Quite what effect this irregular life-style had on Julia Margaret we do not know, although she suffered several bouts of illness sufficiently severe for her to be repeatedly sent to the less humid climate of the Cape of Good Hope to convalesce. It was on one such visit, in 1835, that she met two of the men who were to have the greatest influence in shaping her life. One was Sir John Herschel, who was conducting astronomical investigations there, while also experimenting with chemicals to use in photographic processing. He was to become her mentor in the practical de-velopment of her photographic ability; he is chiefly recalled now for his application of the cyanotype as a 'blue-print' and of thiosulphates ('hypo') as fixing agents, and for his invention of the terms 'negative' and 'positive' (as applied to photographic proces-ses), 'snap-shot', and even for publishing the word 'photography' in English for the first time, in 1839.

The other was Charles Hay Cameron, born in 1794 and twenty years older than Julia Margaret. He was a jurist and a follower of the utilitarian philosopher, Jeremy Bentham, with whom he had been acquainted in England. He had lived for a long time in India, working with Lord Macaulay and latterly with Sir Edward Ryan, a friend from student days, as the legal member of the Council of India. He was an erudite classical scholar with a dinner-table accomplishment of which Julia Margaret would come to be proud: an ability to recite impressive reams of Homer and Virgil from memory. He was a distinguished liberal reformist; his *Two Reports addressed to His Majesty's Commissioners appointed to Enquire into the Administration and Operation of the Poor Law*[2] (published in 1834 before he went to India) showed the same capacity for rational deduction that was to characterise his later *Address to Parliament on the Duties of Great Britain to India.*[3] In the former he refused to distinguish between the so-called deserving and undeserving poor, since he could not find any uniform and

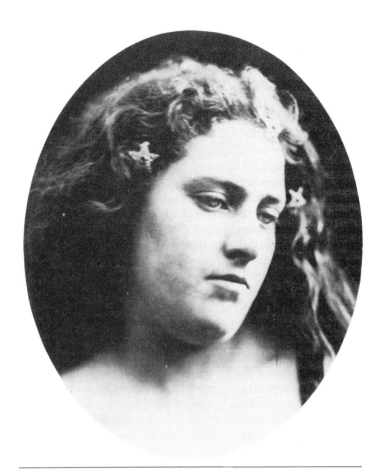

12. 'A Bacchante', 1867. This unknown model posed for a number of Julia Margaret's Grecian fantasies, including a version of the Elgin marbles and, wearing the same diamante hair-clips, 'The Morning Star'. The portrait indicates the variety of Julia Margaret's artistic influences, of which only the Pre-Raphaelite one has been extensively explored. Here there is the three-dimensionality of the classical sculpture that Charles Hay so admired, created by fading the hair into blackness, bringing the face into highly-contoured prominence, and leaving the neck and shoulders as bare as marble.

legally satisfactory means of doing so. The latter tract is a classic example of 'progressive' thinking in the second half of the nineteenth century, advocating rapid reforms to incorporate at least the educated Indians into the colonial power structure in order to stave off mutiny and revolution, and proposing an 'enlightened' (i.e. anglicised) system of education for the rest. His inspiration drew not only on 'twelve years of study and reflection upon the jurisprudence of India' but also on 'the pretensions of our great Milton, whose Areopagitica . . . is the conspicuous example in the history of this country, and of the loftier and intrinsic sort . . .'

Julia Margaret Pattle and Charles Hay Cameron were married in 1838 when she was twenty-two. Although it has been suggested that this plainest of the Pattle sisters was happy to acquire a husband even twenty years her senior, there is absolutely no indication that theirs was a marriage of anything but the sincerest mutual affection and tolerance. In Calcutta Cameron rose to become President of the Calcutta Council of Education and an established member of the Supreme Council of India.

The Governor General, Lord Hardinge, was in the unusual situation of being a bachelor, and Julia Margaret gradually assumed responsibility for organising his social functions. By 1844, although not thirty years old, she was an accomplished hostess. She loved the business of issuing invitations, making introductions, organising outings and marshalling armies of domestic servants to provide a properly relaxed setting for the discreet conduct of British diplomacy. She was well connected both through her father's position in the East India Company, and her husband's on the Council, to play the society hostess on a grandly ambassadorial scale. Seeing no obstacles at all where many would see nothing but, she soon established a reputation as a formidable introducer of the most unlikely guests. Whether for reasons of propriety or simply as a matter of her personal preference, Lord Hardinge's invitations ceased to be issued primarily to Government House and instead were for picnics in the grounds, musical parties on the river, or garden teas in the countryside estates. Children were welcomed – Julia Margaret's

third son was named Henry Hardinge after the Governor General
– and would come trailed by their *ayahs* who, more shocking still,
were not the only members of the native population to be invited.

For Julia Margaret shared her husband's views that Indians
from the educated classes were acceptable in European society.
This attitude, and the response it evoked from the British
expatriates, is well caught by E. M. Forster almost a hundred
years later. Julia Margaret could almost be substituted for Adela
in this passage:

'People are so odd out here, and it's not like home – one's always facing
the footlights, as the Burra Sahib said. . . . They notice everything, until
they're perfectly sure you're their sort.'

'I don't think Adela'll ever be quite their sort – she's much too
individual.'

'I know, that's so remarkable about her,' he said thoughtfully. Mrs
Moore thought him rather absurd. Accustomed to the privacy of Lon-
don, she could not realize that India, seemingly so mysterious, contains
none, and that consequently the conventions have greater force.[4]

Charles Cameron had a number of reformist campaigns, rang-
ing from his desire to see duelling forever abolished,[5] to that of
overseeing the education and incorporation of native Indians into
the civil, military and medical services. Julia Margaret fostered
her own good causes, none of which were subservient to her
husband's. In 1845 the Irish potato famine struck and she became
the organiser of the Calcutta relief fund. By dint of her customary
fervour she succeeded in raising £14,000 to assist the starving, a
phenomenal sum in its time, particularly for a one-woman cam-
paign. Not only did she utilise the captive audience of her guests
to Government House, but there were a substantial number of
Irish regiments based in the Indian sub-continent and a sizeable
Anglo–Irish contingent within the East India Company, all of
whom were concerned for the welfare of friends and relatives
back home. To our eyes it might seem politically incongruous
that a woman of Julia Margaret's social standing should orches-
trate a campaign on behalf of a people who were, after all, merely

the victims of two centuries of British economic exploitation. But to her, such matters were Acts of God, to which she made a charitable response, leaving the finances to men such as her future friend Henry Taylor to elucidate. He explained quite how financially specific God could be, basing his calculations on the natural superiority of the Church of England (and its extension, the Church of Ireland) over Roman Catholicism.

In an undated letter to Lord Grey, Henry Taylor estimated as necessary support to the tune of only '£100 a year for each 1,000 of the Roman Catholic population', adding, by way of explanation: 'I think that the Irish are in some of the essential qualities which lend themselves to good government, an inferior race . . . whilst it is to the credit of the Irish that they are ardent in their corrupt religion, the fact that it is corrupt must be taken to indicate the inferiority of the race morally and intellectually.'[6] Julia Margaret's variety of Christian response can be seen to have much to recommend it, particularly in view of the evidence that the

13. 'The Kiss of Peace', 1869. In a recent book on Julia Margaret Cameron, Mike Weaver finds a religious basis for this theme in *The Treatise of the Apostolic Tradition of St Hippolytus of Rome*, where it is written, 'The baptised shall embrace one another, men with men and women with women.' But in fact Julia Margaret is likely to have known of the early Roman Catholic custom for members of the congregation to 'offer one another the kiss of peace' (a custom that has recently been revived). Julia Margaret knew several of the prominent Roman Catholic converts of her time (like Aubrey de Vere and Coventry Patmore), who may well have told her of the practice.

In infusing the embrace with a religious significance, Julia Margaret eschews both the voyeuristic element common to the male Victorian photographer's view of lesbianism, and the genuine eroticism of Lady Hawarden's portraits of her partially-clothed maids posing in her bedroom. Yet the attribution of the title is unspecific, and there is the same ambiguity of characterisation as in the interpretation of 'The Angel at the Sepulchre' (also portrayed by Mary Hillier), where the subject could be either the Angel or the Magdalene to whom the Angel appeared.

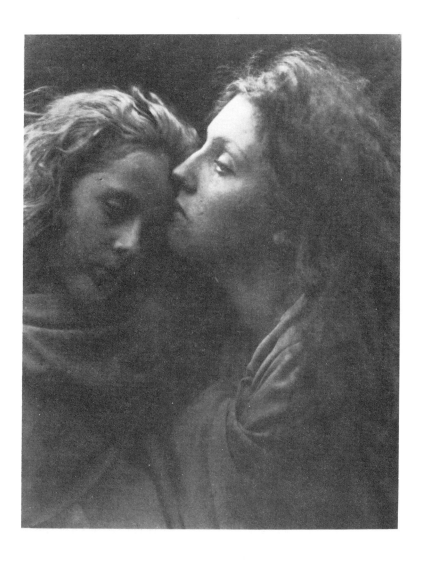

Camerons were unusual in the enlightenment of their attitude towards the subjects of British imperialism.

When not busily entertaining on behalf of the British administration, fund-raising for the needy or directing the education and leisure of her growing family of children, Julia Margaret was an avid reader. This was an interest that remained with her throughout her life (when she retired back to the East, she brought with her a curious combination of classical Greek tragedy and the lives of British sovereigns). She particularly enjoyed the historical romances then in especial vogue with female readers, and in 1847 she published her own translation of Gottfried Bürger's famous neo-mediaeval ballad *Lenore* (written in the 1790s), with woodcuts by the popular illustrator Daniel Maclise.[7]

In order to refute the charge that it was an adaptation of several translations already in circulation, a Preface announced: 'She has endeavoured not only to exhibit the spirit, but to follow the very words of Bürger.' In the light of her subsequent photographic career, the emphasis on literal translation is interesting, especially

14. 'The Dream' (Mary Hillier), April 1869. Mary Hillier possessed the looks that Julia Margaret found most suited to expressing the mystical qualities she believed were the essence of womanhood. Her heavy-lidded eyes, strong profile and long hair were repeatedly exploited to express the amalgam of intensity and sensitivity that Julia Margaret sought. Even in old age, and virtually blind, she retained the grace and beauty captured in the photographs of her youth; she lived until 1936, long enough to be interviewed by hunters of Cameronabilia. She came into Julia Margaret's service as a maid through the recommendations of her sister Sophia, a maid at the Tennysons', and remained until the Camerons left for Ceylon. Two years later she married Thomas Gilbert, a railway official, who then became G. F. Watts's gardener at The Briary.

It was under this portrait that Watts penned his opinion 'Quite Divine!' which Julia Margaret laboriously copied onto innumerable subsequent prints. The picture was one of her best-sellers. Julia Margaret sometimes added after the title the first line of Milton's sonnet on his deceased wife: 'Methought I saw my late espousèd saint'.

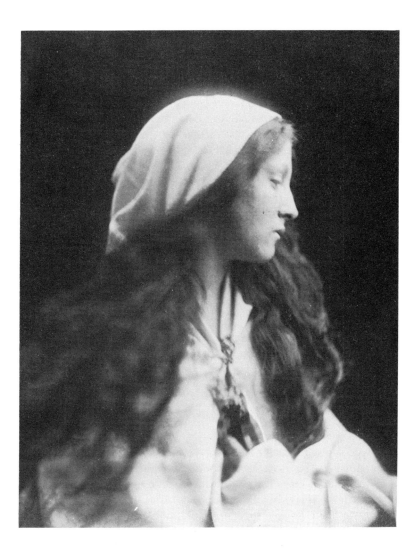

in such phrases as 'the translator, not aspiring to create, has studied only to catch the likeness of a beautiful picture, and to copy faithfully each feature and expression of the original.' These protestations served, perhaps, to differentiate Julia Margaret's version from those of William Taylor and Sir Walter Scott, which she claimed not to have seen, despite the fact that she had numerous volumes of Scott's works in her library.

Bürger's poem is a Gothic horror story, for which a cult existed similar to that for Hammer horror 'B' movies 150 years later. Julia Margaret keeps the rhymes and metre simple as befits a ballad of 65 stanzas, although the rhythm alters from the point where the ghostly knight gathers the heroine up on to his fiery steed. Every suitable cliché is invoked to set the atmosphere:

> Hark! why that sound? who, solemn, sing?
> Why dismal flaps the raven's wing?
> A funeral chaunt arrests the ear,
> Here comes the hearse, there rests the bier.

Impending doom is the ballad's reiterated theme until it achieves its climax:

> Now see! now see! Where is the knight?
> What is this horrid ghastly sight?
> All shivering falls the warrior's steel,
> A skeleton from head to heel!

The poem closes with a conventional pious invocation, imploring God's forgiveness for the hapless Leonora who has done little but be the passive pivot around which the plot unfolds. The richly resounding language gives instant scope for amateur theatrical adaptation, lavish with such noises off as 'hoosh hoosh hoosh', 'whirr whirr whirr' and 'deep bosom groans'. Julia Margaret's visual eye is also evident in the careful presentation of the book, with border illustrations as well as occasional full plates by Daniel Maclise, who was also to contribute woodcuts to the 1857 Moxton edition of Tennyson's *Idylls of the King*.

There is a consistency of approach between Julia Margaret's early work on *Leonora* and her considerable success, almost thirty

years later, in her collaboration on Tennyson's *Idylls of the King*. In between we know she wrote some original work, of which nothing survives but a posthumously published poem in memory of her friend Arthur Clough. With both the *Idylls* and *Leonora* her function, whether as photographer or 'translator', was to interpret an existing work. In both cases, she chose to work in the same format, that of a large-scale book, in which the illustrations, while faithful to the text, were there to complement it. The type of tale was the same, too – a romantic fable, at the centre of which lay knightly codes of honour and a woman's fidelity; both also have similar, at times almost camp, dramatic dimensions.

Leonora was Julia Margaret's last literary foray before leaving India. Thereafter, although we know she had a penchant for writing poetry, there are only two poems that have come down to us – revealingly enough, one is about a literary friend, the other is entitled *On a Portrait*. By early 1848 Charles Cameron had determined to take early retirement – he was, after all, already 54 years old – and the family was packing up for the sea-crossing to England, their unknown 'home'. Their departure bore all the hallmarks of Julia Margaret's passion for collecting: trunk-loads of souvenirs, fabrics, carvings and curry spices were sent on ahead. Official farewells led to rounds of more informal parties. One leave-taking that must have been particularly close to Charles Cameron's heart was that at a 'Public Meeting at Calcutta in honour of the Honourable C. H. Cameron', called on behalf of the 'Native inhabitants of Calcutta' at the Medical College, by a dozen or so of its practitioners. The meeting recorded 'its sense of gratitude . . . for the services he has rendered to the country by his unceasing interest . . . in the moral and educational improvement of the native population', and proposed that 'a subscription be opened among members of the native community . . . to defray the expense of the portrait [of Cameron]'.[8]

Charles Cameron's determination to leave was a curious mixture of confidence in the continuing security and financial viability of his coffee and rubber plantations, and a sense of incipient social upheaval. In 1848 Europe was in political turmoil, nationalist uprisings in Sicily having led to armed insurrections in France

and Italy and spontaneous revolts against foreign oppressors in Eastern Europe. But while the Paris Commune held brief sway across the Channel, in England the Chartist movement had been defeated and it would be another decade before the Reform League would feel strong enough to renew the campaign for extending the suffrage.[9]

Despite the victory of reactionary forces and the complacent sweep of a self-styled 'Age of Progress' that reached its apotheosis in the Grand Exhibition of 1851, to the Camerons the whole of Europe appeared rife with 'international anarchy'. By comparison India suddenly seemed 'secure under the mild sceptre of Queen Victoria', endowed with 'free ingress and egress, free commercial intercourse, equal laws, uninterrupted peace'. Feeling that his landholdings were thus protected, Charles Cameron decided to acquiesce in his wife's wish to rejoin her sisters and his own to enter an active retirement. He would brave a continent

15. 'The Mountain Nymph Sweet Liberty' (Cyllene Wilson), June 1866. Gernsheim believes Cyllene (or Cyllena) Wilson to have sat not only for this portrait but also for 'Ophelia', 'Rosalba', 'Daphne', 'The Dream', and 'The Angel at the Sepulchre'; Ford additionally suggests for 'The Holy Family'. However, I find this one (and its companion profile) uniquely mysterious. 'Cassiopeia' (May 1866) is the only other portrait for which she definitely sat. Until 1866 Cyllene lived with her family; in that year she was orphaned and, together with her siblings, was 'adopted' by the Camerons. It is possible that the similar, but more heavily-jowled, model for 'Rosalba' and 'Daphne' was her sister.

Her father was a traveller, obsessed with taking the Anglican faith to the Greeks and with stamping out 'Papal precepts' amongst 'our Protestant youth'. It is perhaps curious, in the light of his daughter's subsequent numerous marriages, that the frontispiece to the Rev. Sheridan Wilson's best-known work, *Agnes Moreville*, should bear two injunctions inveighing against 'the seducers in our age', on the grounds that 'if our children have no fixed principle of religion, they become an easy prey to seducers'. Within a few years of being taken in by the Camerons, Cyllene had eloped, and after travelling the world by sea, she died of yellow-fever.

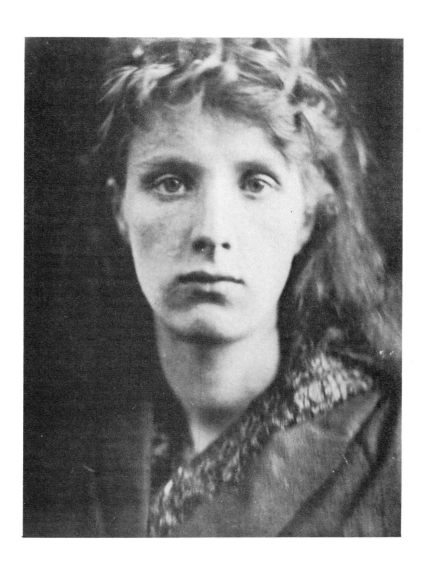

racked, as he wrote in his *Address to Parliament* in 1853, with internal strife, 'hostile Tariffs, by laws hostile to aliens . . . by a vexatious Police stationed at every frontier even in time of peace; and lastly the tremendous scourge of war'.

This image was but part of the whole story, and more accurate about continental Europe than England. Success in breaking the Chartists' movement for political and social change had reinforced the fact that mid-Victorian England was where the middle classes were rapidly growing in numbers, confidence and affluence. They were enjoying the lion's share of the prosperity reaped from Britain's ability, as the world's major imperial power, to milk colonies of their raw materials and turn herself into 'the workshop of the world'. Within this newfound domestic security the unconventional could be accommodated without seeming to challenge the status quo. The Royal Academy might affect outrage at having its high-priest and president called 'Sir Sloshua Reynolds' by the Pre-Raphaelite Brotherhood but most of the offenders had been students there, and Millais himself was to succeed Reynolds as President, his days of rebellion (and innovatory work as an artist) at an end.

● Julia Margaret in England

Three of Julia Margaret's sisters were already settled in the vicinity of London when she arrived in 1848, with her husband and six children. Mia (Maria), the gentlest sister, was living in Hendon with her growing family of daughters, awaiting the return of her husband, Dr John Jackson, from his medical duties in Calcutta. Virginia, the great beauty among the Pattles who hated being known for her beauty alone, had nonetheless taken London society by storm and was remaining aloof from her many suitors pending her final decision to marry Earl Somers, who was, incidentally, a keen amateur photographer. And Sara, whose elderly husband Thoby Prinsep had retired from service in the East India Company in 1843, had established an artistic côterie around Millais, Rossetti, Holman Hunt and Burne-Jones. Her home was Little Holland House, obtained through the interces-

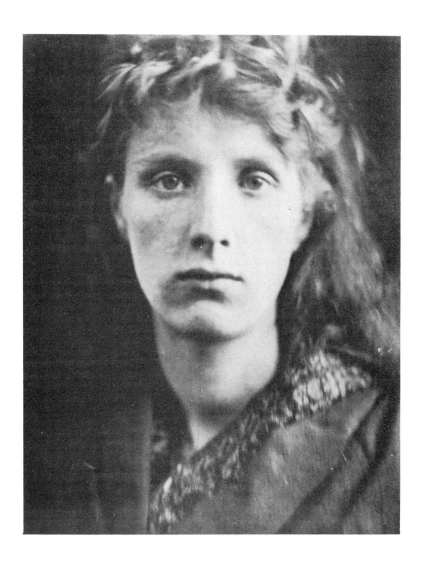

racked, as he wrote in his *Address to Parliament* in 1853, with internal strife, 'hostile Tariffs, by laws hostile to aliens . . . by a vexatious Police stationed at every frontier even in time of peace; and lastly the tremendous scourge of war'.

This image was but part of the whole story, and more accurate about continental Europe than England. Success in breaking the Chartists' movement for political and social change had reinforced the fact that mid-Victorian England was where the middle classes were rapidly growing in numbers, confidence and affluence. They were enjoying the lion's share of the prosperity reaped from Britain's ability, as the world's major imperial power, to milk colonies of their raw materials and turn herself into 'the workshop of the world'. Within this newfound domestic security the unconventional could be accommodated without seeming to challenge the status quo. The Royal Academy might affect outrage at having its high-priest and president called 'Sir Sloshua Reynolds' by the Pre-Raphaelite Brotherhood but most of the offenders had been students there, and Millais himself was to succeed Reynolds as President, his days of rebellion (and innovatory work as an artist) at an end.

● Julia Margaret in England

Three of Julia Margaret's sisters were already settled in the vicinity of London when she arrived in 1848, with her husband and six children. Mia (Maria), the gentlest sister, was living in Hendon with her growing family of daughters, awaiting the return of her husband, Dr John Jackson, from his medical duties in Calcutta. Virginia, the great beauty among the Pattles who hated being known for her beauty alone, had nonetheless taken London society by storm and was remaining aloof from her many suitors pending her final decision to marry Earl Somers, who was, incidentally, a keen amateur photographer. And Sara, whose elderly husband Thoby Prinsep had retired from service in the East India Company in 1843, had established an artistic côterie around Millais, Rossetti, Holman Hunt and Burne-Jones. Her home was Little Holland House, obtained through the interces-

sion of the painter G. F. Watts with his former benefactors, Lord and Lady Holland, with whom he had resided in Italy for four years.

G. F. Watts was clearly a fine catch for Sara to add to her Pre-Raphaelite circle. She honoured him with the title 'Signor' and a private wing of the extensive Little Holland House (albeit a somewhat damp one), in return for using him as a 'painter in residence', to be called upon to sketch guests, instruct her children in drawing, or decorate the house with frescoes as required. Favoured guests would be invited to observe him at work in his paint-stained smock and wide fedora hat. Sara was disposed to tell how 'he came for three days and remained thirty years', regretting that Burne-Jones had not similarly stayed beyond a short visit. Watts was to repay the Prinseps' generosity in later years, when Little Holland House was demolished and he bought The Briary at Freshwater, in which Thoby Prinsep could restfully pass his last years. Meanwhile, Watts was kept from too great a lapse into his customary melancholia by being set to rove among reunions of the famous with his ivory-backed sketchpad. As for the house itself,

It was a place after Mrs Prinsep's heart. She considered that it was made for her. Its rambling rooms and corridors just suited the untidiness of her mixed French and Irish descent. It could not be denied that it was far out, too far to be fashionable, but Mrs Prinsep decided to snap her fingers at fashion in this matter as she had done over dress. She would make it fashionable to live outside London.[10]

Although it was Virginia and Mia for whom Julia Margaret felt the tenderest affection, it was Sara to whom she naturally gravitated on reaching England. The Camerons settled first in Tunbridge Wells, but Little Holland House very rapidly became their London axis: to Julia Margaret the surrounding fields and the mud track connecting the house to town were positive assets. Together the two sisters carved out the social scene they wished to enjoy, Sara taking the artistic and Julia Margaret the literary lions. It was not enough for either woman to live vicariously through her husband's achievements: each wanted other 'great

men' around them, and neither was sparing in the ruses they devised to obtain them. Emotional blackmail was part of their strategy, conducted by making themselves indispensable to their 'victims', as Tennyson was woefully to call Julia Margaret's visitors.

It was the clannishness of the sisters which had led to the coining of the term 'Pattledom'. On their arrival in England from Calcutta, each sister was singled out as having some particular quality, ability or sphere of interest that could render her ripe for the gossip columns of *Punch*.[11] What they held in common was animation of spirit, liveliness of mind, and a taste for unconventionally striking dress and behaviour that occasionally shocked, but more frequently attracted and entertained. A well-connected

16. 'The Gardener's Daughter' (possibly Mary Ryan), 1867. For once Julia Margaret stuck to the text with a literalness she often did not use for religious subjects. At least five years before Tennyson suggested she might like to work on yet another illustrated version of his *Idylls of the King*, Julia Margaret was toying with some of his shorter narratives such as *Maud* and *The Gardener's Daughter*, where Mary Ryan (or just possibly May Prinsep) was posed

> Gown'd in pure white, that fitted to the shape –
> Holding the bush, to fix it back, she stood.
> A single stream of all her soft brown hair
> Pour'd on one side: the shadow of the flowers
> Stole all the golden gloss, and, wavering
> Lovingly lower, trembled on her waist . . .

This portrait is unusual since it was taken outdoors, well away from the ivy-clad wall that adjoined Julia Margaret's studio in Freshwater. One reason why she was reluctant to work outdoors might have been her desire to control the optimum number of variables of light and atmosphere, if only to ensure as much equanimity as possible in her models' expressions during her long exposures. She preferred to bring her garden into the studio, as can be seen from the large number of pictures using displays of flowers – daffodils giving way to lilies and lilies to roses or carnations as the seasons progressed.

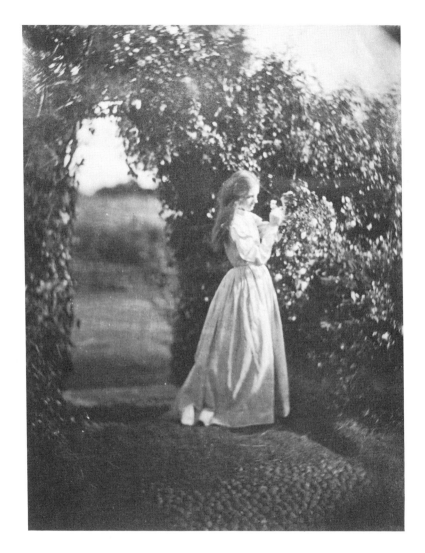

contemporary recounts her first impression shortly after the Pattle sisters' appearance in London society:

To see one of this sisterhood float into a room with sweeping robes and falling folds was almost an event in itself, and not to be forgotten. They did not in the least trouble themselves about public opinion (their own family was large enough to contain all the elements of interest and criticism). They had unconventional rules for life which excellently suited themselves, and which also interested and stimulated other people. They were unconscious artists, divining beauty and living with it.[12]

Recent attempts have been made to play down Julia Margaret's eccentricity, supposedly in the interests of rehabilitating her more convincingly within modern feminist tradition. While it is important not to use 'eccentric' as a term of dismissal where her

17. 'Beatrice Cenci' (May Prinsep), October 1870. Shelley wrote his play *The Cenci* in 1819, and it remained popular throughout the Victorian period, perhaps because it contained the approved proportions of love and lust, crime and punishment, to suit the vivid dramatic tastes of the day. Yet it is also a strong moral indictment of incest and false religion, while it shows open sympathy for the two women who plot to commit murder together.

It tells the story of the early Florentine Beatrice Cenci who, after being raped by her father, plots to rid herself of his attentions by arranging with her mother to have him murdered. The deed is done and discovered, whereupon it is determined that Beatrice must die in retribution for her crime. Appeals win the sympathy and sense of outrage of the masses but not of the Pope, who confirms that Beatrice must pay for her father's life – and so for his sin – with her own life.

This portrait shows no anger or self-righteousness on the part of Beatrice, only a wistfulness for the life she is leaving. The focus is especially clear on the shaded side of her face, signalling that her life is now overshadowed, the downcast eyes portraying her state of spirit. It is one of Julia Margaret's most sensitive portraits, where the model and her roles are perfectly at one.

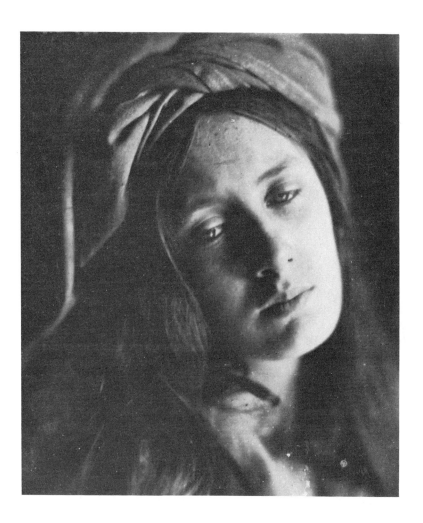

photographs are concerned, there is little doubt that Julia Margaret deliberately played on her renowned unconventionality. It was an age of conscious eccentricities, in which an artistic temperament was allowed to excuse many infringements of the social order, so long as they did not seriously undermine it. Julia Margaret herself, in one of her familiar, long and unpunctuated letters to Henry Taylor near the end of her life, recalled an incident when

After a dull dinner at one of the Roehampton great houses I stirred the stagnant social pool by some eccentric remark and my husband said to me afterwards I do not think it quite answers Julia to throw a bomb shell into the lap of society as you used to do.[13]

Both Julia Margaret and Sara regarded the painter Watts with a mixture of reverence and exasperation. He was a tetchy, morose, often hypochondriacal character, constrained by a kind of accidie alternately to keep to a meticulous self-imposed routine for the sake of his delicate constitution, and to remain inactively seated in a darkened room by the hour. The first therapy the sisters devised for him was harmless, if abortive. In 1847 Watts had won the competition to decorate the architect Barry's new Palace of Westminster with his cartoons of King Arthur (against such strong opposition as that provided by Ford Madox Brown, founder and teacher to the Brotherhood). Watts worked on the project with such application and enthusiasm that Sara proposed that he make frescoes of Assyrian and neo-Egyptian deities in Little Holland House by way of continuing distraction from his frequent depression. Unfortunately, the designs were doomed to failure, Watts taking so long over them that the damp destroyed one section before he could reach completion on the next.

The second device the sisters hoped would enliven Watts's temper was decidedly more invidious, if similarly doomed to failure. Perhaps because Julia Margaret, Sara and Mia had all married men considerably older than themselves, and because their father had been ten years their mother's senior, the sisters naturally looked to a younger generation for a match suitable for

Watts. Perhaps they really believed in a wider philosophical justification,[14] or perhaps no one who seemed appropriate approached Watts's mature years. For whatever reason, Sara and Julia Margaret were instrumental in introducing the teenage actress Ellen Terry to the ailing middle-aged painter, and in hastening elaborate plans for their wedding.

Ellen and her sister Kate were flattered and bemused at being taken up by the Little Holland House set. In the words of the fifteen-year-old Ellen: 'Little Holland House, where Mr Watts lived, seemed to me a paradise, where only beautiful things were allowed to come. All the women were grateful, and all the men were gifted.' She herself was weary of marshalling her numerous brothers and sisters around the country to seedy venues where her parents performed in travelling repertory companies, and where they all had to squeeze into uncomfortable lodgings which, she recalled, were mainly garrets. When Signor begged her to sit for her portrait, and then to give him her hand in marriage, Ellen felt unable to refuse. Years later she recalled:

When I was about sixteen or seventeen and very unhappy, I forswore the society of men . . . yet I was lonely all the same. I wanted a sweetheart. Well, Shakespeare became my sweetheart. I read everything I could get hold of about my beloved one. I lived with him in his plays.[15]

Ellen was sixteen at the time of her marriage to Watts, which failed after a year, by her account unconsummated. A more unsuitable match than that between the nervously withdrawn and prematurely old man, and the effervescent and extroverted teenager who, even after her marriage, used to race about the lawns with the Cameron children, would be hard to imagine. What is certain is that, having virtually set the thing up, neither Pattle sister did anything towards sustaining it. Ellen, finding herself treated like a recalcitrant and forward child, tended towards ever more flamboyant behaviour. Once she made an unexpected entrance into a decorous dinner party clad, or barely clad, as Cupid. When taken to tea with a sorrowing widow, she ignored the conversation, gazed out of the window, and absent-mindedly

let down her hair – the resulting disapproval from Sara Prinsep seems ironic in the context of how hard Julia Margaret had to work to persuade some of her sitters to pose with loose hair (all her society portraits are utterly conventional in dress and hairstyle).[16] Her portrait of Ellen Terry mimics that painted by Watts of her in her wedding dress and is as romanticised as any of her more allegorical themes; but the subject has her hair drawn firmly *away* from her face (Plate 5).

As Sara adopted artistic protégés, Julia Margaret began to acquire literary ones. Each time the Camerons moved house (which they did twice before settling in Freshwater), it seemed to be dictated by an earlier move on the part of their friends. They followed Henry Taylor from Tunbridge Wells to East Sheen, and Alfred Tennyson to Putney Heath. Julia Margaret was a ferociously devoted friend, with the same often overbearing organisational capacity as Sara, but without any of her calculating opportunism. Once she had decided people were to be her friends, she

18. 'Gretchen' from Faust (May Prinsep), 1870. This portrait is often regarded as the prime example of Julia Margaret's Pre-Raphaelite influence, although it is curious that the photographer herself did not devise her usual panoply of associative titles for it. Certainly she was aware of the Pre-Raphaelites' work, and had a particular liking for Arthur Hughes's *April Love*. The expression of the subject owes something to Rossetti's *Daydream* but, perhaps because that artist was somewhat tart with her, and paid her the ultimate insult of agreeing to sit for Carroll while refusing her, Julia Margaret never openly acknowledged his influence.

However, it was untrue to ascribe to Julia Margaret, as her contemporary Emerson did, no higher motive than 'paying the degraders of the art to fix the faces of her friends'. At a time when debate raged over whether photography might supersede the art of painting, Julia Margaret was concerned to demonstrate the true extent of the capabilities of her chosen medium. But she would surely have thought it disloyal to transcribe the Pre-Raphaelites' work, and she was nothing if not an intensely loyal and devoted friend.

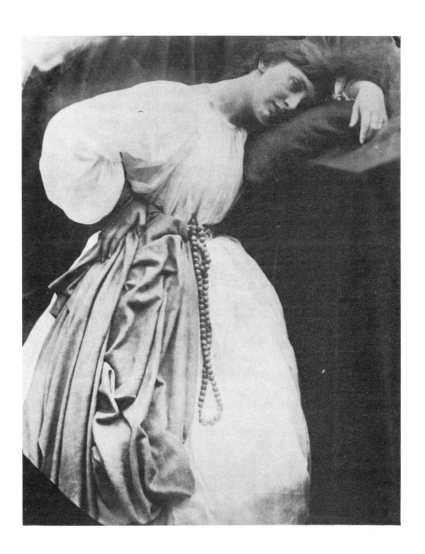

was determined to love them with total loyalty, was blind to every fault and, by some process of automatic extension, incorporated also their families in her affections. 'Before the year is out,' she informed the somewhat startled Alice Taylor, Henry's wife, 'you will love me as a sister.' Alice Taylor may well have been surprised by this, since the two women were at the time locked in a battle to control the boundaries of their comradeship. Julia Margaret was irrepressibly generous, and the sheer quantity as well as the impractical nature of many of her gifts could cause embarrassment. She showered the Taylors with every beautiful artefact she could lay hands on, principally trinkets from India, some of considerable value, made of ivory, silver and turquoise. In 1850 Henry Taylor pondered (in a letter to his father) the 'wonderful energy and efficiency in her. The transference of her personal effects is going on day after day, and I think that shortly

19. 'Alethea' (Alice Liddell), September 1872. Julia Margaret photographed both Henry George Liddell, Dean of Christchurch, and his daughter, the Alice of Lewis Carroll's Wonderland stories. She was both their inspiration and their recipient during a particularly wet boating trip with Gerald Duckworth and her younger sisters, who were given bit-parts as the Duck, the Dodo, and Slow Loris. The first 'Alice' book was published in 1865.

Carroll enjoyed taking Alice's picture when she was around seven years of age, and not twenty as in this portrait. Margaret Harker has written of this as 'One of the finest of Cameron portraits. . . . The interplay between the sharpness and diffusion in the image is most effective with a finely delineated profile, hair flowing like softly running water and flowers revealed in detail without being obtrusive'. Both Alethea and Pomona (a Roman version of the same) were goddesses of fruitfulness and therefore to be surrounded with natural bounty; Alice herself, however, is not an obvious choice for depicting earthly fertility, given her slenderness and pointed, almost cat-like, face. Julia Margaret always liked to use the best of her garden produce in her photographs, so perhaps it was the fruits of the season rather than the model herself who gave rise to the title.

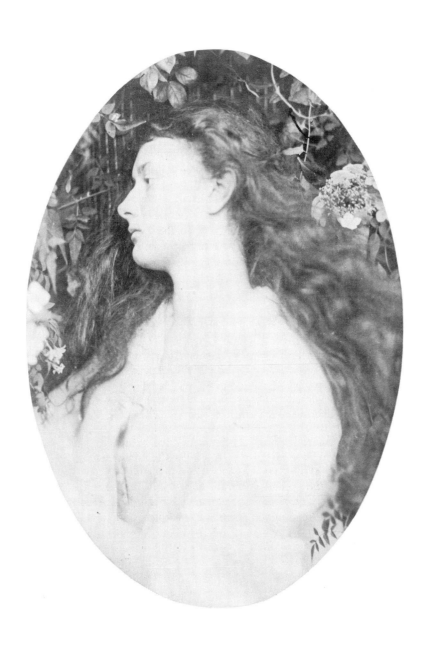

Cameron will find himself left with nothing but his real property.'
A year later, Alice wrote despairingly to her mother that Julia
Margaret remained 'just the same wild generous creature she
was', adding, 'she and I have many quarrels and each thinks the
other in fault, and I think we are both right'.[17]

The incident that almost tore the entire relationship apart was
that of the intricately woven and valuable Indian shawl. Alice
decided it was high time she asserted herself and put a stop to the
daily flow of lavish presents. Contrary to Julia Margaret's explicit
instructions, she returned the shawl with a polite note begging
her to desist from further gift-offerings. It seemed to have
worked, until, on paying a visit to the Putney Home for the
Incurable, Alice discovered an orthopaedic couch inscribed as a
donation from herself. On further enquiry, she discovered that
the shawl had been sold to purchase the couch, which had then
been donated as her bequest. Henry reluctantly concluded:

Mrs Cameron had driven herself home to us by a power of loving which I
have never seen exceeded, and an equal determination to be be-
loved. . . . She pursued her objective through many trials, wholly
regardless of the world's ways, putting pride out of the question; and
what she said has come to pass, and more; we all love her, Alice, I,
Aubrey de Vere, Lady Monteagle; – and even Lord Monteagle, who likes
eccentricity in no other form, likes her.[18]

Her eccentricities as well as her contacts proved useful to
Taylor, however. His play *Philip van Artevelde*, first published in
1834, was greeted with excellent reviews, Matthew Arnold hail-
ing it as 'the noblest effort in the true old taste of our English
historical drama, that has been made for more than a century'.[19]
But it never completed a run at the theatre, and Julia Margaret
was determined to boost its fortunes. She persuaded a Dr
Heimann to translate it into German, and then liberally distri-
buted copies to everyone she could think of who might be
persuaded to give it favourable comment. Their letters back make
somewhat muted and awkward reading, with their variety of
apologies for not having read the book nor replied sooner.
Herschel dutifully notes, 'I find I have to thank you for what

promises to be a great read,' adding, 'I am always glad of a reason to read Philip van Artevelde once more',[20] and marvelling that Dr Heimann's 'spirited German' should have so substantially increased its length. Matthew Arnold and Robert Browning refrain from direct textual comment, the former welcoming the valuable reference notes pencilled into his copy, and the latter claiming that to receive such a gift 'is a pleasure, nay my pride'. The artist and illustrator Richard Doyle wrote back to Julia Margaret quoting not his own but a reviewer's opinion that Taylor's works were 'characterised by a serene and lofty grace' and John Stuart Mill crustily confessed, 'I really have no time to spare for what is not absolutely necessary to me, and the only thing besides working which is a real relaxation is outdoor exercise.'[21]

Clearly, the one way to ensure that Philip would be appreciated (the work and the man were swiftly amalgamated for Julia Margaret) was to organise a domestic reading. Indefatigable as ever in the pursuit of her friend's interests, she issued invitations to a select circle of her and Sara's friends, for which some of the apologetic refusals make even more painful reading. Yet the evening went ahead, and a lengthy evening it was, too: Holman Hunt later affirmed that it took as long to sit through her good works as it did for her photographs. It seems also to have been of dubious promotional value, as the play continued its drift towards the oblivion it reached by the end of Taylor's busy life.

Charles Cameron, meanwhile, was taking care of politics. By 1850, he was again at work with his old friend and colleague, Sir Edward Ryan, on another open letter, to 'The Honourable The Court of Directors of the East India Company on the subject of admitting natives of India to their civil, military and medical services.'[22] In the early 1860s the Duke of Newcastle proposed offering Cameron the governorship of Ceylon, but his friends counselled strongly against it, on grounds of his failing health and years, and the proposal was never put to him. But he always felt that Ceylon was his 'spiritual home' and 'final resting-place', to make sure of which he fixed the site of his tomb some twenty years in anticipation of his death. His behaviour, too, suggested a premature absorption with the next world, as he took to spending

more and more time in bed when he was not walking the garden declaiming in classical Greek. On one occasion he surprised his dinner guests by declining to move into the withdrawing room after the meal, announcing: 'I shall soon be a spirit.' Unperturbed, Julia Margaret wrapped him in one of her shawls and left him alone at the head of the abandoned table until it was bed-time.

Perhaps it was Julia Margaret's excessive interest in other people that drove her husband into a state of withdrawal, as several observers suggested. Yet she was deeply attached to him, and his trips abroad drove her into a state of utter panic regarding his safety and health. Each one had to be prepared for by strengthening him with quantities of beef tea thickened with arrowroot; packing numerous trunks with prescriptions to contend with any imaginable eventuality; and her own self-immolation to care and worries, to which her hurried correspondence copiously attests.

The only way to take her mind off such feelings of incipient despair was to supplant them with more immediately manageable concerns. There were always other family members to worry about and, if they seemed temporarily unproblematic, then Julia Margaret would find someone else to take under her wing. Prayer was always a great solace to her, and she was unhesitating in

20. 'Elaine watching the shield of Lancelot', 1874. The photographer H. P. Robinson created a famous version antedating Julia Margaret's by at least ten years; he made a real effort at establishing place and period, providing a mullioned 'castle' window and a pot-plant growing neglected for so long it has begun to twine with the curtains. Julia Margaret's version is an altogether less Gothic affair. The shield-cover the hapless Elaine has embroidered for the fickle knight Lancelot is there before her, but she has less innocence and so more gravity than Robinson's Elaine. Somewhat unfortunately, Julia Margaret's affection for her favourite props has caused her to reintroduce Little Alamayou's 'Abyssinian' shield (Plate 52) and another embroidered kaftan instead of a mediaeval robe.

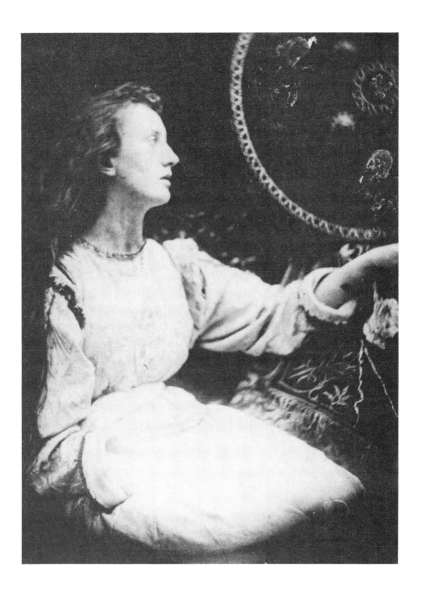

recommending it to others of her acquaintance. The child who her sisters remembered would spontaneously fall to her knees to offer eulogies in praise of the countryside retained the immediacy of childhood in some of her outbursts in later life. We no longer have the prayer she sent to Lord Hardinge, but his reply is instructive: 'I cannot sufficiently thank you for the beautiful prayer. It is so simple, touching and effective in every word that you must allow me to keep it among my papers . . . My grandchildren are learning it by heart.'[23]

A letter written in April 1859 to Henry Halford Vaughan, husband of Mia's daughter Adeline, does however exist in its entirety.[24] It is informative, not only for being one of the few unexpurgated letters of Julia Margaret still extant, but because it propounds a philosophy of life and death, and some of the ideas she would bring to photography. Written on the occasion of the death of Halford and Adeline's first son, it continually seeks to remind them of the transcendence of his state by referring to him as an 'Angel', a 'Lamb', a 'Cherub' or a 'Seraph Babe'.

The letter opens with a prayer: 'Oh let that Light shine upon you through sepulchral darkness – his little Grave seems to me transparent with Eternal Light and lined with Eternal Love. Oh let that Love mingle with the Heavenly Love that gave and that has now with equal Love taken away.' She offers comfort, very much drawn from her own experiences of bereavement, and devout understanding – that we are here only for a blink of eternity's eye; that it is God's chosen who are recalled to Him for reasons we cannot comprehend; that, for the baby, Heaven is a place of reunion and joy. But she rejects some of the tenets of conventional piety: 'I don't think Time softens these losses – I am not tempted to offer you meaningless consolation – but I know out of my own heart what *does* console . . . and *it is* this only certain truth that your child is not dead – [but] Lost to sight for a little time.' Julia Margaret would undergo comparable feelings of loss when separated from her children by a sea-voyage or serious illness, throughout which she could only remind herself that 'every daily event that befalls every precious child I have I feel equally that they belong to God'. The infant mortality rate was so

high in Victorian England, even among the healthier leisured classes, that there was an obvious need to fit what was a common tragedy into a philosophy that could make sense of the harrowing experience. Julia Margaret coped, with unflinching devotion not only to God but to her wide family, and it seems entirely genuine that she felt their bereavements as her own.

Julia Margaret's humanist brand of Christianity had practical applications. While living in Ashburton Cottage, Putney Heath, she was one day approached by an Irish beggar-woman and her daughter. Not content simply with bestowing alms, Julia Margaret invited the pair into her home, then offered to set them up in one of her cottages. Mrs Ryan preferred to maintain her nomadic way of life, but eventually agreed to allow her daughter Mary to be adopted into the Cameron family, and she moved when they did to the Isle of Wight.

Yet Mary Ryan was never adopted in the usual meaning of the word, not even in name. She worked as a parlourmaid and later as a photographic model (like the other Freshwater maidservants), and was never referred to as a daughter by Julia Margaret. Even when her own beloved and only daughter died young, it was not Mary who rose in her affections but her niece, also called Julia, and her daughter-in-law, Annie Chinery. Mrs Ryan was clearly not entirely happy with this state of affairs and paid repeated visits in an attempt to retrieve her daughter. She was denied access. Her last endeavour concerned Mary's marriage to the young Indian civil servant Henry Cotton, after which she was finally obliged to withdraw from any contact with the Cameron household.

At this distance in time it is impossible to judge the source of Mrs Ryan's disquiet, Mary's own opinions in the matter, or how well or otherwise Julia Margaret behaved. Certainly, she was not short of influential friends who regarded her as the great benefactor of a woefully uneducated homeless waif. Yet the episode reflects the more double-edged of Julia Margaret's characteristics: the desire to be seen performing a grand gesture; the self-righteous conviction that whatever she decided was in someone's best interests was also morally proper; and a high-handed

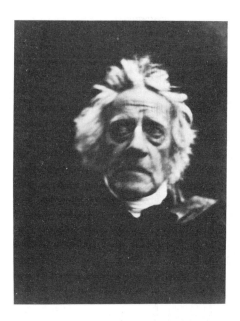

Above: **21.** 'The Astronomer' (Sir John Herschel), April 1867 and *right*: **22.** Sir John Herschel, April 1867. Roger Fry, in compiling the album *Famous Men and Fair Women* with Virginia Woolf, makes the following distinction between two types of sitters:

> It is curious how much the writers and artists are on show. How anxious they are to keep it up to the required pitch . . . and, by comparison, see the supreme unselfconsciousness of the men of science: the Herschel, the Darwin, the Hooker. . . . These men alone possessed an unwavering faith which looked for no external support or approval.

The 'unwavering faith' is here represented much more by the madly far-seeing look of 'The Astronomer' than in the haunted, questing aspect of 'Sir John' – the first a man absorbed by his science, the other simply a man *of* science. These were minutely staged portraits: Julia Margaret herself had insisted on the subject washing and fluffing out his hair, and she took prolonged trouble with the lighting and the pose. She brilliantly drew out of his inner focus and profound intensity of purpose.

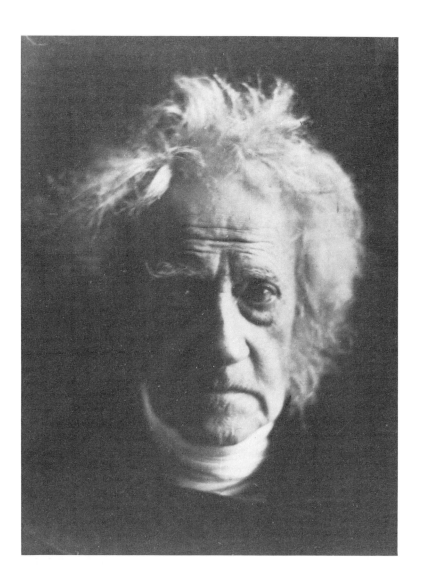

way with servants and 'members of the lower orders'.[25]

Alice Liddell, who regularly went to Freshwater for her Whit-sun holiday, tells the story of how Henry Cotton fell in love with Mary's portrait in an exhibition, waited and saved earnestly for two years to obtain his promotion, and then wrote to Julia Margaret begging leave to pay his addresses:

Mrs Cameron at once asked him to stay, and after a time the affair was settled. The wedding . . . created no small sensation. The bridegroom brought down a *posse* of his friends, rather learned, bookish-looking persons. Mrs Cameron, on her part, collected many of the beauties whom her indefatigable energy had hunted up from the neighbouring regions to act as her models.[26]

Alice Liddell adds that the eve-of-wedding dinner 'was attended by a selection from these two classes. I sat between the two maids and I don't think I ever felt more shy, or had greater difficulty in making conversation'. This certainly suggests some discrepancy between the inner enclave of the Cameron household and the maids with whom Mary had obviously been raised, while at the same time indicating the unusual social flexibility of seating everyone together. Certainly, as far as Henry Cotton was concerned, his match was the genuine thing of which romances are made, and the devotion which Julia Margaret's portrait of Mary had first inspired in him proved sincere and lifelong. According to him, Mary was 'my devoted companion and helpmeet for better and for worse through many years of vicissitudes and successes, sorrows and aspirations, clouds and sunshine'. His somewhat theosophical memoirs recall Julia Margaret as a 'remarkable woman. Visitors were attracted to her hospitable home in Fresh-water no less by her own talents than by the reputation of her venerable husband'.[27]

Julia Margaret first saw and fell in love with Freshwater in 1860. The Camerons had been planning for some time to move to the Isle of Wight, to be near the Tennysons at Farringford. Cameron was away at the time, attending to the coffee plantations in Ceylon which were the family's prime source of income. Production had been falling behind, perhaps, it had been hinted,

because the staff did not feel motivated to work hard for a long-term absentee landlord. So Charles had set off for Dimbola, leaving Julia Margaret in an agony of anxiety that, bereft of her lashings of quinine and 'Jeremie's opiate', he might fall prey to the dreaded and prevalent remedy of laudanum for some imagined ill.

Julia Margaret felt she had to stay behind, to be on hand for the expected birth of the first child of her daughter Julia, and also to be near her young sons. But she confided her unhappiness in a letter to a friend, explaining:

I assume vivacity of manner for my own sake as well as for others, but the only real vivacity now at this moment in me is to conjure up every form of peril, and my heart is more busy when sleeping than when waking. When waking I fag myself to the uttermost by any manner of occupation, hoping thus to keep the wheels of time working until I hear again.[28]

Freshwater in the 1860s was a very fashionable place. In 1846 Prince Albert had approved plans for the building of Osborne House. Constructed in true German castellated style, it provided a holiday retreat for himself and the Queen. The royal quarters had encouraged holiday visitors, and soon the local newspapers were carrying letters of complaint from the residents about jostling and noisy day-trippers. Julia Margaret, however, always remained phlegmatic in the face of unexpected visitors, even when picnickers plucked the primroses on her bank: 'That is why I planted it, so that it should be picked and enjoyed.'[29]

The house she found, which she called Dimbola after the estate that her husband was visiting, was actually two separate cottages, which she had joined by the insertion of a mock-Elizabethan tower between them. This idea may have been partly a homage to Tennyson's 'ivy-clad turrets' next door at Farringford (the two houses were connected through a gate in the garden wall), and partly to permit house-guests as much privacy from the often chaotic Cameron household as they might require, by the judicious use of interconnecting doors: those who were happy to be incorporated could have permanent access through the tower, while those who came to seek solitude could seal themselves off

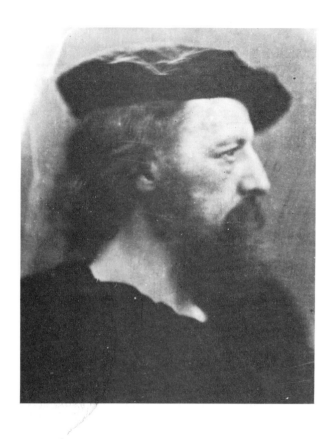

Above: **23.** Alfred Tennyson, 1866 and *right*: **24.** 'The Dirty Monk' (Alfred Tennyson), May 1865. Julia Margaret once told Tennyson, 'Although I bully you, I have a corner of worship for you in my heart.' She bullied him to alter his dinner menu to accommodate some roast lamb she had suddenly decided would be good for him and his guests; when she disliked his wallpaper, thirty rolls of a new, blue-patterned variety were immediately sent to replace it; and when she decided he required a vaccination, she proved her willingness to break down doors to administer it. He resisted her advances to secure his portrait for three

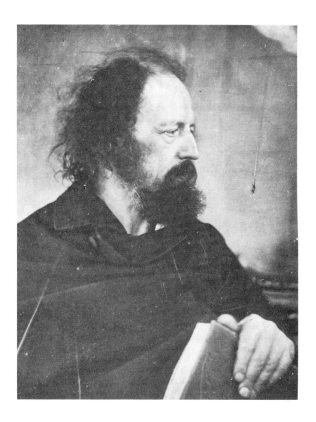

years, but finally succumbed and became her most frequently photographed male model, along with Henry Taylor and G. F. Watts. He was not, however, entirely happy with her representations of him. He claimed they gave him bags under his eyes and made him so well-known that every inn-keeper knew to double his charges at first sight. Despite their bantering, the two had a warm friendship, Julia Margaret being the only woman apart from his wife that Tennyson ever addressed by her Christian name.

completely in the adjacent 'cottage'. The double-faceted house was surrounded by extensive grounds, and was within a quarter-mile of the sea, which it faced.

Julia Margaret threw herself wholeheartedly into equipping Dimbola. She was delighted with the healthy environment it would provide for her younger sons – 'happily together playing mad pranks along the sea', as she rhapsodically anticipated. Also it would provide a base for London relatives and friends to visit on holiday; many of these stayed to make their own permanent or second homes in the vicinity of their friends. The Prinseps established themselves in The Briary, and the Darwins next door in Redoubt House. The Tennysons, of course, were next door, and many of their literary visitors were taken to dine at the Camerons', where the mealtimes were so odd that it was quite possible to sit down for dinner at seven o'clock and not to have risen by midnight.

Anne Thackeray Ritchie's eulogy describes how impressive many people found Freshwater as a place to stay:

My dear, this is the Porch, the gate of Heaven. There is a sense of repose that I think one must feel just after death before beginning a new life. It is inconceivable how I enjoy it. I do nothing for hours together. . . . through the open window one hears the enchanted moan of the sea and the song of the birds . . . I am dying to build a house . . . a constant thanksgiving goes up from my heart as I rest and am thankful'.[30]

Julia Margaret seems to have been impervious to the fact that her adoration could ever seem burdensome. She would un-ashamedly pester Tennyson to re-copy his poems for her to distribute among her friends, the better to impress his worth upon them. Whereas Alfred would occasionally scribble a frustrated note of acquiescence – 'If I made you a promise or half a promise, I will write it out again for you. A.T.' or 'What a bore it will be. Oh, Julia! A.T.' – it was generally his poor, patient wife Emily who was set to do the copying. Julia Margaret always tyrannised those whom she idolised. She literally hounded Tennyson from room to room on one occasion until she ran him to ground in his bedroom and forced on him an unwanted vaccina-

tion. It was a pyrrhic victory, since the dose proved to be stale, and Tennyson was confined to his bed to recover. Or she would appear at the front door long after normal dinner-time, bearing legs of mutton and instructions on how to begin immediate culinary preparations. Perhaps Emily Tennyson counted herself lucky when she came downstairs one morning to find the hall heaped with blue wallpaper embossed after the current craze for the newly-imported Elgin marbles: at least Julia Margaret had not achieved the tour de force she had managed once as an overnight guest of the Taylors – she had covered their entire spare bedroom, furniture and all, with the floral transfers that were then all the rage.

As Julia Margaret annexed those whom she admired by the ruse of irrefutable generosity, so she extended her interest beyond them to whoever happened to be visiting. It was hard for her to admit failure and, even after Tennyson's friend Edward Lear made it known that he wished to be spared having to listen to Mrs Cameron's gruff voice again, she would not be entirely thwarted. Knowing how he and Alfred enjoyed singing parlour songs to musical accompaniment when Lear visited Farringford, she desisted from making one of her impromptu visits, but instead sent an eight-man team bearing her piano across the shingly garden (the Tennysons' piano needed tuning). No wonder Lear crossly complained: 'Pattledom has taken entire possession of the place! . . . However by being (thank God) personally as uncivil as I could to most callers, I saw a good deal of my friends.'[31]

Julia Margaret was, undoubtedly, eccentric even by the standards of the day, as is widely attested by those who knew her. Being a woman, however, she had no power to exercise beyond her own immediate household; and she belonged to a class which took its privileges for granted, and was unaccustomed to being gainsaid. Perhaps most important of all, she in no way touched that giant Achilles heel of Victorian morality, sexuality, where she had no particular desire not to conform. And, through the unfortunate experience of one of her nieces (Virginia's daughter, Isabel), she had seen at first hand the terrible consequences of making non-conforming sexual predilections public.[32]

Even Julia Margaret's appearance was odd. This might be because she was actually doing something a little unusual, like walking to the station stirring a cup of tea or shanghai-ing some confused farmer's donkey in order to send yet another few pages of a many-leaved letter hurtling after the post-boy. Not to mention the effect of her black hands and collodion-stained skirts once she took up photography, which gave her an appearance so strange that when Garibaldi paid a visit to Farringford and she fell on her knees to beg permission for a portrait, he brushed her aside thinking she was a beggar. But even in the most ordinary circumstances her habit of wearing numerous skirts, swathed about with lace mantillas and oriental shawls, struck many observers as, at least, unusual. Anne Ritchie recalls her first impression of Julia Margaret thus:

I remember a strange apparition in a flowing red velvet dress, although it was summer time, cordially welcoming us to a fine house and some belated meal, when the attendant butler was addressed by her as 'man', and was ordered to do many things for our benefit; to bring back the luncheon dishes and curries for which Mrs Cameron and her family had a

25. Henry Taylor, a Portrait, also 'Philip van Artevelde', 1865. Of the three elderly men Julia Margaret lionised and subjected to regular photographic sittings, Henry Taylor was the first to be thus exploited, soon followed by Watts and later by Tennyson. With Taylor she experimented in her use of highlighting, pulling a calico blind over the walls or roof of her glasshouse to diffuse a white light that would best catch the planes of the face and the dappled shades of hair and beard.

To Julia Margaret, Henry Taylor was always 'Philip', because she identified him with the Flemish buccaneer hero of his lengthy play *Philip van Artevelde*. Like Trollope, Taylor also had a career in the service of his country, devoting 48 years to working in the Colonial Office, which provided much material for his plays. He was an esteemed playwright and poet among the Victorian bourgeoisie (despite being virtually unknown now), although he lacked the popular appeal that got Tennyson the Laureateship, for which Taylor had also contended.

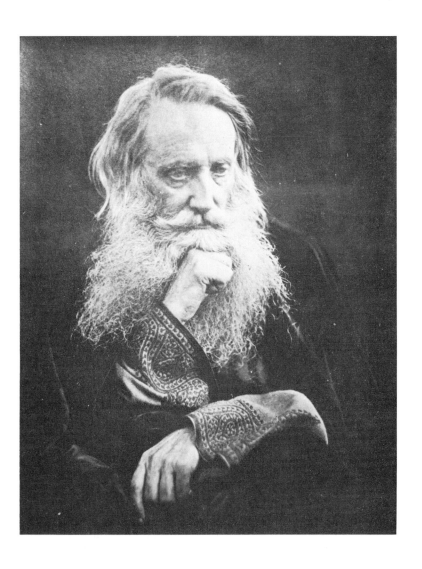

speciality. When we left she came with us bareheaded and trailing draperies, part of the way to the station as was her kind habit.[33]

Anne Ritchie, daughter of William Thackeray, was a faithful devotee of Pattledom, and rarely resisted a chance of mentioning it in her various volumes of memoirs. Thackeray himself was notable, in terms of his connection with Julia Margaret, for having remarked that from her girlhood in Paris to her matriarchal days in London she 'remained quite unchanged'. He was also distinguished for having the unpleasant task of denying Julia Margaret something she had set her heart on, that of becoming his ghost writer; 'nobody writes as well as I do', she assured him, and pleaded to 'let me come and write for you'.

Gushing is probably the most obvious adjective to use of Julia Margaret's prose style, according to her few remaining letters. It does, of course, take a while to become acclimatised to a way of writing free of punctuation other than dashes and unexpected capital letters, and scrawled both horizontally and vertically over the page with some words written so large as to take up an entire line. Her technique changed little over the years, bearing out Thackeray's impression of her. She always felt the need to write down everything exactly as she thought it, without letting any process of reflection or editing come between her spontaneous outpourings and the recipient reader, who might be indulged with tens of pages several times a day. Or one could regard it charitably and decide that she was, perhaps, an original stream-of-consciousness writer, antedating her great-niece Virginia Woolf's considerably more professional ability by a couple of generations.

Yet beyond the immediate need to pour out her most intense feelings and worries, and to reassure herself of the close communion of her friends and sisters, Julia Margaret's letters express a constant preoccupation with beauty. Interestingly, given the dearth of landscapes in her photographs, her letters show her to have been especially in tune with the natural world. The starlit walks along the cliffs that Tennyson so enjoyed; the garden that was razed of its vegetable plot and endowed with a lawn overnight

to satisfy a passing wish of her husband's; the bucolic pleasures of cowslips and black-faced lambs of an English Eastertide – all inspired her abundant and marvelling appreciation. She wrote naturally and almost daily of what she saw around her; and it never became commonplace to her. Her eye for beauty expresses itself, for example, in the view she sees from her bedroom window on waking to a Freshwater autumn:

The elms make a golden girdle round us now. The dark purple hills of England behind are a glorious picture in the morning when the sun shines on them and the elm trees. . . . There is something so wholesome in beauty, and it is not for me to try to tell of all we have here in those delicate tints of a distant bay and the still more distant headlands. These I see every day with my own eyes . . .[34]

- Return to the East

The Camerons lived at Freshwater for fifteen years, during which time their sons grew up with just that sunnily secure background Julia Margaret had intended for them, along with an appreciation of the value of beautiful surroundings. She was undoubtedly close to her sons during this time; but it was a relationship that unfortunately did not survive separation intact.

During this period Julia Margaret's standing as a photographer steadily and rapidly increased. By 1875 she was at the height of her professional success. The second volume of Tennyson's *Idylls of the King*, illustrated with her photographs, was newly published; she had exhibitions on in London and Bournemouth; and there was such a market for her prints that she had instructed the Autotype Company to make new negatives and re-issue some seventy images in red, brown and black carbon editions.

Julia Margaret's feelings about leaving England for good after almost thirty years are hard to establish. They were certainly very mixed. On the one hand, she wanted to be near her three sons Charles, Henry Herschel and Ewen who were already established in Ceylon (Hardinge was to accompany the Camerons on the trip). On the other, she regretted leaving behind so many 'loved

living ones'.[35] Only two primary sources still exist to provide clues, and they are contradictory. The painter and traveller Marianne North, who visited the Camerons at their new home at Kalutara, was convinced that it was Julia Margaret's decision to emigrate, albeit 'to give the best to my Boys and Husband'. But Henry Taylor, to whom she poured out her loneliness and home-sickness in many letters, claimed that their departure was due to Cameron, who had 'never ceased to yearn after the Island as his place of abode, and thither in his eighty-first year has he betaken himself, with a strange joy'.[36] (According to one account, Cameron rose from his sick-bed for the first time in twelve years, in order to walk to the harbour and board the ship unaided. From the time they set sail, he seemed to have re-entered his element and was entirely serene.)

On 10 October, the day of the departure, Julia Margaret was still trying to clear up outstanding business, ensure that her

26. W. H. Longfellow [sic] from Life (Henry Wadsworth Longfellow), 1868. In July 1868, Longfellow was on his fourth and final tour of Europe. It was incumbent upon him to visit fellow literary lions and, during his visit to Tennyson, he was taken for a sitting with Julia Margaret and handed over with the understandably now famous words, 'I will leave you now, Longfellow. You will have to do whatever she tells you. I will come back soon and see what is left of you.'

What the reverentially celebrated subject, whose company was also imperiously requested by Queen Victoria and Charles Dickens, made of his sitting is not recorded. But a few days later he sent a calling card together with a *carte-de-visite* to Julia Margaret, with a note saying, 'Mr Longfellow presents his compliments to Mrs Cameron, and begs her to accept the enclosed photograph as a souvenir of the pleasant hour he passed at her house this morning.' Was his selected *carte-de-visite*, which made him look more like Father Christmas than the Moses whom Julia Margaret evoked, a provocative joke? If he had talked it over with Tennyson at all, then he knew how Julia Margaret loathed 'outfitters' like Elliot and Fry, and how annoyed she had been when Tennyson taunted her by saying that her portraits of him were on a par with those by Mayall, another West End studio photographer.

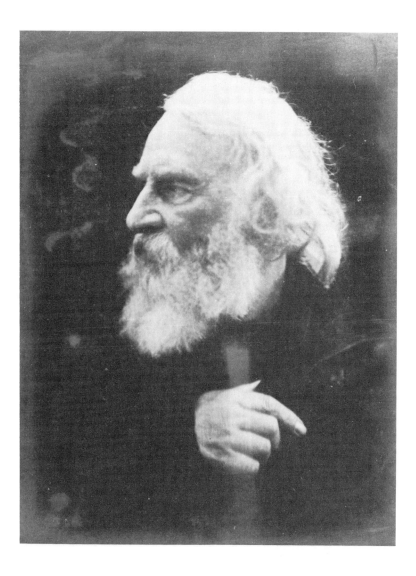

portfolio would be adequately circulated and the pictures well-mounted, and was describing herself as 'fevered with work and anxious care'. Her surroundings were even more chaotic than usual, too, since Dimbola had already been transferred 'into the hands of Philistines', whilst she and Charles 'crowded into our dear White Porch into which everything has been brought that we could not part with so that we are choked up to the very chin and now I have to decide what to take with us and what to leave behind'.[37]

In the event, Julia Margaret's decisions over what to take erred on the side of abundance, and bore all the hallmarks of her dotty practicality. There was a cow, whose milk would save the passengers from tuberculosis during the long journey; and two coffins in case of sudden death at sea (might she have been recalling her mother's demise?), and which in the meantime served nicely as additional trunks. And of course there were packing cases and crates galore, such that a team of porters had to be hired to take them on board, who had the surprise of receiving tips in the form of photographs. Money was by this time extremely short, and

27. Robert Browning, 1865. Browning, like Longfellow, was warned of what to expect from a session in the chilly Cameron studio. On this occasion Julia Margaret managed to outdo even her own reputation by first swathing him in a favourite piece of velvet curtain, and then vanishing in search of an additional item of photographic equipment. Two hours elapsed before she remembered the nature of her errand, and returned to discover the sitter tremulously frozen in the uncomfortable pose she had obliged him to adopt.

She shared Browning's love of Italy and things Italian even though she never joined the coterie of acolytes who attended the Barrett-Brownings' afternoon tea parties in their Florence apartment. She produced illustrations to Browning's *Sordello*, apparently more for love of the poetry than as a professional undertaking. Perhaps it was Browning himself who intimated that her photography might blend with his poetry, with his theory that all arts should be one in the name of 'Love' – 'Oh, their Raphael of the dear Madonnas . . .' (*One Word More*).

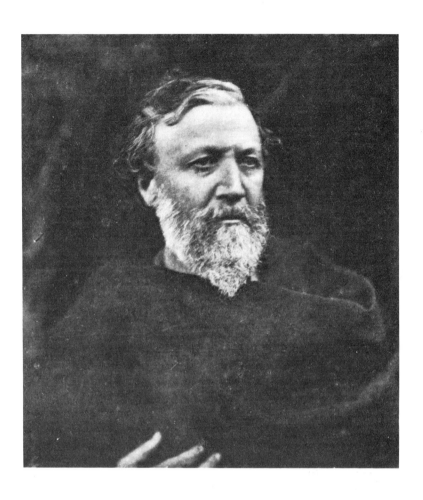

Julia Margaret was counting on her sons and her picture-sales to make good their needs. The 'relatives and friends who have been all around me so depressed by my approaching departure that it has been doubly hard for me to persist in the inevitable duty of preparation'[38] had additional little tasks pressed upon them – to label packets, oversee the distribution of further prints she intended as gifts, ensure that Colnaghi's were handling her picture-sales efficiently – and tragic farewells were said.

On arrival in Ceylon, Julia Margaret poured her energies into sorting out accommodation problems, somewhat dismayed by Hardinge's 'little hut with only mud walls 4,400 feet above the level of the sea' at Kalutara, and the lowland estate at Lindoola. For once she seems to have found herself thwarted, unable to direct and control matters exactly as she would have liked. With all her indomitable energy and domineering personality, she must have been a difficult woman to have as a mother, and perhaps even more so as a mother-in-law. Ewen's wife, the former Annie Chinery, whom she had so doted on as a beautiful and malleable young girl (Plate 6) resisted her attempts at keeping Ewen at her beck and call. Having removed herself at such great distance from her friends in order to be near her 'Beloved Boys', she found that she did not see nearly enough of them, and that her summonses were frequently ignored. Whilst duly grateful for their gifts of coffee, flowers and green-groceries from their lands, she declared herself bitterly disappointed, for example, with Ewen's decision that she might have a mere £10 to build an extension to her home, instead of the £50 she had anticipated. Unable to bring herself to find fault with her beloved sons, she vented her wrath on Annie, ending with the lofty comment: 'How very poor are those who *dread* to spend – and hoard.'[39]

It is from this early period of her retreat that her few extant letters to Henry Taylor remain. Almost alone of his illustrious correspondents, she refused to return his earlier letters for inclusion in his autobiography, but had them destroyed after her death. Nor would she allow hers to be used for publication, something which she felt to be entirely against the tenor of their longstanding friendship. Shortly before leaving Freshwater, she

had written to him, 'Your letters can have no meaning for any one of the Public – I hold the Public to be "swine" and why cast my pearls before them . . .'[40] She also refused to return any of John Herschel's letters when requested to do so by his son after his death, writing to Taylor: 'I refused for the same reason which made me refuse you – His scientific opinion upon my Photography the Public may see, but what has the Public to do with the sacred seal of Friendship?'[41] In a letter written shortly after to a Mr B. Grosaint, Henry Taylor expressed remarkably similar sentiments, concurring with Wordsworth that the best testimonies are a writer's own published works, and emphasising that 'Wordsworth himself wished that none but a very brief memoir of him s[hd] be written, giving the principal facts of his life, with the dates.'[42]

Despite her strict reprimand to Taylor for omitting to add a 'God Bless You' at the end of every letter, Julia Margaret wrote letters to him from Ceylon which are imbued with real affection. They all begin 'my dear Philip' and close with expressions of regret and nostalgia. The importance of the post had long been a leitmotif of Julia Margaret's daily existence, which was perhaps why O. G. Rejlander composed a series of photographs on the postman while staying with the Camerons at Freshwater.[43] In Ceylon, it took over her life more and more: she was always in a hurry, for she had twenty-one letters to write that day; the post-boy was due to arrive and there were still nine more to be completed. And when there was some little delay in their collection, she would scrawl on the backs of the envelopes such anecdotes as 'I wrote to the Post Master a native to ask if they were in time for the mail He wrote across my book "tolerably in time!!" ', and cannot refrain from finding another corner in which to add, 'God bless I say with all my soul. May He bless us all in our short [stay?] here and long hereafter.'[44]

In return, she was clearly touched by all those who took pains to reply, listing first the three Tennysons,[45] especially Emily who 'writes from her sick couch, often'. Mia and Virginia were her sisters who set regular time aside and wrote each Thursday – 'but *Sara* never!!' Sara, always preoccupied by the problems of man-

servants who *would* leave at awkward moments and maids who wished to get married, at least had a governess (obtained, apparently, through Julia Margaret) who 'writes long dear letters' in her stead. Her niece Julia and great-niece Adeline also wrote 'almost every mail', and many other friends whose identities often overlapped with the parts they had played as sitters. Isabel Bateman/Queen May was by this time acting professionally, and Julia Margaret was wistful to photograph her 'in these mountain heights far from theatrical heights!'[46]

Yet there is no evidence written in her own hand that Julia Margaret was still able to take her photography seriously. When she first took it up, she claimed to work night and day to produce some five hundred prints a year – an astonishing total, given what was involved. Her letters from Ceylon speak ruefully of the major portraits that she, perhaps along with posterity, regarded as the apex of her achievement. Yet she always avoided discussing photography in any depth, although of course it is impossible for us to know what more she might have said in pages no longer available. Reading remained important to her, and she was particularly excited by the arrival of a draft copy of Henry

28. William Holman Hunt, May 1864. Holman Hunt was a mentor of Lear and of Watts, though he was younger than both, and despite the fact that neither artist followed the style and beliefs of the Pre-Raphaelite Brotherhood, of which Hunt was a founder-member. His technique was not to Julia Margaret's floridly Italianate taste, but for once she resisted the temptation to dress him in her favoured artist's garb of cloak and cap and capitalised instead on his preference for oriental dress. His politics were also diametrically different from those of Julia Margaret's circle: the 1848 Chartist march from Russell Square to Kensington, so sympathetically observed by him and Millais, was the 'riotous rabble' deplored by Henry Taylor and the Prinseps. However, although his visits to Little Holland House were relatively infrequent, Julia Margaret clearly got on well enough with him to persuade him to sit for her again the following year. By that time she had him draped in a heavily patterned curtain, with a large hat almost falling off one side of his head.

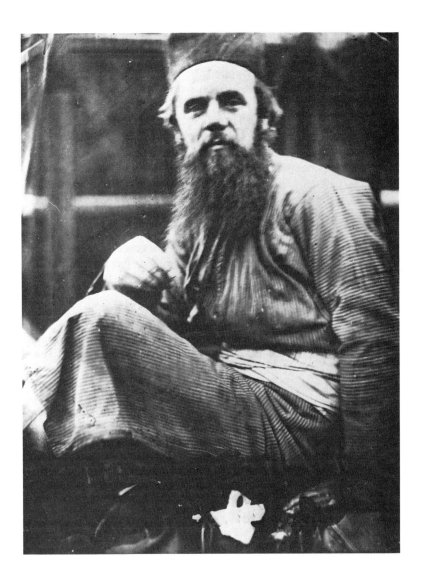

Taylor's autobiography as a fitting testament to their valued friendship.

In 1878, the Camerons returned briefly to England, 'a visit', as Julia Margaret described it, 'of turmoil, sickness, sorrow, marriages and deaths'. She was unable to console Sara for the loss of her husband Thoby, whom Charles also deeply mourned as a longtime, if combative, companion in the East India Company. There was also the problem, fabricated largely by Julia Margaret, of whom her niece Julia should remarry, following the premature death of her husband, Herbert Duckworth. Julia Margaret wished somewhat incestuously to match her with Charles Norman, her daughter Julia's widower. But Julia Duckworth was capable of making up her own mind and, after refusing numerous other offers, settled on marrying Leslie Stephen.

What appear as the reiterated let-downs and frustrations of these last four years are sharply contradicted by the impressions

29. William Michael Rossetti, 1866. Fated never to leave portraits of the more eminent members of the Rossetti family (Christina sat for her but the results are, lamentably, unknown; Dante Gabriel refused even to meet her), Julia Margaret had to content herself with this one of William Michael, in which only the face is really successful, the rest of the composition being distractingly messy. William Michael was not an artist, despite the beret and cloak with which Julia Margaret endowed him. He was a civil servant but, through his brother, was drawn into becoming a founder-member of the Pre-Raphaelite Brotherhood and then into editing its publication, *The Germ*. He was also useful in offering art criticism; in a letter to Sir Edward Ryan, Julia Margaret added an appendix: 'Lastly, as to spots, they must, I think, remain. I could have them touched out, but I am, I think, the only photographer who always issues untouched photographs and artists, for this reason, among others, value my photographs. So Mr Watts and Mr Rossetti, and Mr du Maurier write me above all others.' She also wrote directly to Rossetti himself, ordering him to Colnaghi's to collect copies of the portrait, to give an opinion and then, if it was favourable, to see it was broadcast as widely as possible by using his influence with the editor of *The Times*.

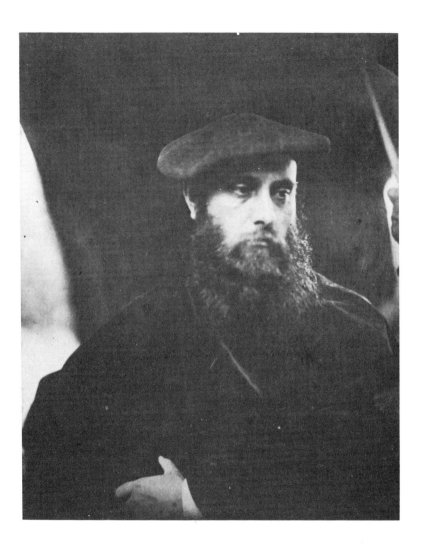

of Julia Margaret given by Marianne North in her *Recollections of a Happy Life*. Perhaps Julia Margaret came to life and spirits in the company of this woman whom she could admire and get on with, and who encouraged her to use her camera once more. Or perhaps Marianne's own sunny enthusiasm was infectious. Either way, they shared an artistic eye for what was beautiful around them, and it is Marianne's descriptions of the people that give us clues as to what Julia Margaret might have been seeking to capture in her last few photographs:

The Cingalese looked quite handsome after the Malay race, and were extremely neat and peacocky in their dress, which is always white; their hair is most carefully combed, oiled and knotted up, both men and women wearing the same combs. . . . My driver and his horses both had long baths while I painted, and the former drove me home with the long shiny waves of black hair spread over his shoulders and bare back to dry, just as the elegantly dressed young ladies used to do in *Punch* a few years ago.[47]

After such an elegy, it is the more surprising that she took Julia Margaret to task for hiring a gardener for the beauty of his back, having no formal garden for him to cultivate and only her lens to work for. She found Julia Margaret energetically active, in contrast to Charles who, now in his eighty-fourth year, preferred to devote his day to reading, preferably Homer, and preferably out loud. But, after taking a constitutional turn around the bungalow with the help of a walking stick, his long hair blowing and his glasses removed, he was always 'perfectly happy and ready to enjoy a joke or enter into any talk which went on around him'.[48]

Julia Margaret was similarly in good humour at the arrival of the guest she had summoned to the house. 'She took to me at once, and said it was delightful to meet any one who found pearls in every ugly oyster. Her oddities were most refreshing after the "don't care" people I usually meet in tropical countries.' The climax of the visit was, however, the photographic session. Regrettably, the only picture still extant shows Marianne dressed as inappropriately as any British expatriate, in heavy crinolines

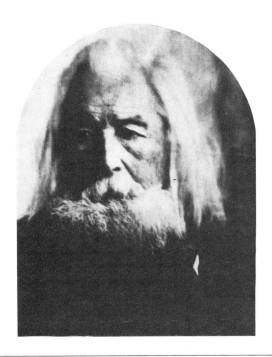

30. Charles Hay Cameron, c. 1864. Despite being depicted by books on Julia Margaret as indulgent of her 'hobby' to the point of senility and of her numerous friends to the point of hypochondria, Charles Cameron had had a distinguished career up until the family's return to England in 1848. As late as 1861, when Henry Taylor was canvassed for a testimonial regarding Cameron's possible allocation to a colonial governorship in the Cape, he described him as 'a man of far higher intellectual power than any who was likely to be his competitor'.

His contribution to Julia Margaret's pictures is often portrayed in terms either of 'allowing' her to stray from the domestic path and undertake such an enterprise in the first place; or of being the giggly old man in the silk brocade dressing gown, who could not be made to hold still to play Merlin or Lear. Yet much of Julia Margaret's literary inspiration was strictly derived from his own favourite authors – Milton, Shakespeare and Keats – and her abundance of classical Greek maidens and goddesses show a striking similarity to his Homeric favourites.

and yes, a fringed shawl (she had only to tell her hostess how much she admired a particularly dazzling one to see it instantly rent from hem to hem and partitioned between them), a misty figure on the dark verandah of a shuttered bungalow. What we lack entirely are examples of what Julia Margaret had 'for three days . . . kept in a fever of excitement about', namely the results of the occasions when

She dressed me up in flowing draperies of cashmere wool, let down my hair and made me stand with spiky cocoa-nut branches running into my head, the noonday sun's rays dodging my eyes between the leaves as a slight breeze moved them, and told me to look perfectly natural (with the temperature standing at 96°). Then she tried me with a background of breadfruit leaves and fruit, nailed flat against a window shutter, and told *them* to look natural, but both failed, and though she wasted twelve plates, and an enormous amount of trouble, it was all in vain, she could only get a perfectly uninteresting and commonplace person on her glasses, which refused to flatter.[49]

The intense heat and humidity, the lack of a studio, and perhaps also a shortage of chemicals or stimulus, prevented Julia Margaret from turning her little maid Ellen into a Mary Hillier, or any outbuilding into a darkroom. Only a few photographs remain from Ceylon, and all are quite atypical of the style she had made her own. The importance Julia Margaret attached to a woman's vocation for 'Love' had been translated in her work into an intensely subjective relationship with her sitters. Whilst it is true that in Freshwater she occasionally dragged day-trippers or local fishermen in to play bit parts in her costume dramas, most of her portrait subjects she knew intimately. There is a direct relationship between her most powerful images and the sitters to whom she felt closest or admired most. Amongst the men, Henry Taylor, Alfred Tennyson and Sir John Herschel had perhaps the greatest influence on her – and there is more than an element of that homage she felt she owed them in her representations. Julia Jackson (later Duckworth and Stephen) and May Prinsep among her nieces, and her daughter-in-law Annie Chinery, were young women with whom she closely identified, and something of that

interaction is present in their portraits, however allegorical the guise.

But there was no relationship of this quality with the Sinhalese natives. The very enthusiasm that Julia Margaret experienced in setting up Marianne North to be photographed proves that she did not make it a habitual practice. Yet she never lost her eye for beauty, as the selection of the gardener and other local sitters clearly shows. And she possibly felt more resigned to her final resting-place after her depressing visit to England, despite the purple prose in her letters about mountains and monsoons.

Quite suddenly, in January 1879 and after only ten days' illness, Julia Margaret Cameron died, aged sixty-three. She was happy that she was staying with Henry Herschel, her youngest son who was her portraitist and who would soon turn professional photographer, and that he had shifted her sick-bed so that she could see directly out across the balcony. It was after thus gazing out at the starry night sky that Julia Margaret breathed her last word, 'Beautiful'. It was the one word she would have wished her life's work to be remembered by.

THE WORK

Julia Margaret Cameron's photographic career lasted no more than fourteen years, during which time she printed some three thousand images. As far as we know, only two of her giant plate glass negatives remain – both of her son-in-law Charles Norman – and these are in private hands. The bulk of her work was concentrated in the years 1864–74, a period when she claimed to be producing around 500 images annually. She may well have been exaggerating, but this was nevertheless an enormously prolific decade for her.

It was not until after the Second World War that any attempt was undertaken to catalogue Julia Margaret's work. Her pictures were scattered through any number of collections, mainly private, often appallingly looked after and credited with little or no artistic or commercial value. Today many of those pictures are still scattered, but are less likely to be in the hands of uninterested heirs. They are in collections ranging through many of the major British museums and galleries; from the Royal Collection at Windsor Castle to a private home north of London where a bedroom and a capacious entrance hall are covered with Cameron prints; and in the hands of numerous minor collectors and descendants of the Bloomsbury group (for more details, see p. 173).

The rediscovery of Julia Margaret was one of the major achievements of Helmut and Alison Gernsheim, researchers into Victorian photography. They produced a book on her in 1948, followed a year later by one on her contemporary, Lewis Carroll. They divided Julia Margaret's work into four distinct stylistic and chronological periods which, despite the subsequent unearthing of further material, and perhaps a greater degree of overlap than

was at first allowed for, still holds true. They denoted her first period, 1864–66, as comprising largely 'religious, symbolical and allegorical subjects'; the second, 1866–70, as 'certainly Mrs Cameron's best period . . . all her outstanding portraits of famous men and fair women'; the third, 1870–75, as 'chiefly devoted to illustrations to poetry'; and the last, 1876–78, consisting of the few remaining Sinhalese pictures, as 'of no great importance'.[1]

The first of these dates is of interest. We know that Julia Margaret described a delightful picture of 'Annie' (Plate 34) as 'my first success', adding the date January 1864, yet two pictures, inscribed 1862 and 1863 in her own hand, were also found amongst her collection. The earlier one is of her friend Henry Taylor, seated in a large wooden armchair (such as also appears in two of her Tennyson portraits) and is described, in Julia Margaret's unmistakably looped handwriting, as 'taken from life – Henry Taylor Author of Philip Van Artevelde'. The dramatic white highlights on the face and hand are similar to those of Julia Margaret's most confident portraiture period yet the pose, with its subject seated diagonally towards the right but with the head turned back and eyes looking down towards the lower left corner, is very atypical of her compositions. The other early picture is that of Arthur and Emily Tennyson walking in the garden at Farringford with their sons. Dated May 1863, it boasts what has often been taken as an unfortunate characteristic of Julia Margaret's work, a blurred focus, though it is due in this case to a limited depth of field rather than a lack of focus entirely.

The latter picture has, however, been more recently ascribed to the Swedish photographer, Oscar Gustav Rejlander.[2] He was certainly a visitor to the Isle of Wight, and knew the Tennysons and Camerons well enough to photograph not only them but also the minutiae of their domestic lives. A whole series of photographs, previously ascribed to Julia Margaret, of her maids going about their daily chores, is in fact more probably by Rejlander, and was taken at the same time as a sequence of 'country life vignettes' so popular at the time, depicting the Camerons and 'the story of the post'. Given this degree of familiarity, it is perhaps not surprising that there should have been some overlap in the

work of the two photographers. A portrait of Julia Margaret's maid,[3] assumed until recently to have been taken by her, has since turned up in a cabinet card edition with Rejlander's name-plate stuck to the back. This could, as I suspect, mean that it was Rejlander's own original, but it could also imply that he had borrowed one or more of Julia Margaret's negatives, or that he simply owned that print. This may also be the case with Julia Margaret's inscription across the bottom of the print of Henry Taylor, which in my view is much more typical of Rejlander's work than of her own.

This still leaves a further problem in dating her earliest work. By the time Julia Margaret came to write her autobiographical fragment *Annals of my Glass House* in 1874, her memory for dates was far from sound. Nevertheless, there is little reason to doubt that her daughter's gift of a camera was made as she was leaving

31. 'Iago', also 'Study from an Italian' (possibly Alessandro Colorossi), 1867. Although taken only three years after Julia Margaret first peered through a camera, this portrait has the profundity and sensitivity of a lifetime's achievement. There is no detail – whether of lighting, pose, size or expression – that one could wish to see in any way altered, an astonishing feat given that no cropping, retouching or editing has been done to the original. The face has such a powerful quality as to look quite timeless: taken out of the Herschel album (where the only original print exists), it would look as natural in a Masaccio fresco as in a modern photographic studio.

It seems likely, according to research done by Colin Ford, that 'Iago' represents another example of the permeating influence of Watts's tastes. In order to paint 'Genaro – an Italian Nobleman', along with several biblical subjects, Watts made use of one of a whole colony of Italian artists' sitters, a young man named Alessandro Colorossi, whom he may have introduced to Julia Margaret. She was not in the habit of using professional models, and most probably never did so again, yet she managed to elicit such force of feeling that one can only regret that no other pictures from the session (and not even the negative of this unique print) survive.

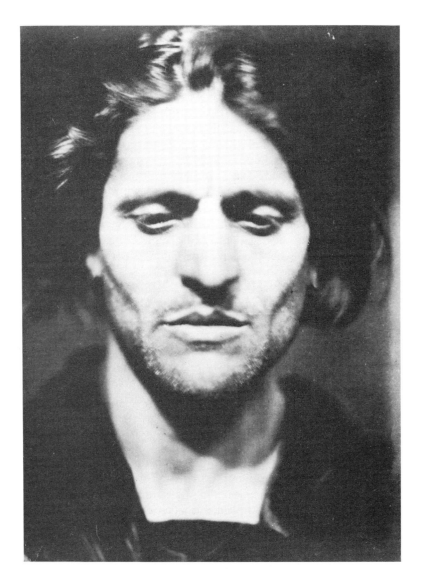

home in July 1863, and that 'after many trials and errors' Julia Margaret achieved her 'first success' in January 1864. This is despite the fact that there exists an album of photographs, inscribed in Julia Margaret's hand: 'To my best beloved Sister Mia with a blessing on the New Years and the old July 7th 1863'. It contains 119 plates, by no means all taken by Julia Margaret but all from around that period. Few even of the sketches (by G. F. Watts and artists unknown) are dated, but it is certain that many, if not all, the photographs were in fact taken after 1863.

Very little research has been done into this volume (now in private hands), and its reproduction in book form[4] does little towards attributing the contents definitively to identified photographers. Nevertheless, certain of the photographs, such as that of her son 'Ewen's betrothed' (Annie Chinery) and of her niece Adeline's husband, Henry Halford Vaughan, could not have been taken before the later 1860s, and those of Marie Spartali[5] are commonly ascribed to the 1870s. What Julia Margaret seems to have done is to have given Mia an unfilled album, intending it as a gift to be added to over the years to make a family memento, including portraits not only of family but of friends, along with copies of sketches and paintings either done by them or of which they were especially fond. In all, it has the character of an artistic scrap-book, with its reproductions of Woolner's famous bust of Tennyson, of a Spanish portrait of Mary Tudor and an unascribed Pietà, and with photographs by most of the best-known amateur portraitists of the day, including Rejlander, Carroll, Lord Somers and, of course, Julia Margaret herself.

It could hardly be more different to the Herschel album,[6] which bears the dedication 'To Sir John F. W. Herschel from his Friend Julia Margaret Cameron With a grateful memory of 27 years of friendship'. Appended is a first date, 'Nov 26th 1864', with a note that on 8 September 1867 it was 'completed restored with renewed devotedness of grateful friendship'. This seems to confirm Julia Margaret's intention to donate her albums as documentation of 'work in progress' rather than as finished œuvres. Again it offers evidence as to the date she commenced photography, with the note: 'I began taking my first Photograph

eleven months ago. I have worked assiduously and devotedly at Photography ever since.'

Her other boast was that 'Every Photograph is from the life taken direct not enlarged'. Indeed, many of the photographs almost overlap the edges of the pages, though others have been somewhat unevenly cut, often with arched tops, which adds to the church-window effect of the religious subjects. It is at once a daring and effective technique. Giant negatives were not in themselves unusual – the largest one known was three foot square, a pane of glass cut to fit the reproduction of a Leonardo – but the combination of size with her characteristic soft focus challenged the idea that size necessarily meant greater verisimilitude. It was Rejlander who set her 'monstrous heads' into generous perspective, by commenting:

In connection with a question arising out of the exhibited works of Julia Cameron (1864, her first exhibition) and which has been pretty widely discussed, without arguing in favour of woolliness and the effect of imperfect vision, much may be said in favour of the idea of having a representation of flesh without an exaggerated idea of the bark of the skin, such as we have seen in many large photographs by eminent photographers.[7]

Much speculation has been devoted, then and since, to guessing the cause of Julia Margaret's 'imperfect vision'. Everything from a family history of myopia to the difficulty of encountering a suitable imported camera lens has been invoked by way of explanation. According to the Gernsheims, Julia Margaret started work with a Dallmeyer lens possessed of a large aperture and a fixed stop, making it impossible for her to obtain a sharper effect by 'stopping down', even if she had wanted to. Her refusal to enlarge, already a common practice by the 1860s, meant that she began by working with $11'' \times 9''$ plate negatives, moving on to even larger ($15'' \times 12''$) ones in 1866. All her pictures are what we would now call 'contacts', i.e. prints taken directly from the full negative. The combination of size and focus was clearly deliberately chosen by Julia Margaret to achieve an expression of what she called 'divine art', rather than the type of portraiture churned

out on innumerable *cartes-de-visite* by the photographic studios. Her vision of reality was not the miniaturist's meticulousness that created the stereotyped images of the Victorian bourgeoisie, but something on a metaphorically as well as a literally larger scale.

Her *Annals* record how early she was taken to task for her soft technique. She remembered how her son, Henry Herschel, told her 'that my first successes in my out-of-focus pictures were a fluke. That is to say, that when focussing and coming to something which to my eye, was very beautiful, I stopped there instead of screwing on the lens to the more definite focus which all other photographers insist upon'.[8] This appears to contradict Gernsheim's claim that her first lens had a 'fixed stop'; if true, it might indicate how early she chose to continue doing something which had, perhaps, first occurred by accident. Her early work was dominated by half- and full-length studies; but when in 1867 she replaced her Jamin lens which had a focal length of 12″ with a

32. Henry Herschel Hay Cameron, aged about eleven, 1864. Described by Henry Taylor, together with his brother Hardinge, as 'refined and tender as girls', Henry Herschel Hay apparently grew up – according to a relative who preferred to remain anonymous – 'given to every sort of vice'. He was doted on by his indulgent mother, who chose his bungalow in Ceylon as her final resting place. From Julia Margaret he inherited both a taste for amateur theatricals (a great-niece recalls him excelling himself as the Carpenter in *Alice in Wonderland*), and for photography. After her death he left the coffee plantations of Ceylon behind and, using his mother's camera, turned professional and opened a studio near Cavendish Square where he advertised his skills as a 'photographic artist'. He took what is probably the best-known portrait of his mother, and one of Aubrey Beardsley which the sitter pronounced 'superb'.

In gratitude for her younger sons' safe return from an Asian trip, Julia Margaret presented the station where they were reunited with a series of her finest portraits. 'The railway stations of Lymington and Brockenhurst are still decorated by her pictures which grace the walls,' Henry Cotton wrote at the end of the century. It was still true in the 1940s, when the Gernsheims made their first discovery of Cameron pictures.

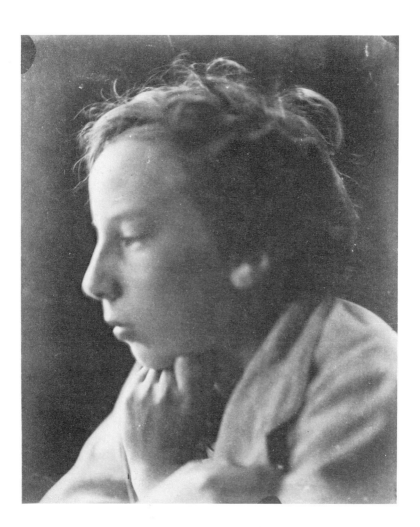

Rapid Rectilinear one of 30″ she was able to move to the close-up, which became her hallmark.

On occasions she did not desire the whole focus to be on the face, and shifted it instead to the drape of an arm, or even to a bouquet of flowers in the foreground. In these pictures, where the camera pulls back to afford a wider view and the focus appears 'soft' rather than 'out', the Pre-Raphaelite influence is most apparent. Yet Julia Margaret's strongest influences came from people she knew rather than what she saw and, although she got on well enough with Holman Hunt and William Michael Rossetti (his more famous brother, Dante Gabriel, scowled his refusal ever to be drawn into sitting for her), it was always to G. F. Watts that she turned as her artistic authority.

• Influences and individualism

Watts differed significantly from his Pre-Raphaelite contemporaries in his interpretation of comparable themes. He remained on fraternal terms with Millais, the Rossettis and Holman Hunt, yet his taste in Italian art was far more catholic than theirs. He saw himself as a Renaissance man, drawing on classical antiquity and incorporating the widest possible view of the world with a clear sense of the eternal themes, ones that appeared grand rather than grandiose to Victorian ears – themes of war and suffering, guilt and chastisement, justice and truth, love and mercy. The Anglican church may have been in ferment, but the universe was still ordered according to moral laws that held for all time, and it is curious how long this morality persisted, even after it had become devoid of all religion.[9]

Julia Margaret entirely shared this world-view, and it prescribed a scale of values in determining her subject matter and even, to some extent, the scale of her pictures. It also conditioned her style, and one can go no further in estimating the breadth of Watts's influence than by considering the album she gave to Annie Thackeray. Annie noted that the favourite contents included 'a very beautiful study of the head of her niece, Mrs Herbert Duckworth, so lovely that one felt photography never

will or can go further . . . a noble portrait study of G. F. Watts in the manner of Titian . . . "The Salutation" after the manner of Giotto, is striking. Now comes a very beautiful woman's head entitled "A Dream" under which Mr Watts has written "Quite Divine".'[10] (It is irresistible to add that Julia Margaret, showing her practical streak alongside the romanticism of her pictures, inscribed on the frontispiece, '*Fatal* to photographs are cups of tea and coffee, candles and lamps, and children's fingers!')

With the sweep of a Titian gown or the three-dimensional effect of a Giotto figure, the dramatic chiaroscuro of the Venetian Renaissance combined with the human scale of the Florentine school (Watts himself claimed that the best art was like Bellini's, 'imperfect because unfinished'), Julia Margaret was clearly open to a variety of influences, but they were primarily filtered through a person, and that person was most often Watts. He bestowed on her gifts from his Italian travels; they may be reflected in some photographs of Madonna and child paintings and tondos, presumably taken by Julia Margaret, which were in her bequest to the Royal Photographic Society. Renaissance artists, alive to the revived influence of the Greeks, sought after hidden laws of beauty, completely breaking with the mediaeval priority of affording picture-sermons to largely illiterate audiences or congregations. In the same way, by choosing to represent classical personifications or to illustrate poetry, Julia Margaret placed an emphasis different from the didactic on her work. And when she did use directly Christian inspiration, she omitted the powerful aspects of doubt and anguish, choosing subjects that lent themselves to beauty unalloyed by suffering. Just as there was a sort of innocence about her life, so there was in her art – and she never let her portrayals of Jesus, for example, grow beyond the age of four (even for a depiction, the Preaching at the Temple, when he was in fact supposed to have been twelve).

It was probably Watts who was largely responsible for generating Julia Margaret's Italianate early style. He, after all, believed in the superiority of Titian and Raphael over Turner and Constable, on the ground that the human form was inherently nobler than a landscape, since it was possessed of a soul. His frescoes at

Little Holland House illustrating Flaxman's edition of Dante's *Inferno e Paradiso* greatly impressed Julia Margaret in the 1850s, and might have encouraged her to relate one of her own stylised allegories to Giotto. It is surely too restrictive to believe, with Clive Bell, that 'she was Giottesque, or early *quattrocento* even, rather than twelfth century, belonging to one of those fortunate ages which came just before an embarrassing technique was thrust between the artist and his emotion',[11] but she did pay homage to Perugino, as well as to Giotto, Francia and Raphael. One portrait of Henry Taylor was simply inscribed 'A Rembrandt', and Italian themes, both tragic and folkloric, abounded in her work. At this stage, one cannot know how many of these inscriptions suggested themselves to her afterwards, how many were included to impress artistic friends, and how many they themselves might have put forward.

In John Herschel, Julia Margaret found the greatest encouragement for her technique, the stronger in that he refused to stop short of criticism where he felt she had failed. It was not always to her advantage that there were not ready-made techniques for her to follow. She might know what she wished to express, strive desperately after it, and fail through sheer technical inability. On 25 September 1866, in response to a 'Series of my Photographs which form I think a theological work of some Interest', John Herschel wrote back, suggesting the lines she should develop:

The last batch of your Photographs is indeed wonderful and wonderful in two distinct lines of perfection. The head of the 'Mountain Nymph Sweet Liberty' (A little farouche and égarée by the way, as if just let loose and half afraid that it is too good to last) is really a most *astonishing* piece of high relief – She is absolutely *alive* and thrusting out her head from the paper into the air. This is in your own special style – the other of the Summer days is in the other manner – quite different but very beautiful and the grouping perfect.[12]

The 'Mountain Nymph' (Plate 15) is indeed one of the most stunning photographs ever taken.[13] The literary reference is to Milton's *Allegro*, from which the relevant verse runs:

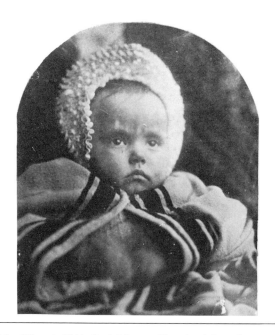

33. Baby 'Pictet', 1864. Carlyle's considered opinion of young infants was remarkably similar to that of the preacher who wrote in the *British Journal of Photography* (see page 113), and was perhaps typical of Victorian men. On the one hand, 'A Baby is the most wonderful of all phenomena in this variegated world', but on the other, 'Babies have no features at first – they're small red things, but gradually you come to discern some features'.

Julia Margaret's eye never failed her, even with babies. Baby 'Pictet' is as much of an individual as any of the adults whose souls she sought to reveal. As if to whet the viewer's appetite further, to some prints she added the tantalising rider: 'One year old Infant shipwrecked once in the Madras Surf & again in the wreck of the Colombo steamer.' The second of these wrecks was notorious, the freak currents off Minicoy being blamed for the ship's being so far off-course as to run aground. Less is known of the baby's identity. Rose Mackenzie (Julia Margaret's niece, daughter of her oldest sister Adeline) married a Swiss-born Captain Francis Pictet of the 49th Madras Native Infantry and this is possibly their child.

Come, and trip it as you go,
On the light fantastic toe;
And in thy right hand lead with thee
The mountain nymph, sweet Liberty.

Herschel had hit on exactly what was arresting, not simply in the model. Julia Margaret's technique of highlighting the face brilliantly from one side while casting the other in shadow, and of allowing a perfectly-shaped head and neck to protrude from a black background, was one of her earliest hallmarks, and was unmistakably sculptural in its effect. As well as the paintings, sketches and tondos that Watts had given her, Julia Margaret was also influenced by one of the most notable pieces of cultural plunder being achieved at the time: the Elgin Marbles had completed their long and disaster-dogged journey to England, where tens of thousands of people fought to see them exhibited. Julia Margaret attempted several more-or-less disastrous versions of sections of that Grecian frieze: she was too literal in her attempts to transfer one technique to another medium, but her interest was an indication of the source from which she was most keen to learn.

Herschel made eruditely light of her failures, but also attempted to direct her experiments:

34. Annie 'My First Success' (Annie Wilhelmina Philpot), January 1864. This portrait of Annie Philpot, an orphan who regularly summered on the Isle of Wight, is unusually modern by virtue of its informality. Julia Margaret had a twin vision of childhood – one that epitomised its ethereal, almost fairy-like quality, and another that was strictly down to earth. Annie is presented without any attempt to give her the feyness so popular with the Victorians, still less as a stiffly-posed and formally-dressed adjunct of her parents. Her hair is untidy, her expression solemn, and she is buttoned into her coat, perhaps to keep her from the January cold of Julia Margaret's studio.

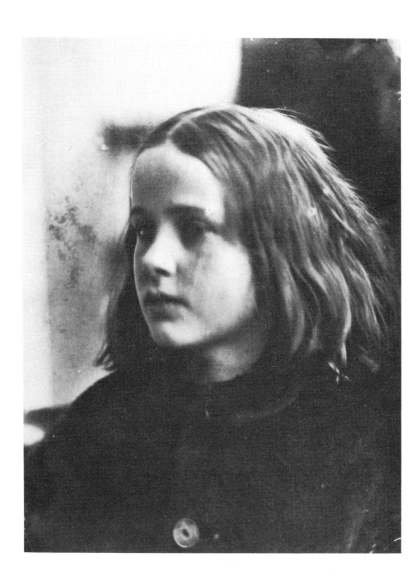

Proserpina is awful – if ever she were 'herself the fairest flower' her 'cropping' by 'Gloomy Dis' has thrown the deep shadow of Hades into not only the colour but the whole cast and expression of her features – Christabel is a little too indistinct to my mind, but a fine head. The large profile is admirable *and altogether you seem resolved to outdo yourself at every fresh effort.*[14]

It is curious that Julia Margaret very rarely photographed famous women. According to Cecil Beaton and Gail Buckland, the only prominent aspect of her women sitters was 'the prognatheous-jawed "butch" matrons with good bones, whom the Victorians admired'.[15] She knew George Eliot, sent her bundles of photographs on approval, which Eliot duly approved, and began illustrations for *Adam Bede*, yet she never sought to take Eliot's portrait. She persuaded William Allingham to sit for her, but does not seem to have bothered with his wife, a noted water-colourist. Emily Tennyson – according to her husband, amongst 'many women who are excellent . . . the noblest woman I have ever known'[16] – does not feature any more than the esteemed Alice, wife of Henry Taylor. Ellen Terry, who ought to

35. Daisy (Margaret Louisa Bradley), 1864. This strikingly contemporary-looking picture of Annie Philpot's holiday companion Daisy Bradley has all the naturalness of 'My First Success'. Daisy's father was the Rev. Granville Bradley, later Dean of Westminster, who took prolonged cliff-walks with Tennyson, exploring and analysing the geology of the island's rocky promontories.

Daisy was one of Julia Margaret's 'victims' who attempted to crawl past her garden hedge in order to avoid detection; her sister Mabel was younger and unluckier, and got caught to pose as the Infant Jesus. Daisy herself had to play a death-bed sequence in Tennyson's *May Queen*, with Julia Margaret chiding the author over her head: 'Now *you* know, Alfred, that *I* know that it is immortality to me to be bound up with you.' Daisy made her own reputation as a prolific novelist, and in her unpublished memoirs (in the Bodleian Library, Oxford) she offers affectionate memories of her holidays at Freshwater.

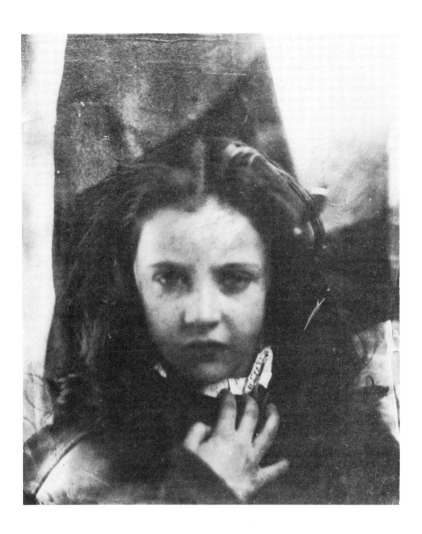

have been well-schooled for Julia Margaret's brand of discipline by Watts ('I remember sitting to him in armour for hours and never realising it was heavy until I fainted'[17]), was only taken in one rather fey pose, on the eve of her wedding (Plate 5). Her portrait of Robert Browning was never accompanied by one of Elizabeth Barrett. She *did*, however, photograph Christina Rossetti, but since the picture has not survived, we shall never know whether she was portrayed as the reputed and respected poet, or as the anorexically lovesick maiden who never quite grew up.

The different ways in which Julia Margaret chose to portray (or not to portray) women and men are an indication of her adherence to the dominant norm. In her selection and presentation of material, just as in her professionalism, Julia Margaret was male-identified. Unlike a veritable flowering of 'lady amateurs' after the 1850s (Lady Hawarden, Lady Nevill, Lady Mildmay and the Mostyn sisters), Julia Margaret was determined to be professionally and financially viable, and her choice and arrangement of subject reflected this determination.

She saw women very much as a male photographer might have done, and how her predominantly male purchasers certainly would have done. Women were alien to the worlds of power, politics and intellect; their qualities were those of beauty, delicacy, maternity and spirituality. Ironically, for all the female allegories intended to present this religious dimension – enlarged in order to feminise the angel at the sepulchre and even to turn St John the Baptist into a girl (Plate 37) – it is some of Julia Margaret's 'straight' portraits that number among her earlier successes in this field. Julia Jackson, whom she continued to photograph as Mrs Herbert Duckworth and Mrs Leslie Stephen, and who was never dressed up as anyone other than herself, represents the fullest range of this vision of womanhood. She appears in the Mia album in a variety of quasi-religious poses, often with her heavy-lidded eyes fixed mystically on some distant point, and in one with a church window (depicting Mary's washing of Jesus's feet?) sketched into the corner. In others she has her hair down, the face dramatically half-lit and a wild or withdrawn intensity in her look. For Herschel, Julia Margaret

could not resist portraying her niece 'after the manner of an Antique' and, in a couple of later compositions (unusual in that they are situated out of doors), in very much a caring role, her arms encircling an assortment of sailor-suited and frothy-frocked children (Plate 3).

In her later work, there was more of an overlap between the allegorical and the realistic portraits. Yet despite Julia Margaret's conformity to womanly stereotypes, often suggested by or suggestive of literary and religious fables, her technique was throughout inimitably her own. There could hardly be a greater contrast between the stiff little full-length depictions of fashionably-dressed Victorian matrons mass-produced by the commercial studios, and her enormously evocative close-ups. For Julia Margaret the expression, often of neck and hands as well as of face, was of paramount significance. She was at her worst when attempting to cram too many individuals and props into the composition, and her few essays into more conventional group portraits are similarly unsatisfactory – even when, as with the du Mauriers, the sitters were close family friends.

The composition of her illustrations and allegories of this earlier period (1864–68) have drawn adverse comment. Defenders of her very differently treated portraits of men and women dismiss her set pieces as no more than a foible, and her use of children as adjuncts. Helmut Gernsheim considered them 'absurd . . . sentimental . . . affected, ludicrous and amateurish . . . excesses in photography'.[18] Graham Ovenden found 'a number of her more complex images are badly constructed and sentimentalised to an unpalatable pitch', although he added, without explanation: 'it is unjustified and incorrect to dismiss categorically her romantic vision as inferior to her dignified rendering of the Victorian intelligentsia'.[19] While it is true that many pictures mingled the real and the romantic and, as Colin Ford has amply proved,[20] were certainly no more extravagantly sentimental than many artistic currents of the day, her integral use of children is often overlooked.

- Of infants and angels

Throughout her working life, and most especially in the first two overlapping periods (the allegories and portraits, 1864–70), Julia Margaret loved photographing children. She doubtless loved children themselves, in enthusiastic unawareness of her inhibiting effect upon them. She quite openly records her bullying techniques to get them to sit for her – and sit again, if they moved – explaining how 'a sputter of laughter' lost her one attempt, and so she 'took one child alone, appealing to her feelings and telling her of the waste of poor Mrs Cameron's chemicals and strength if she moved'. When her 'first success' was attained, 'I was in a transport of delight. I ran all over the house to search for gifts for the child. I felt as if she entirely had made the picture. I printed, toned, fixed and framed it, and presented it to her father that same day: size 11 by 9 inches.'[21]

In the midst of a vigorous dedication to her work and her presentation of the feminine woman lies an attitude to children that is at once warm, appreciative – and strict. No doubt she would have concurred with Henry Taylor that 'the essential qualifications for training a child well . . . are First, The desire to be right in the matter; Second, Sense; Third, Kindness; and Fourth, Firmness.'[22] A wholly Victorian ideology, but one that in her case was tempered by a real delight in the child's natural grace and sensibility.

Local children were bribed as sitters, not only with sweets and coins, but with what was assumed to be the pleasure of dressing up. Nevertheless, it must have been a painful ordeal in many cases, for Julia Margaret's studio was an outdoor glasshouse, necessary to admit the maximum amount of light, but hardly a source of warmth for poses staged whatever the weather or season and with a bare minimum of the promised costumes. In several of the Hillier Madonnas, the Keown children and the ever-popular wavy-locked Freddy Gould were commandeered into supporting roles, with sometimes predictable results (see the expression on Plate 43).

Freddy Gould (a local fisherman's son), Lizzie and Alice

Keown (daughters of a fort-keeper on the island), and the girls' baby brother Percy, appear in a number of guises during the 1860s, as everything from adjuncts to the Madonna sequence to cherubs and seraphs personifying 'Prayer', 'Love' and 'Heaven'. Unfortunately, these local children left no record – beyond their facial expressions – of how they felt about being thus used, but Laura Gurney, one of the regular summer visitors, recounts how she and her sister Rachel

were pressed into the service of the camera. Our roles were no less than those of two angels of the Nativity, and to sustain them we were scantily clad, and each had a pair of heavy swan's wings fastened to her narrow shoulders, while Aunt Julia, with ungentle touch, touzled our hair to get rid of its prim nursery look. No wonder those old photographs of us, leaning over imaginary ramparts of heaven, look anxious and wistful. This is how we felt, for we never knew what Aunt Julia was going to do next, nor did anyone else for the matter of that.[23]

Children were enormously popular subjects with Victorian artists and photographers and, at a time of such high childhood mortality, much sentiment surrounded their untimely deaths. One of the best-selling prints of the 1860s was H. P. Robinson's 'Fading Away', taken in 1858, with its set-piece vignette of domestic tragedy surrounding the young girl's deathbed. In order to afford an extended dimension, and some consolation, photographers were encouraged to represent not only deathbed scenes but also images of children who had 'passed over'. The trend was a developing one, and it proved so elastic that by the 1890s handbooks on the creation of 'Angel Pictures' were being marketed. One offered instructions on the preparation and arrangements of duck and swan wings to assist photographers anxious to capitalise on public demand.[24]

More general advice on photographing children also abounded. In 1867, the *British Journal of Photography* proffered a 'Philadelphia Photographer's' advice on 'Taking the Baby'. Written by a Reverend Taylor clearly exasperated and alienated by his subject, it refers to the child throughout as 'it' and is littered with such negative advice as 'It doesn't look like anything much as yet'

and 'It doesn't do pretty things, considered in the abstract'. More specifically, the photographer is instructed 'that if you want to give satisfaction . . . you must introduce expression where there is not the faintest trace of any . . . you must make a nose where there is only a little shapeless knob of flesh; you must bring out the light and shade where there is only an indefinite blank; in short, you must *make* the face of a baby in a picture.' Only someone utterly inexperienced with young children could write with quite such arrogant blindness, but he does at least offer copious comfort to photographers. He reminds them that children 'try the patience of your Job of an artist' and that 'Babies are sometimes worse than boils!', but that the artist/photographer must be ever ready 'to transform them into smiling cherubs on his magic plate'.[25]

It would have been impossible for Julia Margaret to create *smiling* cherubs even had she wanted to, given the extended exposure times she used, varying from two up to as much as ten minutes. She alternated between using older children for her

36. Rachel and Laura (Rachel and Laura Gurney), 1872. Being born into a strict Quaker family did not prevent Rachel and Laura from being somewhat extravagantly dressed at times (although there exists a contemporaneous picture of them in which two large crucifixes stand out most in their apparel). Neither did it prevent the grown Laura's taste for publishing gossipy journals, critically evaluating the social milieu in which she was raised. By the 1920s she was remembering Julia Margaret as:

a remarkable woman apart from that hobby of photography with which her name was so identified during her life, and by which her memory lived many years.

Now she is only remembered by a few of those who knew her in her prime. I doubt if any survive.

To me, I frankly own, she appeared as a terrifying elderly woman, short and squat, with none of the Pattle grace and beauty about her, though more than her share of talent.

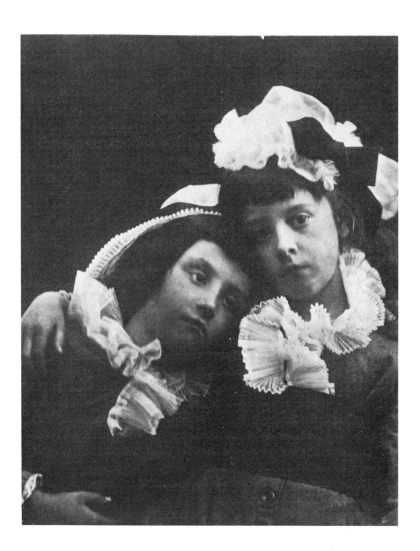

Madonna sequence to photographing only sleeping infants (see Plate 11). Her distant relation, 'Baby Pictet', seems to have been the unique exception, and one suspects he may have maintained his fixed stare less for the camera than as a result of his early maritime adventures, having been shipwrecked twice before the age of one (Plate 33).

Whereas the emphasis on discipline was apparent in Julia Margaret's insistent marshalling of her younger subjects, her delighted appreciation of them shines – quite literally – through the best of her allegorical representations. She believed that 'great thoughts shone like haloes from the heads of great men', and it seems that some of her children were wholly endowed with this luminescent quality. 'Cupid's Pencil of Light' (Plate 41) is a late illumination of this concept, ambitious in its conception and brilliant in its execution. Taken in the garden studio, it achieved an effect of streaming sunlight by her refraction of the sun's beams through glass and her 'holding back' the developer to give a granular texture like dusty rays of light. Great boldness is used in making a white blank of paper the centre of the composition, so that one's eye moves from it along the child's highlighted limbs and only gradually to his semi-shaded face with its tousled hair just tipped with light.

There could hardly be a greater contrast between this and her illustration to the Charles Kingsley ditty 'The Three Fishermen', alternatively titled 'Pray God Bring Father Safely Home' (Plate 48). A number of prints of this exist, cropped differently, but always retaining the girl praying at her mother's knee. The setting is unique, being a humble cottage, with the grandfather darning his nets and the kitchen range surmounted with bellows, teapot and a smoothing iron – all the utensils of daily life among a social class with which Julia Margaret barely mingled. Only the children look somewhat out of place, the boy elevated by a sailor suit and shiny boots and the girl irredeemably another cherub, with her loose white nightie and tumbling hair.

More often than not, children would be used to represent a single image, the religious often overlapping with the secular, the mythological with the literary. The remarkably 'straight' and

unpretentious portraits of Annie Philpot and Daisy Bradley (Plates 34 and 35) look all the more modern, despite the cracks and streaks on the plates, when compared with the archaic quality of those endowed with poetic captions. But even when she depicted little girls with loose hair in nighties, and naked young boys, it was completely without prurience or voyeurism. Her vision of childhood was one of quintessential innocence which each picture sought to encapsulate, however pretentiously couched.

Her vision was diametrically opposed to that of her photographic contemporary, Lewis Carroll. Called by Gernsheim 'the greatest photographer of children of the nineteenth century', Carroll still has new editions of his work appearing that show only his portraits of pre-pubescent girls and completely exclude his more famous photographic images.[26] We know that he and Julia Margaret did not get on; they avoided one another's company when he visited the Tennysons. Perhaps looking at their different approaches to the photography of children one can see why.

Carroll's child photographs were never published during his lifetime and at his death he requested that they be destroyed, and a great many were. When the Gernsheims were researching their book on him in 1949, his executors were still dubious about the publication of the remainder, and wholly opposed to relevant excerpts of his diary appearing. As recently as 1965 a biography could be written of him with reference only to his mathematical and story-telling skills, and not his photography. Much theorising has since gone into distinguishing the fantastical private world of Lewis Carroll from the theological brilliance of Charles Dodgson. All that matters in this context is that there was clearly a rift between his two worlds, with one side firmly suppressed as the other was called into the ascendant. His photography of children was dissimilar from his story-telling in that it was intended to provide him only with personal pleasure; after objections from several parents, he no longer even showed the child-sitters his portrayals of them. Yet he also imposed rigid strictures, whether they were listeners or sitters. His famous remark, 'I like all children – except boys', was made to apply insofar as a boy could

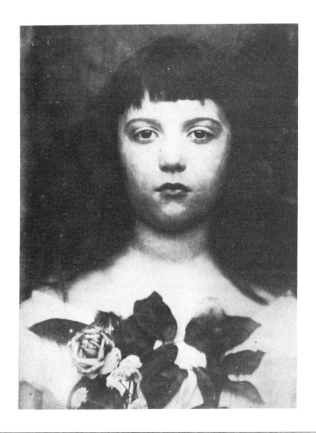

Above: **37.** Florence, and *right*: 'St John the Baptist' (Florence Fisher), 1872. Florence was the grand-daughter of Julia's beloved sister Mia, the eldest of eleven children born to the historian Herbert Fisher and Mia's consumptive-looking daughter Mary, whom Julia Margaret also photographed. Florence learnt the violin from an early age and, accompanied by her sister Adeline on the piano, so impressed Tchaikowsky that he declared himself as honoured to sport their gift of a rose as he was to collect his honorary doctorate, the purpose of his English visit.

Contemporaries were divided between those who saw the subject as cold and reptilian – and there *is* an obsidian look to those hooded eyes with their perfectly arched eyebrows – or 'as if she had stepped straight

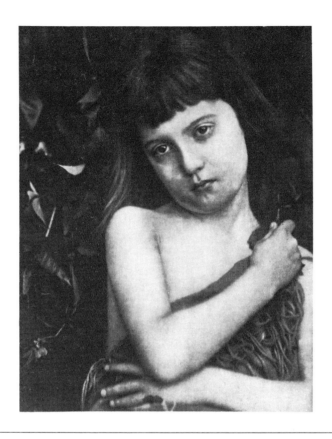

out of a Burne-Jones picture' (Gwen Raverat, *Period Piece*, London, 1952). It is to the latter Julia Margaret seems to have looked in the pose of the 'boy' against the leafy background, an effect that is sharply differentiated by her preferred close focus. Where one of the Brotherhood would have travelled to the Middle East in pursuit of background and similitude, Julia Margaret simply made the child's head and torso fill the picture. The one called simply 'Florence' shows the model decidedly ill-at-ease with her party frock and bouquet. The slightly wild side of her nature, which Julia Margaret perceived, looks completely at home as St John.

not pass for a girl in front of the camera. Furthermore, even girls were acceptable only between the ages of four and approximately fourteen; pubescent girls disgusted him. Finally, Alice Liddell (the original subject of the 'Alice' books, together with her sisters in supporting rôles) remained his especial inspiration and favourite. He relived the betrayal he felt he had suffered when she grew up through other little girls who most resembled her.

It is interesting that Julia Margaret began to photograph Alice at just about the time Lewis Carroll stopped. Her two most famous representations of her are as 'Alethea' (Plate 19) and 'Pomona', goddesses renowned for their fertility; the first for her motherhood of three sons by as many fathers and of Deianeira by Dionysius, and the second a Roman goddess of trees and fruitfulness. Carroll's visions of little girls were altogether less grand, and he tended to prefer the pert, if not provocative. Whatever the subjects thought of being posed in black lace stockings and gloves or draped in ripped rags as beggar-maids the Liddell parents, at

38. 'Paul and Virginia' (Freddy Gould and Lizzie Keown), 1864. Bernardin de Saint Pierre's romance of 1795, *Paul et Virginie*, appealed to a wide Victorian readership, and went through seven English editions. Possibly a favourite from Julia Margaret's French childhood, it was a moral fable – elevating the virtues of a simple Rousseauesque existence, true love and chastity – whose principal protagonists were children. It combined Julia Margaret's love of the exotic (a setting on the isle of Mauritius and a dramatic shipwreck) with homely virtues of family life and childhood companionship. Incidentally, despite Julia Margaret's claim never to retouch her work, there has been some clumsy shading on Paul's feet, presumably to stop them protruding within the composition.

Saint Pierre's own idea was to represent 'morals in the midst of natural beauty', and to 'let the purity of the children's souls shine in their faces'. (Unfortunately, this had to mean that the unlucky slave was depicted with 'a face as black as his heart'.) Julia Margaret's representation of natural beauty is restricted to a few flowers strewn on the floor, and a tussle over the sunshade looks as though it has won over sublime expressions.

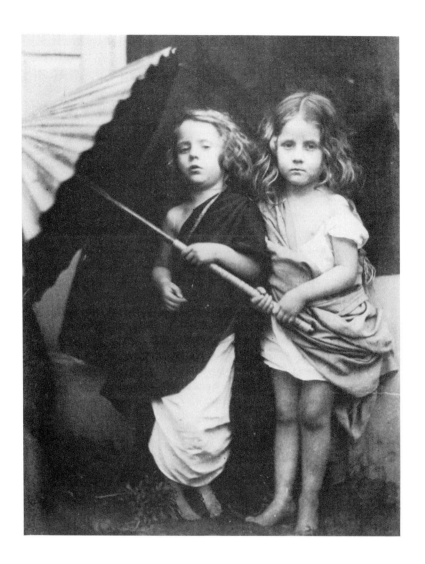

least, were not amused, and forbade Carroll the courtesy of their drawing room.

Edward Lear was another contemporary bachelor with a fascination for young children. In his case, he claimed, this resulted from his possession of a 'child's mind', which happened to see the world differently from adults, and he always viewed himself as a day-dreaming child might do, barrel-shaped and with birds nesting in his beard. It was an attitude he might have shared with Julia Margaret, for she also retained a child-like ability to view everything anew. Yet she succeeded in alienating him utterly. Lear gruffly recollected of a visit to Farringford: 'Mrs C. came in

39. Girl Praying (Florence Anson), 1866. Prayer was always important to Julia Margaret, and she did not see it as a necessarily private matter. She bestowed her spontaneous supplications among her friends with a total lack of embarrassment or reticence. Fortunately at least some of her offerings were well received by those to whom they were circulated. Lord Hardinge, whom she knew from his days as Governor General in Calcutta, wrote in thanks for her letter concerning the loss of his son: 'I cannot sufficiently thank you for the beautiful prayer. It is so simple, touching and effective in every word that you must allow me to keep it among my papers . . . my Grandchildren are learning it by heart' (Mss. Eng. Lett. Cl., Bodleian Library, Oxford).

He could not have paid her a more welcome compliment, for elsewhere she writes of her delight in hearing young children at prayer. What is conveyed by this portrait of Florence Anson, however, is decidedly at variance with sentiment and the mass-produced representations of it that hung over so many Victorian children's beds – the family all kneeling together for evening prayers, with angels who look like fairies in sycophantic attendance. This version is much more an expression of solitude, eyes gazing down rather than heavenwards and hands clasped rather than in the conventional attitude of prayer. Yet it has an angelic quality also, created not only by the white blouse and swoop of hair, but by the same process Julia Margaret employed in 'Cupid's Pencil of Light': she held back the developer to allow what appear to be rays of light to fall diagonally from an upper corner.

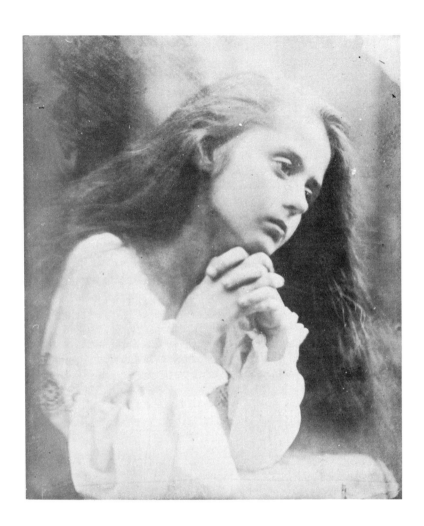

only once – with feminine perception not delighting in your humble servant. We jarred and sparred – and she came no more.'[27]

- Future fame and present pursuits

In her quest for the beautiful, Julia Margaret turned first, as befitted her gregarious character, to her friends. Like her mentor Watts, she believed that 'what really counted in this world' were 'the achievements one could bequeath to posterity – and friendships'. She could receive no greater compliment than that paid her by Darwin concerning her portraits: 'There are sixteen people in my house and every one your friend.' Watts himself, with his tendency towards misanthropy, sent repeated requests for the happily undemanding 'friends' – portraits of Taylor, Cameron, Faraday and 'The Professor'.[28] Her two extant poems, one addressed to 'A Portrait' and the other to the memory of the poet Arthur Clough, seem an appropriate metaphor for her two concerns, Art and Friendship.

Perhaps Julia Margaret adhered to the belief expressed by F. D. Maurice (a long-standing friend of Tennyson) when he said: 'Had we such portraits of Shakespeare and of Milton, we should know more of their own selves. We should have better commentaries on Hamlet and on Comus than we now possess, even as you have secured to us a better commentary on Maud and on In Memoriam than all the critics have given us or ever will give us.'[29] Certainly it is arguable that Julia Margaret's sequence of portraits of Tennyson over the years she knew him, growing gruffer and greyer, more wild and lined, are more revealing than her pictorial commentary on the *Idylls*.

It was inevitable that Julia Margaret's artistic influences should have come through people rather than through study or travel. Her time abroad was all the consequence of family matters. The classical influences in her pictures came through her husband's scholarly pursuits, the familiarity of his intonation of Homer and Euripides out loud on his evening walks in the garden. And it was the Renaissance rediscovery of earlier classical styles that in-

formed much of Watts's interest in Italian art, and no doubt encouraged Julia Margaret to inscribe 'after Perugino' (or Titian or, to demonstrate the catholicity of her Italian leanings, Giotto or Francia) beneath some of her religious poses.

Christian iconography was also something she could assimilate from her social circle. Lord Lindsay, a family friend, had composed a three-volume work on the subject and Lady Eastlake took over from the renowned Anna Jameson in completing *The History of Our Lord* in 1864, emphasising the 'aesthetic and not the religious view of those productions of Art which in as far as they are informed with a true and earnest feeling, and steeped in that beauty which emanates from genius inspired by faith, may cease to be Religion, but cannot cease to be Poetry'.[30] Together with *The Poetry of Sacred and Legendary Art* and other books of Christian 'legends', Anna Jameson had contributed to creating a new way of looking at paintings and sculpture simply through deciphering its Catholic iconography. But to go as far as one modern critic, and claim that, with her portrait of 'Iago' (Plate 31), Julia Margaret was actually 'following Jameson's advice to merge Christian iconography with English poetry' seems rather more dubious.[31] Inasmuch as the face encapsulates so much of human care, suffering and remorse, to identify it as Christ's may be a valid personal ascription. But not only do we have no evidence that Julia Margaret ever read Mrs Jameson's *History of Our Lord*, the evidence of her other photographs tells against her ever having sought to depict the adult Christ.

She was unpredictable and unsystematic in her choice of sources, which was what presumably encouraged her to describe her pictures as 'in the style of' almost any significant Italian painter. Yet if one ever has the impression that Julia Margaret's turns of phrase are a trifle extravagant, or her allegories over-optimistically ambitious, then a glance at Watts's meditations on six of his most famous pictures can offer a new perspective. Beside a painting of Hope blindfolded on a globe, chained to her unstrung lyre, presumably in illustration of how she became undone by spurious knowledge, the text instructs us:

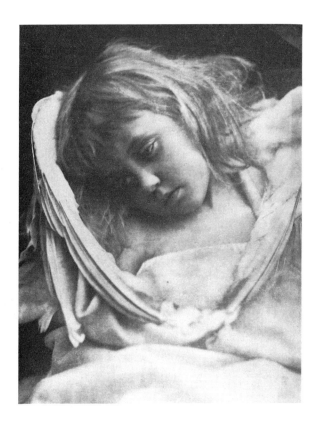

Above: **40.** 'The Nestling Angel', 1870 and *right*: **41.** 'Cupid's Pencil of Light', c. 1867. Winged children, whether of the classical or angelic varieties, were a recurrent feature in Julia Margaret's view of childhood. The extravagant terms in which she described her 'heavenly divine' grandchild was matched by the fragility of a Victorian infancy. She wrote with incoherent fervour on the death of Halford Vaughan's baby of how 'might we not all have seen that it had an angel's soul already blessed. . . . The mysteries of Heaven it had to teach unto you, thro' the memories of the sacred kisses, your hand and your foot can never forget . . . [you have] yielded to God an unspotted Angel'.

'The Nestling Angel' was the sentimental Victorian equivalent of the

innumerable little shrines devoted to departed infants in Catholic coun-
tries. But the continental custom of attaching a photograph of the
deceased child to the grave was considered idolatrous to the British and,
paradoxically, realistic images gave way to supposedly heavenly ones. In
her typical overlap of the sacred and profane, Julia Margaret moved
immediately from heavenly to carnal love with her 'Cupid' series. Cupid
had the added advantage, like the other young Greeks she portrayed, of
being more suited to nudity than angels. By her bold use of light, strong
outline and a focus more on the feet than the face, Julia Margaret here
maximised the gently sensual quality of a young child's flesh.

Love touched the eyes of Hope, and Hope for one brief moment saw the greater beauty behind this gorgeous show of things. Hope took Love back to the land of Knowledge, and Science came out onto the fields with Love, and deep in the heart of Hope Insight and Science – the child of Love and the child of Knowledge – were wed, and the fruit of the union was Wisdom.[32]

Watts's images of Science and Art, as later on the still more stentorian ones of Greece and Rome, are female potentates, and he believed that his type of painting was a perfect 'marriage' of art and science to induce wisdom in the viewer. This may have been his personal view of his style of painting, but it was the commonly held one about photography, before ever 'technology' insinuated its way into the relationship. The elevated plane on which Watts wished to maintain matters is suggested by the tendency to turn commonplace descriptive nouns into allegories by the simple

42. Captain Speedy and the Prince of Abyssinia (with Basha Felika, the prince's servant, on the right), c. 1870. The photograph is probably mis-dated, since it was in August 1868 that this strange band appeared at Freshwater. Captain Tristram Charles Sawyer Speedy was as colourful as his garb suggests, a wandering mercenary and gifted multi-linguist who trouble-shot his way through the hottest spots of the empire. He served in Abyssinia at King Theodore's court and as Vice-Consul in 1863–64. Appointed Amharic interpreter to the 1867–68 campaign, he outdid himself not only in earning Napier's praise, but in attracting attention for his increasingly exotic dress and habit of accompanying himself on the bagpipes.

'Poor little Alamayou' was orphaned after the bloodbath of Magdala, and at the age of only seven sits dolefully by the accoutrements of his kingly power. Brought to England by Napier, chaperoned on world tours by Speedy and his faithful servant Basha Felika, he was subjected to the further strangeness of education at Rugby and Sandhurst, before dying of pleurisy in his graduation year.

Julia Margaret may have known of him through her family connection with the Arnolds of Rugby, but is more likely to have pounced during his holiday as a guest of the Queen at Osborne House on the Isle of Wight.

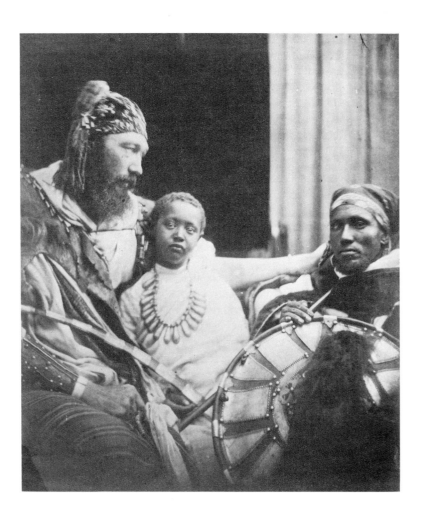

imposition of a capital first letter. This preoccupation with transforming everyday into 'High' art was one Julia Margaret came to share, and which led her into a number of experiments she later abandoned, such as sketching a piece of architecture or a stained glass window into a photograph or even doing some rudimentary 'retouching'. The only known example of a composite picture by her is one where she intercut Mary Hillier (who commonly posed for her full-face 'Marys', while Mary Ryan provided the profiles) with Archie, her young grandson, to create an 'altarpiece'. This lengthy Madonna sequence was one especially close to her heart, and one about which she felt the more bitterly when it failed to receive critical acclaim. When in May 1865 she had submitted for exhibition 'a head of Henry Taylor with the light illumining the countenance in a way that cannot be described [and] a Raphaelesque Madonna called La Madonna Aspettante', she took it as a personal insult that the winning photograph 'clearly proved to me that detail of table cover chair and crinoline skirt were essentials to judges of the Art which was then in its Infancy'.[33] Having disregarded the dictates of fashion in her own attire (it was publicly remarked that only within Pattledom were crinolines deemed dispensable), she resented the implied pressure to begin representing it in her own work. The judges did, however, go so far as to remark that 'The Council recognise with pride the cooperation of ladies in photographic work. The walls of the exhibitions have borne evidence of the excellent practical results produced by them.'[34]

As with art, so also with literature she was a magpie who collected the interests and suggestions of those around her, either illustrating their work or that of their favourite authors. It is curious that she was restrained with the grand and complex subject-matter afforded by the now virtually unread and unreadable plays of Henry Taylor, but she capitalised on all the most popular Tennyson poems. Recently published best-sellers like Eliot's *Adam Bede* (see Plate 49) or Patmore's *Angel in the House* were grist to her mill, as were her husband's beloved Milton ('The Dream', Plate 14) and Shakespeare, Shelley and Keats from among the poets of earlier generations. This was all very English,

but entirely at variance with the then current style of theatrical representation. To produce Shelley's *The Cenci* or *The Tempest* on stage necessitated the maximum of heavy drapes and cumbersome props, whereas Julia Margaret's interpretations highlight a single figure or the intensity of a relationship between an older man and a younger woman, whose faces stand starkly out of the darkness, the depth in their expressions being all.

● The *Idylls of the King*

The Arthurian cycle falls into the 'third phase' of Julia Margaret's photography, and is her most determined attempt at book illustration. She was so disappointed in the format of the two-volume edition when it appeared, because of its diminutive size and the poor quality of its woodcut reproductions of her photographs, that she issued her own versions in a limited edition. True to her style, this was large enough to accommodate a dozen full-plate-sized photographs alongside handwritten copies of the poems; although after the second volume was printed in 1875, she did bring out a miniature compilation of the two volumes.

When she took on this commission at Tennyson's suggestion in 1873, she was following in the footsteps of several artists within her circle. Gustave Doré (whose portrait she and Rejlander both took) had provided one set of illustrations; Lear had worked for twenty years on another; and altogether eighteen artists, including the principal Pre-Raphaelites, had worked on the 1857 Moxon edition. Lear had obtained his commission through Holman Hunt (his artistic mentor, although fifteen years his junior), and it was Lear who defined the illustrator's role as he saw it: 'I don't want to be a sort of pictorial Bosworth, but to be able to reproduce certain lines of poetry in form and colour.'[35]

Julia Margaret's problems with the *Idylls* were threefold. First, she did have that tendency to serve as Tennyson's Boswell, for however much she tyrannised him emotionally, as a poet she always looked up to him. Second, her over-literal transcriptions of his poetic images were difficult to achieve in her ill-equipped

studio. And third, she had an uneasy relationship with Pre-Raphaelitism, whose influence she was not quite confident enough to assimilate and forge in her own photographic images, and whose pictures were still very much in the public memory through the phenomenal success of the Moxon edition.

Actually creating the two volumes of the *Idylls* proved something of a nightmare for all concerned and, as in many of Julia Margaret's ventures, her household and even the whole neighbourhood were prevailed upon to play a part. Hitherto there had been a somewhat unusual but nonetheless pleasurable routine into which the entire household was drawn: guests became accustomed to the idea that at Dimbola there were neither bed- nor meal-times, and the maids would be too busy with more creative activities to pay more than passing attention to their formal duties. But the period when 'Mrs Cameron photographed all day long and at night she would organise impromptu plays and dances in the big panelled hall, and partners would come out on to

43. 'The Whisper of the Muse' (Freddy Gould, G. F. Watts and Lizzie Keown), c. 1867. G. F. Watts was known neither for his love of music nor of children, against which all the noisy festivity of Little Holland House failed to inure him. He warned Sara Prinsep's small but bossy grand-daughter of the dire consequences of her behaviour – 'You will grow up to be an imperious woman if you are not careful' – and when finally coerced into providing art classes for the young Gurneys, horrified them by seating them around a table with nothing but a brick to spend the morning copying.

However, in the interests of classical composition, he was prevailed upon to take up one of the few acceptable outside places by the ivy-clad kitchen garden wall adjoining Julia Margaret's studio, and to hold the fiddle as though it were a guitar. Lizzie seems to have learnt her part well, although the blurred focus on her side of the picture might work in her favour, but Freddy manages to combine the tedium of the moment (or rather the long, slow moments) with a faint insolence all his own. Watts's strong nose, tall brow and lavish beard have the sensitive elegance that Julia Margaret so appreciated in her male subjects.

the lawn and dance under the stars'[36] was doomed when the commission to illustrate the *Idylls* came through in 1874. From then on the amateur theatricals were not just for the family at evening-time but became a day- and night-long obsession. Paradoxically, in thus wholeheartedly giving herself over to one cause, Julia Margaret lost her capacity to 'feel beauty and record it'; working under less pressure and allowing her own imagination its erratic rein, she had succeeded in making 'every day in the week a Saint's day, every commonplace event into something special, just as she transformed a village maiden into a Madonna, or a country bumpkin into a paladin'.[37]

Julia Margaret was always able to see an inherent dignity and beauty in certain faces regardless of social origins, and selected them for her most illustrious characters. The search for a suitably noble Arthur caused her to comb the island until a fisherman possessed of an appropriately aquiline nose and staring eyes was found. In searching for a Lancelot, she came across Cardinal Vaughan visiting some mutual friends and eulogised the perfection of his countenance, at which Tennyson, ever a little hard of hearing and short of sight, loudly and in the Cardinal's presence reminded her, 'I want a face well worn with evil passion'.[38]

44. 'The Three King's Daughters Fair' (model on left unknown, Miss Peacock and Annie Chinery), 1873. This was Julia Margaret's favoured group portrait of young women; when she took more than three together the ones at the edge had a tendency to become amputated (as in 'Peace, Love and Faith'), or fall out of focus (as in 'Too Late! Too Late!', Plate 45). Here there is the incorporation of the spray of flowers that characterises 'The Flower Girl' (Plate 10) and several of her Madonna sequence and young girls (see 'Alethea' and 'Florence', Plates 19 and 37). Miss Peacock, evidently a guest of the Cameron household in 1873, was occasionally allowed to pass for herself, though Julia Margaret decided more often that her looks lent themselves to reincarnation as Coventry Patmore's *Angel in the House*. Here the expressions show the strain the models must have been under, the one on the left bearing a distinct resemblance to a lamb brought to the slaughter.

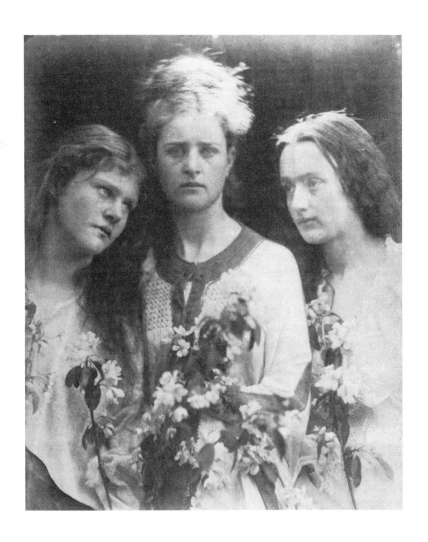

Finding sufficiently expressive models was but the start of Julia Margaret's problems. The *Idylls* themselves were, after *In Memoriam*, Tennyson's second greatest exploration of philosophical themes, a mixture of what he believed to be life's eternal laws and the then fashionably banal (such as his insistence, in the name of British patriotism, that Arthur should be represented as a Saxon rather than as the Celt he was). The loss of faith afforded by the ructions and defections in the Church of England led to a philosophical quest for some form of 'Holy Grail' that would infuse the partial answers offered by new sciences such as evolution (and pseudo-sciences such as phrenology) with a holistic illumination. The Arthurian quest becomes each person's own search for a soul and a god.

Just as *In Memoriam* was born out of the untimely death of Arthur Hallam, Tennyson's brilliant and beloved young friend, so the *Idylls* concern themselves with the journey through life of a Christian soul and again return to the impact of death as Tennyson re-experienced it with the sudden loss of his younger son, Lionel. It was a theme which had fascinated him from childhood

45. 'Too Late! Too Late!', 1868. Julia Margaret's 'Peace, Love and Faith' (or 'The Three Sisters') was taken a year after Dante Gabriel Rossetti's 'Rosa Triplex' was put on public view in 1867, and is in very similar vein. Her attempts to give it shape by arching the top did not improve the original composition. Here, a greater number of models dissipates the focus further in what is thematically a similar picture, taken at the same time.

As to the models' expressions, they put one in mind of Virginia Woolf's short story 'The Searchlight', in which her great-aunt Julia Margaret appears 'with clenched fist and threats of damnation' to 'force those around her to hold still', with the rhetorical question, 'Surely you can put up with a little discomfort in the cause of Art?' It was, however, only for a picture entitled 'Despair' that Julia Margaret was reputed to have locked her sitter into a cupboard for several hours to obtain the appropriate expression. One wonders what techniques were employed to obtain these expressions of rich and gloomy piety.

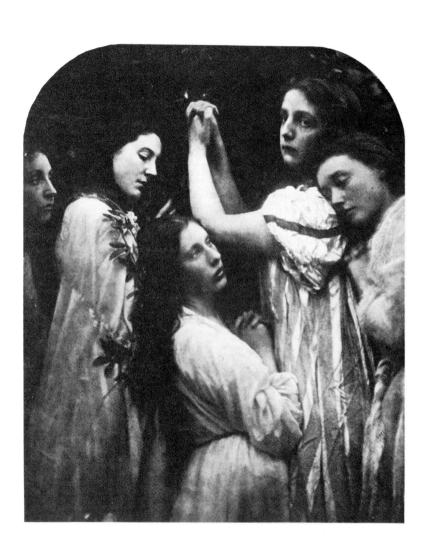

and which, he rightly anticipated, would intermittently obsess him throughout his life. He was well aware of its eternal nature, and also of the historical influence it had exercised. Ever since the tale of the warring chieftain's decline from charismatic leader into lonely exile had first been told, it had had the inspirational power of a laicised version of Adam and Eve: man in his natural kingship betrayed by his treacherous wife, and so losing all power and control over destiny. It was a fable that had attracted artists almost as much as writers. The Pre-Raphaelites' return to mediaeval England, however imagined, made it an obvious choice for them and so it continued down into the 1890s with Beardsley's grotesque visions of the *Morte d'Arthur*. The 1857 edition of the *Idylls* was illustrated with five designs by Dante Gabriel Rossetti, four by William Mulready, six by Spencer Stanhope, seven by Holman Hunt, no less than eighteen by John Millais and two by Daniel Maclise, already famous for his book illustrations including Julia Margaret's translation of *Lenore* (see p. 45).

The main problem even with the finest designs was that few wood engravers were competent enough to execute the intricate task of transferring them to the block, ready for large-scale reproduction. Dissatisfaction with crude engravings was perhaps a contributory factor in encouraging some artists to become photographers; as far as we know, only one engraver, Paul Martin, made the same decision. But for the writer, the prospect of choosing certain designs only to see them rendered literally into dead wood (or, more occasionally, hacked on to stone or metal) by copyists inadequate to the task could be gloriously at an end with the advent of photographic illustration. The 'introduction of mechanical photographic processes towards the end of the nineteenth century [would mean] the work of the living copyist was eliminated, and publishers, intoxicated with the power of the camera to give almost exact representation of the original, were content to disregard the essential quality of illustration, namely its power to blend with the rest of the book'.[39]

Julia Margaret lionised Tennyson, and sought to translate his words faithfully into pictures, using all the realism her art could

bring to bear. Yet, as Turner had already demonstrated (and as the Impressionists would demonstrate again) truth to nature was not achieved only by what Ruskin called the 'quasi-photographic fidelity to the observed facts'. Julia Margaret knew that the truth she was after was greater and more important than that of literalism, yet in the *Idylls* she seems to have been unable to go beyond taking the literalism 'from literature', as though it were possible to copy directly from one medium into another. George Bernard Shaw ruefully concluded that 'There is a terrible truthfulness about photography that sometimes makes a thing ridiculous'; he found her edition of the *Idylls* ridiculous because he felt that only by focussing on one's own time could 'the photographer produce convincing and acceptable pictures'.

The series Julia Margaret produced was, indeed, so uninspired that one wonders if it were due not merely to the unsuitability of her medium to the subject but also to a lack of real inspiration on the Laureate's part. She was herself no intellectual, and she set about as faithful a rendition of his work as, with the extremely limited resources to hand, she could muster. On the one hand, each picture next to its accompanying verse transcribes every detail of dress and furniture as nearly as she could manage; on the other, the props she accumulated bear very little resemblance either to the mediaeval version of the Arthurian legend or to the wild outside (see Plate 50). But she also kept half-an-eye on the commercial proposition it afforded and advertised: 'The photographs will be also sold singly at 16/- each to those who prefer single copies, then the set would come to £10 8s for the 13 pictures without the binding whereas the book is only 6 gns.' Needless to say, she could not resist binding it in the finest red Morocco, thus greatly increasing her initial outlay, a charge she sought to offset by the decision 'to dedicate the book to the Crown Princess [of Prussia] because of her most amiable friendly to me [sic]. She is so charming towards me'.[40]

Julia Margaret certainly enjoyed being professionally as well as personally linked with the Poet Laureate. She stoutly defended his work, loyally disagreeing with Arnold as to his dearth of intellectual prowess and with Sidney Colvin's much-publicised

preference for 'the full-blooded splendour and passionate colouring of Rossetti's work' to the poet's own. She applied herself conscientiously to transcribing rather than evoking his themes. Her work was in its turn poetically praised by Tennyson's brother, Charles Turner, who provided a handwritten sonnet to face the frontispiece portrait of Tennyson.

Hill and Adamson, the Scottish perfecters of the calotype which used sunlight to imprint a negative image on sensitised paper, had called their earliest works 'Sun Pictures'. With Charles Turner's invocation ('The Sun obeys thy gestures') Julia Margaret began to add 'Priestess of the Sun' to her familiar signature. And in 1875, when the second volume of the *Idylls* appeared, she wrote one of the only two poems definitely credited to her. Like the one she sent to Clough's widow on 20 July 1862, entitled 'On receiving a copy of Arthur Clough's poems at Fresh Water Bay', 'On a Portrait' is full of hyperbole and implied

46. 'Friar Lawrence and Juliet' (Henry Taylor and Mary Hillier), 1864. Henry Taylor noted as early as 1859 'the small beginnings of what was so soon to be developed into the phenomenon presented by Mrs Cameron's art in multiform impersonations of King David, King Lear and all sorts of kings, princes, prelates, potentates and peers'. It would be fascinating to learn where he found those 'small beginnings' some five years before Julia Margaret actually took up photography.

From her earliest historical representations Julia Margaret focused on the inter-relationship between an elderly, venerable and often powerful 'potentate' or 'prelate' juxtaposed with a young maiden, often in an attitude of appeal. Henry Taylor and Charles Hay were usually obliged to alternate in the kingship roles, whilst any available servant would serve in the female part. Emily Tennyson complained how, when Julia Margaret tired of using one of her own maids to portray a clearly palling 'Sympathy', she was bold in requisitioning other people's: 'I sent a housemaid around with coffee. Mrs Cameron returned the coffee but posed the servant in flowing robes as Goneril.' 'King Lear', 'The Tempest' and 'Romeo and Juliet' were her principal Shakespearean endeavours.

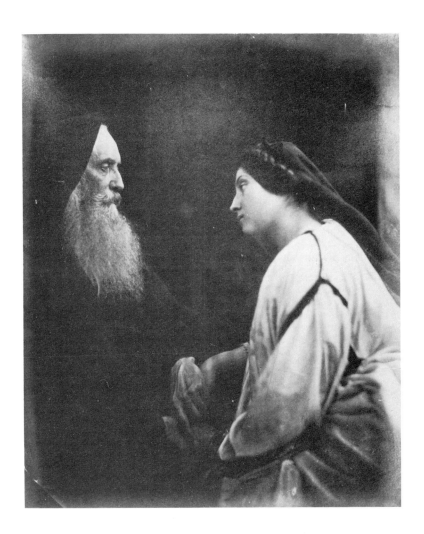

mystery.[41] But it does suggest what she most sought after in both the person and the portrait. It is the story-telling voice she most misses in the departed subject, along with the verve and valour of the man's face; the artist, whom she addresses as 'Oh, noble painter!', is invoked to ensure that:

> . . . all we love best in classic art
> Is stamped for ever on the immortal face.

Just as the very term 'calotype' was derived from the Greek 'kalos', meaning 'beautiful', so Julia Margaret's preoccupation was with achieving beauty in her pictures. The first verse suggests what she had been striving after in her past decade's work:

> Oh, mystery of Beauty! who can tell
> Thy mighty influence? who can best descry
> How secret, swift, and subtle is the spell
> Wherein the music of thy voice doth lie?

47. 'King Ahasuerus and Queen Esther' (Henry Taylor, Mary Ryan, model on right unknown), 1865. The Old Testament story of Esther and Ahasuerus is one well suited to Gothic horror and Victorian morality. It tells of how the Jewish Queen Esther saved her people from a holocaust devised by the immensely powerful despot Ahasuerus, whose kingdom was believed to have reached from India to North Africa, on the counsel of his false minister Haman. Esther not only interceded directly with the king, at considerable personal danger, but instructed the chief priest Mordecai: 'Go, gather together all the Jews . . . neither eat nor drink three days, night or day: I also and my maidens will fast likewise; and so will I go unto the king, which is not according to the law: and if I perish, I perish' (*Esther*, 4:16). This is not the version Julia Margaret chose to illustrate, despite its being the standard one. Instead she went to the Apocrypha for a version in which Esther goes pale and swoons away before the 'countenance that shone with majesty'. It is the more interesting that she selects the weaker version, given the grand presence on the throne of Queen Victoria, from whom Julia Margaret always strove to receive official recognition.

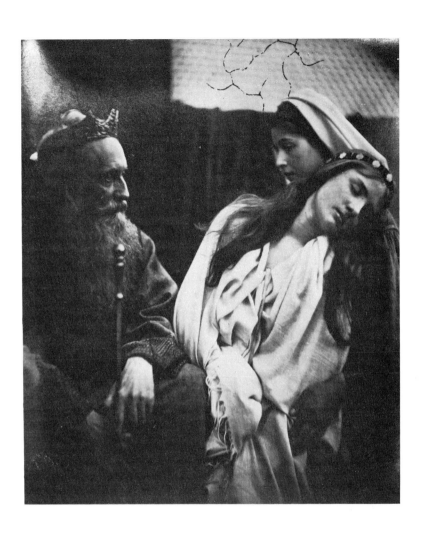

Indeed, the illustrations that most successfully render the ideal of beauty are those most like portraits, unencumbered with the clumsy props of a heavyweight narrative. 'And Enid Sang' and 'Elaine the Lily Maid of Astolat' were sold as individual portraits, whereas 'Too Late! Too Late!' (Plate 45) with its echo of 'The Five Foolish Virgins', and the photographs of the embarrassed-looking knights laden with chainmail and souls tormented by guilt and sorrow, illustrated little but the impossibility of applying photography to the poet's vision.[42] In the same way that opera requires an exceptional fusion of acting and singing abilities, so photographic illustration requires the ability of the photographer to combine poetic inspiration with his or her own vision. Julia Margaret's respect for Tennyson was such that she strove to be as literal as possible, but her technical equipment as well as her technique were unequal to representing an image such as:

> The moony vapour rolling round the king,
> Who seem'd the phantom of a Giant in it,
> Enwound him fold by fold, and made him gray
> And grayer, till himself became as mist
> Before her, moving ghostlike to his doom.

The *Idylls* appeared with the poems in Tennyson's handwriting, on $11'' \times 12\frac{1}{2}''$ blue vellum, each excerpt next to a picture that takes up the whole page minus a gold border. Julia Margaret's obsession with the beautiful included the format of her work. In a surprising acknowledgement of David Wilkie Wynfield's influence on her style, she advised Colnaghi's, the gallery responsible for promoting the *Idylls*, that 'My Book held the one great fact that to my feeling about his beautiful Photography I owed *all* my attempts and indeed consequently all my success.' The Book was certainly not as successful as earlier editions, of which Tennyson had confidently had 40,000 printed at a time, 10,000 of which went in the first week. The Pre-Raphaelite edition had its own impetus since, as Gleeson White sweepingly owned, 'the people of the 50s, 60s and 70s paid their tribute in gold freely and lavishly, and if they offered the last insult of the populace – popularity – to these undoubted works of

art, it prevents one placing artists of the period among the noble army of martyrs. Their payment was quite equal to that which is the average today'.[43]

• A professional apart from her peers

Julia Margaret clearly viewed herself as a professional. If the artists and writers amongst whom she circulated were commanding substantial sums for their creations, it was natural for her to put herself on a par with her talented sitters. Had she not offered to ghost Thackeray's books for him? Did not even the 'wee slip of a girl' Ellen Terry command sixty guineas a week while still a teenager? With the ebullience she expressed about her writing and her nightly amateur theatricals, was she not a *prima inter pares*? She might lack an Emily Tennyson to be her secretary, or Trollope's experience in aiming high in wheeler-dealing overseas rights, or Thackeray's appeal to his fellow 'men of business', but she would do her best.

What this amounted to was some erratically ambitious pricing of her pictures and a series of clumsy and intermittently successful attempts at rigging the press reviews, either by planting favourable write-ups by friends or by pressurising the same friends to exercise their influence with the editors concerned. Many of her picture mounts bear her untidy scrawl with such instructions as 'Earl of Lichfield's Children – £2 because negative has perished' or 'This series of 14 is not for Sale. Orders will be taken'. Her correspondence is littered with messages such as that to Alexander Wedderburn on 19 October 1874:

Thanks for your zeal and your sympathy. . . . Thanks also for the P.O. order I will send the Carlyle but tell me first whether y. friend likes a *brown* c. or a *grey* And then I will send together with the 2 Lionels to you about the end of this week . . .

May has just been here looking very bright and handsome I have send to her Reviews on the Suffolk St Exhibition of Photographs fr the Standard of 15th & Morn Post of 16 w. flaming accounts of my Photography . . .[44]

We have already seen how, even on the eve of her departure for Ceylon and surrounded by packing cases, Julia Margaret was dispatching directives to a Miss Moseley to return her portfolio with an order within the week. The prices she quotes are 16 shillings for each copy of 'Arania' or 'The Priestess' (neither of which are now known to us); an original 16 shillings marked up to 1 guinea for 'Sir Henry Taylor'; there is no price quoted for 'Sir John Herschel'. The reason for these variations usually lies either in her having obtained a batch of signatures from the patient sitters, or in the negative having become damaged so that she could demand more for prints. The phrase 'the Negative is spoilt and Copies are scarce' recurs.[45]

From the first Julia Margaret was canvassing opinions with a view to her photographs being taken seriously. In her letter to John Herschel of 31 December 1864 she begged to learn what he 'and dear Lady Herschel' estimated as their worth, in particular 'a theological work of some Interest . . . [and] a few other Photographs of great interest one especially of the three Marys at the sepulchre'. By 1866, she was half-threatening William Michael Rossetti for showing a reluctance to comment. 'I have never had more remarkable success with any Photograph, but I should like to know if you yourself are of this opinion for I have never heard even whether you approve of the picture!' Two copies were awaiting his collection at Colnaghi's, to facilitate the widespread publication of his critique, and she added the threat that 'I am under promise to *stop* Photography until I have recovered my outlay . . . to take no *new* pictures and limit myself to printing from the old and depending on their sale – but this is duty – and my delight can only be in the past until a lucrative present sets me afloat again'.[46]

Clearly impatient at Rossetti's delay in bringing his influence to bear upon Sir George Webb Dasent (assistant editor of *The Times*, 1845–70), she decided to set about blowing her own commercial trumpet. By 1873, she had collected, bound together and printed a selection of four flattering reviews simply entitled 'Mrs Cameron's Photographs'. The fly-leaf contains the information that 'Mrs Cameron's Gallery of Photographs, 9, Conduit Street, is

open now and all through the Christmas and New Year Season'
with details of opening times and the advice 'Catalogues will be
presented at the Gallery to Visitors'. A further note instructs
would-be purchasers to order from Colnaghi's in Pall Mall or
from Lambert's Hotel in Freswhater Bay. The reviews come
under the headings 'Fine Art' or 'Artistic Photography' and
emphasise her artistic credibility. That in the London *Morning
Post* of 6 January 1873 opens with:

Combining, as she does, poetic sentiment and dramatic spirit with
singular skill in composition, and executive ability of the highest order,
Mrs Cameron is, of all photographers, the most genuinely artistic. Her
portraits, which are usually of larger size than is customary in this
description of art, attract admiration at a glance by their vigour and
brilliancy of character . . .[47]

The reason that she went to such considerable lengths to obtain
favourable press coverage of her exhibitions was not simply in
order to sell more pictures, or even to counteract negative
criticism, but specifically to fight back against the photographic
societies she felt had ridiculed her unfairly. The first Photo-
graphic Society was founded at a public meeting on 20 January
1853. Fox Talbot, inventor of the calotype (or Talbotype) and
effectively of English photography, was proposed as the first
president – an obvious suggestion that was thwarted by the
somewhat astonishing view of the vice president-elect that if they
accepted Fox Talbot 'they would almost certainly acknowledge
his right to patent the sun itself'! Sir Charles Eastlake (whose wife
showed an early interest in photography as well as in the history of
art, on which she became an authority) was eventually unani-
mously elected, his background being entirely artistic. However,
the first invited lecturer was Sir William Newton, arguing a
scientific case for the medium, and invoking scientific justifica-
tion for leaving some parts of an image in greater or lesser focus
than others, and advising artificial light or suggestion of light to
give the impression of a skyscape. The Society's second presi-
dent, Sir Frederick Pollock and Lord Chief Baron, actually
'objected . . . to photography being called an art'. It was, he said,

'a practical science. . . . The practical photographer, in his view, was he who handled the science in its largest scope, with the manipulations which would be necessary to render that science effective'. And its first secretary, the successful English landscape and Crimean war photographer Roger Fenton, 'confessed that when the society was first proposed he never thought it would be more than a comfortable little body of gentlemen meeting together to ride their hobby, whereas it is now, three years after its formation, becoming one of the institutions of the country'.[48]

Small wonder that Julia Margaret should have been shunned by that clique of self-appointed scientists and gentlemen; greater wonder that she should never have paused to consider why the Photographic Society failed to afford her a warm welcome. The Society itself had been formed as the result of an open exhibition staged in December 1852, which included an unprecedentedly high total of 774 exhibits in the gallery of the Adelphi Society of Arts and attracted a great deal of public attention. To Julia Margaret it was thus entirely natural to seek to launch herself in 1864 at the by then well-established annual exhibitions, and she continued to exhibit each year from 1864 to 1868 and again in 1870 and 1873 in London. Stung by the hostility of the initial response to her work, by 1865 she was extending her work to exhibitions in Edinburgh (the Scottish Photographic Society), Dublin and Berlin. Paris was added in 1867 and Vienna in 1872 and, by the time she wrote the *Annals of my Glass House*, Australia

48. 'Pray God Bring Father Safely Home', 1865. The genre of picture-stories, illustrating titles such as 'He never told his love', 'Wayside Gossip' or 'Waiting for the Boat', was much more in H. P. Robinson's style than Julia Margaret's. This picture seems to have been an experiment, since nothing similar by her has come down to us. Shunning a conventional studio backdrop, she went into the bare-boarded home of a local family and assembled a few of her favourite models (including Mary Hillier and a little Keown). As though to prove the division of labour, the grandfather is busy at work mending his nets, while the woman sits disconsolately to hear the daughter's prayer.

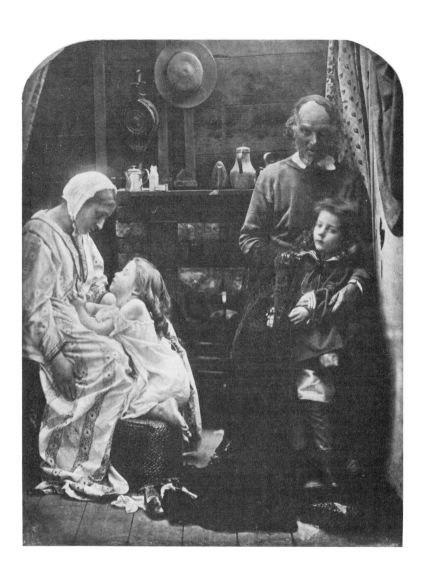

and America were also included in her list, but without any corroboration that she actually exhibited there.

Alongside these increasingly international exhibitions, she also rented galleries at her own expense, holding displays at Colnaghi's in November 1865 and January 1866; at the French Gallery in December 1866 and January 1867; and at the German Gallery in the New Year of 1868. The first two were in Pall Mall, and she succeeded in obtaining the services of the Irish poet William Allingham to 'blow the trumpet . . . in the *Pall Mall Gazette*',[49] an opinion that went against those expressed in the more photographically influential *Photographic News*, *Photographic Notes* and *Photographic Journal*. The consensus at the 1865 Berlin exhibition was that her work was 'technically faulty, but artistically no less interesting than Rejlander's photographs. The Madonna pictures from life and several portraits, particularly those of Henry Taylor and Tennyson, are all pictures deserving close study, and should not be passed by as some people, too easily put off by glaring technical short-comings, are inclined to do'.[50] The following year she won the Berlin gold medal.

These two contradictory attitudes to her work were reflected at Dublin and at Paris. The former offered the major qualification that 'although as photographs very indifferent (arising possibly from the want of first-rate apparatus, or sufficient expertise in manipulation . . .)' they were 'the works of a true artist. . . . At first sight they may be neglected and misunderstood, but at a second and third visit her frames are those which at once attract attention'.[51] At the 1867 Universal Exhibition in Paris 'her pictures created a sensation'. The reason was clearly pinpointed by the photographic scientist Professor Wilhelm Vogel, who saw the divide as not within her work – though she submitted pictures on a variety of themes – but amongst the viewers:

Those large unsharp heads, spotty backgrounds, and deep opaque shadows looked more like bungling pupils' work than masterpieces. And for this reason many photographers could hardly restrain their laughter, and mocked at the fact that such photographs had been given a place of

honour next to Robinson and Rejlander. But . . . all the more interested were the artists . . . [who] publicly praised their artistic value, which was so outstanding that technical shortcomings hardly count . . . the photographs belong, if not to the most beautiful, at least to the most remarkable photographs of the English section in the Paris exhibition.[52]

While controversy raged, Julia Margaret obtained another honourable mention.

At the same time as she was keeping a close and often worried eye on press reports of her many exhibition entries and firing off lengthy letters of despair to her friends (particularly those who might be in a position to bring influence to bear on her behalf), Julia Margaret was also exploring other avenues of publicising her work. The ones that beckoned most hopefully were to popularise it at a price ordinary people could afford, and to approach 'famous names' to give it public praise. She had already harnessed to her cause those whom she knew, but was not averse to approaching those whom she didn't, on both sides of the Channel. She sent a selection of photographs to George Eliot in 1871, and received a tactful letter in return which, despite its warm wishes, tiptoes around a direct commentary on the pictures themselves: 'I thank you with all my heart. Wise people are teaching us to be sceptical about some sorts of charity, but this of cheering others by proofs of sympathy will never, I think, be shown to be harmful; at least you have done me good. . . . I suppose you will some time return to the uglier world here [in London], and in that case I may hope that the kindness which sent the photographs may bring you to me in your own person.'[53]

The great French writer Victor Hugo was less reserved. Already something of a buff about things British (he ordered certain garments from 'l'excellent fabricant Dixon de Sunderland'), he was so delighted with her 'flyer' (the Ellen Terry portrait) that she was emboldened to send him a selection to add to his already famous photographic collection in Guernsey. His response was pleasingly effusive: 'How can I thank you enough, Madame, for this kindness? You overcome me. All of them are beautiful. Not one of the photographs but is in itself a "chef

d'œuvre". No-one has ever captured the rays of the sun and used them as you have. I throw myself at your feet.'[54] The Maison de Victor Hugo in Paris now has twenty-nine Camerons, presumed to have been sent in three separate lots direct from Colnaghi's between June 1874 and January 1875. They turned up, along with a number of original manuscripts and drawings, in a cupboard in the room of his son, where they had been locked for safe-keeping when Hugo returned to France from exile in the Channel Islands.

Perhaps Julia Margaret was expressing no more than a pictorial appreciation of each writer's work, but it is hard not to suspect that she was concerned to approach them as one fellow-artist to another, and that there was always the possibility that they might repay her generosity with praise in their own medium. She felt that she had conquered the artistic world with relatively little effort – 'Artists have immediately crowned me with laurels' – and that it was high time to hit back at malicious scribblers. In

49. 'Hetty and Adam Bede', also 'In the Twilight Hour', 1874. Whether because of an unexplained reluctance to photograph famous women, or because Julia Margaret simply concurred with Tennyson that George Eliot looked 'very like the picture of Savanarola', she never invited the famous author to sit for her. However, perhaps with a shrewd eye to furthering her development as a book illustrator, she began a sequence to accompany *Adam Bede*. She posted these pictures to George Eliot for her approval and received a positive commendation. However, either because there was no actual suggestion of an artistic collaboration or because her move to Ceylon was already being arranged, the series does not seem to have gone beyond a couple of prints.

Had Julia Margaret determined to make book illustration rather than portraiture or allegory her major field of photographic activity, this study suggests a willingness to take her heavy equipment out of doors, in pursuit of greater realism and 'a different class of people'.

Some prints also bear a quotation from the book, in Julia Margaret's hand, beginning, 'And always when Adam had stayed away for several weeks . . .'

recalling the adverse comment at her first exhibition, she tried to protect herself from the Photographic Society's printed attacks with remarks that have a distinct whiff of sour grapes about them: 'It was unsparing and too manifestly unjust for me to attend to it. The more learned and discerning judges gave me large space upon their walls which seemed to invite the irony and spleen of the printed notice.' While hurt by the vehemence with which she was attacked – as a woman and amateur, as well as a 'bungling pupil' – she was aware of the succour that respected approval could bring. She made an ambitious distinction in acknowledging that, while popular morals might hold that 'Fame is the last infirmity of noble minds', to be judged successful in her undertakings caused her 'heart to leap up like a rainbow out of the sky'.[55]

Julia Margaret received unstinted indulgence from her family, but she wanted respect as well, and the only way for her to be taken seriously as a photographer was to seek a wider audience. If the photographic societies and press treated her with condescension or worse, then she would seek to counteract them not only

50. 'The Passing of Arthur', 1874. This is the illustration of Julia Margaret which can best lend itself to ridicule; there is no way of bettering the fun poked by Quentin Bell and the Gernsheims:

'So like a shattered column lay the King.' He looks as though he might easily be sick. They are going to lose an oar. Something unexpected has happened to the moon, and to the water. In fact Mrs Cameron has more poetry than she can deal with.'
(*Those Impossible English*, London, 1952, p. 100)

In fact, it is not the poetry that is the problem – 'Iago' and Milton's 'Dream' are, by any account, two of Julia Margaret's finest pictures. The problem here lies with using the poetry not simply as an inspiration but as something to be taken literally. The disjunction between the intended sublime pathos of the models' expressions and the failed realism of the props leaves the viewer stranded between the two, unable to believe in one or the other. Yet Julia Margaret was attempting to push the limits of a medium that was so new that no law claimed it had to be naturalistic.

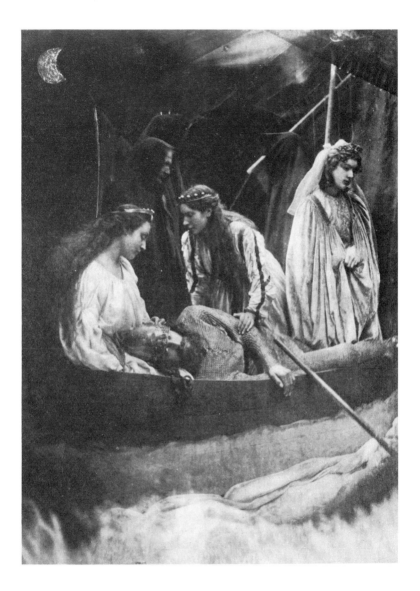

with respected artistic and literary opinion, but with the forceful success of the market place. She began producing series of *cartes-de-visite* of a wide cross-section of her work. They included everything from her more ambitious allegories and literary illustrations ('Paul and Virginia', 'Prospero and Miranda', 'The Rosebud Garden') through quainter variations on the theme of childhood ('Little Margie', 'The Flower Girl', 'The Bridal Kiss') to her most noted 'straight' portraits (of Aubrey de Vere, G. F. Watts, Marie Spartali, Virginia Dalrymple). In spreading herself this thin she was risking a considerable financial outlay, and in insisting that her *cartes-de-visite* should be larger than anyone else's and have gold-deckled edges she was risking more than she could justifiably afford to lose. Far from recouping her husband's losses on his Ceylon estates, she failed to recoup even her own investment on photographic materials.

On the face of it, Julia Margaret had had every reason to believe that in miniaturising her work she would be popularising it. Nationally, the total number of *cartes* sold annually was estimated to be in the region of three to four million, mostly depicting famous music-hall and theatrical stars – and, of course, portraits of the woman largely responsible for the 'cartomania'. 'Queen Victoria sells by the 100,000' was the disrespectful-sounding conclusion; only one shot was known to have caught her smiling,[56] the majority of the others tending to confirm the 'we are not amused' characteristic. In effect, the *cartes* themselves were generally of repetitious dullness, stereotypes that through their very monotony verged on caricature. Broadly, they could be characterised as the pert performer; the sonorous politician, bishop or member of royalty; and the bourgeois family, even when it was members of the industrious working classes striving to look 'improved' by means of fancier clothes, rigid posture and set expressions.

None of this suited Julia Margaret's style any better than it suited her pocket. The full-length portrait was her least successful genre and faded from her repertoire when she became more practised. Her large close-ups were eminently unsuited to the *carte* format and she refused to employ painted back-drops (of

mock-Grecian ruins or an aspired-after stately home). Apart from a rare foray into a fisherman's hut (Plate 48), her family groups – mainly friends like the Elchos, Hoods and du Mauriers—were not especially successful. Her failure was partly due to the difficulty of focusing a larger – and often poorly situated – group within her limited aperture range but more, one suspects, through a failure of interest. Julia Margaret's preference was for getting in as close as possible to a powerful model, effectively permitting them to stage the picture and to take over the fullest possible space with their own presence. All of this set her apart from the mainstream studio photographers.

Julia Margaret was also unusual at the time in her refusal to photograph out of doors. Perhaps her reluctance to use the heavy camera and equipment outside was primarily mechanical; William Allingham's is the only account we have of her transporting it to a hayfield to photograph a picnic. Lewis Carroll wrote a couple of amusing satires on the subject of photography, both of which could be read as comments on Julia Margaret's penchant for a certain type of subject. In an essay 'Photography Extraordinary', his fantasy proposes the direct rendition of poetry into photography, experimenting with such themes as 'working up a passage of Wordsworth into strong, sterling poetry: the same experiment was tried on a passage of Byron . . . but the paper came out scorched and blistered all over by the fiery epithets thus produced'. The conclusion was that 'The recent extraordinary discovery in Photography, as applied to the operations of the minds, has reduced the art of novel-writing to the merest mechanical labour.'[57]

In 'A Photographer's Day Out' the scenario has to include 'Paterfamilias, Materfamilias', plus 'two sons from school, a host of children from the nursery and the inevitable BABY', and up to seventeen sittings per composition. But the day has to start 'in a great hurry, luckily breaking only two bottles and three glasses'.[58] The hazards of the field lay not only in the heaviness of the contraptions but in the extreme fragility of the glass components. But even these problems would not in themselves have stopped the indefatigable Julia Margaret had she been convinced

Right: **51.** 'A Sinhalese Woman', and *overleaf*: **52.** 'A Gathering of Natives'. Only a dozen or so images have come down to us from Julia Margaret's final years in Ceylon, and this last period is deemed to have been an unsuccessful and unfruitful one for her. Setting aside all the perfectly plausible reasons why even a large body of photographic work might not have made its way back to England after Julia Margaret's death, there seem to be three main possibilities why she might have decided not to continue working seriously.

One was simply the climate. In that heat, there would be considerable problems in preventing the plates and varnish from cracking, and the collodion from peeling off. Her earlier problems about the labour of washing the prints would be even worse in a country where fresh water was in restricted supply. The great age of British travel photographers was barely a decade away, when techniques were considerably simplified, particularly with the advent of the hand-held camera, and waxed paper negatives rather than giant and fragile glass plates.

The second reason was to do with Julia Margaret's attitude to photography and her perception of herself as a photographer. From her very first endeavours, Julia Margaret had sought recognition and payment for her work. With those avenues now effectively denied her, she may well have decided that it was time for her to retire, that to photograph purely for herself was a self-indulgent process. She was always devoted to her husband and sons and was, in her own somewhat erratic way, a conscientious housekeeper. It may also have been harder to justify the expense and difficulties of maintaining her creative work when it could no longer be published.

Finally, the subject matter available was not what she felt to be within her own particular remit. She produced her best work photographing individuals whom she knew and admired, using that intimacy to elicit what she called their 'souls' through their expressions and 'features'. She had only a remote aesthetic admiration for a people whose language she never learnt and whom she came across almost exclusively as her social inferiors. She did not share the interest of travel photographers in recording the landscape and architecture of a place, still less street life or political activity. Nevertheless, her pictures of the peddlers and 'A Gathering of Natives' show a degree of experimentation, perhaps with the encouragement of the traveller Marianne North that she should 'paint a wider canvas'.

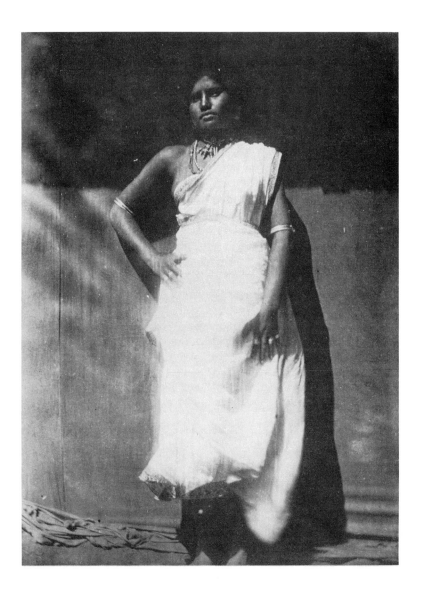

that true beauty was to be found out of doors. Watts had taught her that the first matter of High Art was the human form, and she joined him in fighting Ruskin who was always hankering for the two of them to include 'just a little more botany' in their creations.

- Beauty and focus

Julia Margaret Cameron was certainly prepared to work, and to work extortionate hours, to obtain recognition. The best form of it, of course, would have been a royal accolade, and her peevishness at the Royal Consort's standing order for a copy of every composite photograph made by H. P. Robinson is eminently understandable. She courted a royal imprimatur for her own work, and she did not 'cheat' as Robinson did, composing with numerous negatives rephotographed together. She pursued minor members of the German royal family, and was delighted to be able to dedicate an album to the Russian prince and princess who visited Freshwater. She shared Emily Tennyson's adulation of Queen Victoria, and it must have been a bitter pill to find that not one of her *cartes-de-visite* was included in a royal album. Perhaps she felt her chances were harmed by Robinson, known as 'the most bemedalled photographer of his day', who had called her work 'badly defined', or perhaps she felt that the possibility even of a visit by minor royalty was prevented by the rumours, put about by Lear, of 'odious incense and ornamental trash in her house'. But whilst she would have liked a royal accolade, with all it would do for increased picture sales, it was not in her character to be affected so much by this omission as by Tennyson's 'treating her like an amateur', as one contemporary put it. (In fairness to Tennyson, this was not an attitude he maintained once he had envisaged employing her as an illustrator for the *Idylls*.)

Perhaps it was her dedication to the cause of High Art that allowed Julia Margaret to value her talent and take her work so seriously. Although she had found her métier in what Carroll had critically called 'Mrs Cameron's large heads, taken out of focus', she never ceased experimenting, inventing new ways of applying her art, regardless of the amount of time and energy it absorbed.

Her very willingness to push the bounds of photography in new directions brought criticism from contemporaries, both professional photographers and Photographic Society amateurs, and from present-day critics, who regard it as a sign of incompetence and lack of technical application. But at a time when other 'lady amateurs' were taking photographs just to fill in time, Julia Margaret was obsessed by photography, obsessed by what she saw – and what other people could see in real life – but which other photographers ignored. She wanted photography to distil the essence of an abstraction, whether a scientist's genius, a child's innocence or a woman's beauty, and present it as both unique and typical, in a single image. The best of her pictures have this quality, preventing us from seeing them merely as the period pieces so many Victorian photographs are, but as powerful and relevant to our own time. Julia Margaret was no photographic pioneer in terms of advancing the technique of photography; indeed, she advanced as an artist through disregarding much of what passed for technical development. And she worked at a time when photography was too new for anyone to gainsay her right to use it as an artist's medium, to create rather than to record. Her creativity was based on what she called 'the recognition of the Individual . . . the men great through genius, the women through love'. In her own case there was no such gender-stereotyping. Her love was for the greatness at the heart of each individual; her genius was for transforming the artistic vision into a thing of beauty.

NOTES

Frontispiece

Julia Margaret Cameron with her daughter Julia (photographer and date unknown). Perhaps the most strikingly original portrait of Julia Margaret, this shows her reclining in the garden or on a patio, presumably at Little Holland House. Leaning against her is her daughter Julia, apparently asleep. The picture is the only known portrait of Julia who, despite being her mother's only and beloved daughter, and the person who first gave her a camera, appears not to have sat to be photographed.

Introduction

1. See, for example, *Victorian Photographs of Famous Men and Fair Women* with introductions by Virginia Woolf and Roger Fry, The Hogarth Press, London, 1926.
2. ibid., p. 2.
3. Leader, 'Commercial photography', *British Journal of Photography*, 2 January 1867, p. 47.
4. A decade of the *British Journal of Photography* includes, in almost every issue, yet another piece of advice on how to try to prevent the varnish from streaking.
5. Literally: see her letters at the Royal Photographic Society and in the Bodleian Library.
6. *British Journal of Photography*, 357, Vol. XIV, 8 March 1867, p. 107.
7. L. Troubridge, *Memories and Reflections*, London, 1925, p. 38.
8. Julia Margaret Cameron, *Annals of my Glass House*. The original, in the author's own handwriting, is in the Royal Photographic Society, and a transcript in the *Photographic Journal*, July 1927, pp. 296–301. It is published in full in Mike Weaver, *Julia Margaret Cameron 1815–1879*, London, 1984, pp. 154–57.
9. ibid.
10. ibid.

11. Ironically, Herschel's aunt was a famous astronomer in her own right, a discoverer of fourteen nebulae and eight comets, although she had no formal mathematical training.

12. An entire book has been devoted to this subject. It is by Mike Weaver, *Julia Margaret Cameron 1815–1879*, London, 1984.

13. Sir Henry Taylor, whom she endowed with lengthy daily missives, declared himself 'very nervous' lest he be called upon to read the whole of it. His comment was: 'She lives upon superlatives as upon her daily bread.'

14. One wonders if Virginia Woolf was in any way inspired by this commonplace, expressed in the photographic labelling of her mother, when she wrote: 'Rosalind had still to get used to the fact that she was Mrs Ernest Thorburn. Perhaps she never would get used to the fact that she was Mrs Ernest Anybody, she thought. . . . Ernest was a difficult name to get used to. It was not the name she would have chosen.' 'Lappin and Lapinova', collected in *A Haunted House and Other Stories*, London, 1943.

15. We know that Julia Margaret took something in the order of three thousand pictures in her ten years' photographic activity in England. What is less clear is how much she was able still to achieve during the last four years of her life in Ceylon, from 1875–79.

16. V. Woolf, *Freshwater*, ed. Lucio P. Ruotolo, London, 1976.

17. Starting in 1874, Thomas Barnes and Roderick Johnstone began taking photographs of the ragged urchins in the Dr Barnardo's Homes for Destitute Children. The major problem with turning these children into objects of charity, however, was that the photographs sold to the public were all carefully posed and not, as was implied, of actual children in actual distress. A furore ensued when the duplicity was discovered, the public feeling it had been generous with money under false pretences. The case became a *cause célèbre* over the veracity of the camera.

18. Letter to John Herschel, 31 December 1864. The Herschel correspondence is in the Royal Society, at 6 Carlton House Terrace, London SW1.

19. ibid.

20. Mike Weaver, 'The Hard and Soft in British Photography', *The Photographic Collector*, p. 195.

21. But the number of 'lost prints' went through three variations in as many letters sent to a long-standing family friend, Sir Edward

Ryan: other options were 180 or 245, leading to quite improbable calculations.

22. Margaret Harker believes that even on the Isle of Wight, Julia Margaret may have 'farmed out' her printing to a local photographer. At present we have no evidence for this, but rather the opposite. Her note in the frontispiece of the Herschel album (1867) states: 'I have no assistant and the whole process from first to last including the printing is all done by my own hand – and all done at Freshwater Bay.' She also complained, in the *Annals*, of having to go nine times to the well in freezing weather to draw water for rinsing the prints.

23. H. J. Slack, *Intellectual Observer*, 1890.

24. Virginia Woolf and Roger Fry, op. cit., p. 5.

25. ibid., p. 9. In this context, it is interesting to recall the Arts Council's recent axing of its Photographic Committee, the committee that had a brief to award photography its long-awaited status within the arts.

26. J. B. Priestley, 'Old Photograph', *Delight*, London, 1949, p. 53.

27. Helmut Gernsheim, *Julia Margaret Cameron, Her Life and Photographic Work*, London, 1948; rev. edn., Aperture, London, 1975, p. 84.

28. ibid.

The Life

1. This is not the only 'appalling and fantastic disaster' that occurred, but James Pattle's body did eventually reach England six months later, and was interred in St Giles's Church, Camberwell, along with that of his wife. The whole story is told in Brian Hill, *Julia Margaret Cameron, A Victorian Family Portrait*, London, 1973, pp. 34–39.

2. By C. H. Cameron, J. Wrottesley and J. W. Cowell, London, 1834.

3. C. Hay Cameron, London, 1853.

4. E. M. Forster, *A Passage to India*, London, 1924, chap. 5.

5. *Two Essays. On the sublime and the beautiful and On duelling* by Charles Hay Cameron Esq (privately printed), 1835. Others in a correspondingly campaigning vein were *Two reports addressed to His Majesty's Commissioners appointed to enquire into the Administration and Operation of the Poor Laws*, London, 1834; *A letter from Sir*

Edward Ryan and Mr Charles Hay Cameron to the Honourable the Court of Directors of the East India Company on the subject of admitting natives of India to their civil, military and medical services, London, 1850, and *An Address to Parliament on the Duties of Great Britain to India,* London, 1853.

6. Mss. Eng. Lett. d. 12 no. 68, Bodleian Library, Oxford.

7. *Gottfried August Bürger, Leonora,* trans. Julia Margaret Cameron, with illustrations by Daniel Maclise, London, 1847; published in full in Mike Weaver, op. cit., pp. 146–51.

8. Cameron-Coleman Collection of Tracts, British Library; 22 February 1848, p. 1. See also Cameron's reply, p. 7.

9. It is interesting to compare the two very different ways in which Cameron's friends responded to the Chartist crisis. Whilst the Whig peer Lord Macaulay (with whom Cameron had long worked on his Indian educational programme) referred to 'a great war of the classes. . . . All the power of the imagination fails to paint the horror of such a contest', Lord Taylor (who was working in the Colonial Office) writes of how the Duke of Wellington's battalion had been set to 'fight the Chartists': 'Troops were posted everywhere out of sight, but everywhere available. The Duke said, "Only tell me where they are and I'll stop them," and his old eyes, Lord Monteagle said, sparkled like a girl's at her first ball.'

10. R. Chapman, *The Laurel and the Thorn,* London, 1945, p. 50.

11. Thackeray wrote eulogies to Virginia's beauty, and George du Maurier gently satirised the family right down to Val Prinsep (Sara and Thoby's second son), who was the model for Taffy in his best-selling novel *Trilby* (1894): 'For Taffy was, or thought himself, a passionate realist in those days. He has changed, and now paints nothing but King Arthurs and Guineveres and Lancelots and Elaines, and floating Ladies of Shalott.'

12. Anne Thackeray Ritchie, *Alfred, Lord Tennyson and his Friends,* London, 1893, p. 13.

13. Mss. Eng. Lett. d. 13, Bodleian Library, Oxford.

14. As, for example, that quoted by Henry Taylor in his essay on marriage, *Notes from Life,* Boston, 1853, p. 67. He uses Aristotle to support the idea 'that the bridegroom should be thirty-seven years of age and the bride eighteen', though with a sceptical aside, wondering that if the groom be too advanced in years 'it tends to the degeneracy of the race'.

15. Quoted by Christopher St John in the introduction to *Ellen Terry: Collected Lectures*, London, 1933.

16. Not that she seems to have put much of herself into these. Even those of her friends, such as the du Mauriers and the Elchos, are uncomfortably conventional.

17. Henry Taylor, *Autobiography*, London, 1885, Vol. II, p. 34.

18. ibid., p. 24.

19. Mss. Eng. Lett. C1, Bodleian Library, Oxford; letter from Matthew Arnold dated Christmas Day 1872.

20. ibid., letter of 1849. It is interesting to note that as late as 1891, when presumably Henry or Alice had taken over the distribution network, Kipling was writing in similar vein from the Savile Club: 'Dear Taylor. Forgive me. The book is with me. It will be sent very soon. I am six varieties of Beast but my excuse is that I am half-slain with an English cold.'

21. ibid.

22. Copy dedicated to Lord Monteagle in the British Library, 31 January 1850, p. 5.

23. Mss. Eng. Lett. C1, Bodleian Library, Oxford; letter from Hardinge at Stanhope, 1 February 1850.

24. Mss. Eng. Lett. c. 457, fol. 64–73, Bodleian Library, Oxford. The letter, dated 5 April 1859, is published in full in Mike Weaver, op. cit., pp. 152–53.

25. However, it is only fair to point out that she was equally overbearing with her own children. When her son Charles decided to become an actor, she struck swiftly and brutally, sending the unwilling boy out to farm coffee in Ceylon rather than see him succumb to an improper vocation.

26. A. C. C. Liddell, *Notes from the Life of an Ordinary Mortal*, London, 1911, p. 86.

27. H. Cotton, *Indian and Home Memories*, London, 1911, pp. 53, 54.

28. Quoted in Brian Hill, op. cit., p. 93.

29. Hester Thackeray Fuller, *Freshwater Friends*, Dublin, 1933, p. 34. A rare copy is in the National Portrait Gallery.

30. Anne Thackeray Ritchie, *From the Porch*, London, 1913, p. 264.

31. Quoted by J. Richardson, *The Pre-Eminent Victorian*, London, 1962, p. 66.

32. Isabel made an unhappy marriage to Lord Henry Somerset, who was not long afterwards found in flagrante delicto making love to a

footman. Virginia had the bad form to make the matter public in an attempt to obtain a divorce for her daughter, and succeeded only in ensuring that Isabel was banned from good society for the rest of her life.

33. Lady Ritchie, *From Friend to Friend*, London, 1919, p. 4.

34. ibid., p. 7.

35. Letter in the collection of the Royal Photographic Society.

36. Henry Taylor, *Autobiography*, London, 1885, Vol. II, p. 35.

37. Letter in the collection of the Royal Photographic Society.

38. Letter in the collection of the Royal Photographic Society.

39. Mss. Eng. Lett. d. 13, Bodleian Library, Oxford; letter from Lindoola.

40. Mss. Eng. Lett. d. 12, Bodleian Library, Oxford; letter dated 8 March 1875.

41. ibid., letter dated 5 April 1875.

42. ibid., letter from Henry Taylor to Mr B. Grosaint, dated 5 April 1875.

43. This shows that, unlike Lewis Carroll, Rejlander was a photographer with whom Julia Margaret did get on well and could confer (one of the series actually shows the coalhouse that served as Julia Margaret's darkroom). Perhaps because Rejlander started as an artist, perhaps because his relationship with his subjects was as humane as her own, perhaps because she admired his work or coveted his royal accolades, Julia Margaret clearly made an exception in taking him – a photographer, rather than an artist – as a colleague.

44. Mss. Eng. Lett. d. 13, Bodleian Library, Oxford.

45. Alfred, Emily and Hallam. Lionel, the other son, died tragically young at sea.

46. Mss. Eng. Lett. d. 13, Bodleian Library, Oxford; letter from St Regulas, Lindoola, dated 21 May 1876.

47. Marianne North, *Recollections of a Happy Life*, London, 1892, p. 302.

48. ibid., p. 302.

49. ibid., p. 315.

The Work

1. Helmut Gernsheim, *Julia Margaret Cameron, her Life and Photographic Work*, London, 1948; rev. edn., Aperture, London, 1975, pp. 56–57.
2. By H. Wheatcroft, *The Tennyson Album*, London, 1980, p. 89.
3. Not one of the Marys she regularly required to dress up and pose for her allegories. At the time of the 1871 census, the Camerons had five maids.
4. Ed. Graham Ovenden, *A Victorian Album, Julia Margaret Cameron and her Circle*, London, 1975.
5. Daughter of the Greek consul general, Marie Spartali was a Pre-Raphaelite model and a painter. She married W. J. Stillman, an American author and photographer, in 1870, and thereafter gave photographic sittings.
6. Now on display at the National Museum of Photography, Film and Television, Bradford.
7. Quoted by E. Yoxall-Jones, *O. G. Rejlander, Father of Art Photography*, Newton Abbott, 1973, p. 32. The date 1864 is a mistake; Julia Margaret's first exhibition was in 1865.
8. *Annals of my Glass House*.
9. For example, in 1856, Leslie Stephen lost his faith and wrote: 'I now believe in nothing, to put it shortly; but I do not the less believe in morality &c &c. I mean to live and die like a gentleman, if possible'; quoted in Quentin Bell, *Bloomsbury*, London, 1968, p. 24. And, of course, there was always the danger that if the 'lower orders' discovered atheism, they would be even harder to keep in line.
10. Described by Anne Thackeray Ritchie's daughter, Hester Thackeray Fuller, in *Freshwater Friends*, Dublin, 1933, p. 31.
11. Clive Bell, introduction to Helmut Gernsheim, op. cit., rev. edn., p. 7.
12. The letter is quoted in full by Julia Margaret herself in *Annals of my Glass House*.
13. The title 'sweet Liberty' has a certain ironic aptness. According to Alison Gernsheim, the model Cyllene Wilson, orphaned and adopted by Julia Margaret, 'hated being photographed by Mrs Cameron. In 1870 she ran away, became a stewardess, and married the first engineer on an Atlantic liner.' See Helmut Gernsheim, op. cit.

14. Quoted in *Annals of my Glass House*.
15. Cecil Beaton and Gail Buckland, *The Magic Image*, London, 1975, p. 64.
16. Rev. H. D. Rawnsley, *Memories of the Tennysons*, Glasgow, 1900, p. 91.
17. Quoted from her memoirs in A. Pippett, *The Moth and the Star*, London, 1955, p. 8.
18. Helmut Gernsheim, op. cit., p. 83.
19. Ed. Graham Ovenden, op. cit., p. 10.
20. Colin Ford, BBC broadcast, 26 January 1979.
21. *Annals of My Glass House*.
22. Henry Taylor, *Notes from Life*, Boston, 1853, p. 90.
23. Laura Troubridge, *Memories and Reflections*, London, 1925, p. 38.
24. Paul Hasluck, *Book of Photography*, London, 1895.
25. *British Journal of Photography*, 1 March 1867, pp. 100–1.
26. For example, an Italian collection called simply *Le Bambine* [The Little Girls], Milan, 1984.
27. Quoted in A. Davidson, *Edward Lear, Landscape Painter and Nonsense Poet*, London, 1968, p. 149.
28. Probably Jowett. Other favourable comments include Carlyle's opinion on his portrait: 'It is as if suddenly the picture began to speak, terrifically ugly and woebegone, but it has something of a likeness: my candid opinion'; letter to Julia Margaret, quoted in H. Thackeray Fuller, *Freshwater Friends*, op. cit., p. 31.
29. Letter from F. D. Maurice, an Oxford friend of Tennyson, to Julia Margaret in 1866, quoted by Henry Herschel Hay Cameron in the introduction to Anne Thackeray Ritchie, *Alfred, Lord Tennyson and his Friends*, London, 1893, p. 7.
30. Anna Jameson, *The Poetry of Sacred and Legendary Art*, London, 1883, Vol. I, p. vii.
31. Mike Weaver, op. cit., p. 26.
32. H. B. Dowson, *Love and Life*, London, 1902, p. 84.
33. *Annals of my Glass House*.
34. *Photographic Journal*, 15 February 1865, p. 191.
35. In 1859 Lear wrote, as only he could: 'When the 300 [Tennyson] drawings are done, I shall sell them for £18,000, with which I shall buy a chocolate-coloured carriage speckled with gold, and driven by a coachman in green vestments and silver spectacles – wherein, sitting on a lofty cushion composed of muffins and volumes of the

Apocrypha, I shall disport myself about all the London parks' (quoted in J. Richardson, *Edward Lear*, London, 1965, p. 25).

36. H. Thackeray Fuller, *Freshwater Friends*, op. cit., p. 35.

37. Henry Herschel Hay Cameron, in the introduction to Anne Thackeray Ritchie, *Alfred, Lord Tennyson and his Friends*, op. cit., p. 12.

38. The full and highly laudatory quotation comes from the contemporary writer, Wilfred Ward: 'Freshwater in these days seethed with intellectual life. The Poet was, of course, the centre and that remarkable woman, Mrs Cameron, was stage manager of what was, for us young people, a great drama. For Tennyson was still writing the "Idylls of the King" which had so greatly moved the whole country, and we felt that we were in the making of history. . . . I recall her bringing Tennyson to my father's house, while she was photographing representations for the characters and calling out directly she saw Cardinal Vaughan (to whom she was a perfect stranger): "Alfred, I have found Sir Lancelot." '

39. P. James, *English Book Illustration*, London, 1947, p. 7.

40. Letter to Sir Edward Ryan, 29 November 1874, Gernsheim Collection. The Morocco half-binding alone cost her 35 shillings a copy.

41. Published in *Macmillan's Magazine*, Vol. XXXIII, February 1876, p. 372.

42. 'The Lily Maid' was secure in public consciousness, having been one of the subjects selected for a series of *tableaux vivants* staged at Mars Lodge on the occasion of the first Scottish state visit of the Prince and Princess of Wales in 1863; the next year Victor Prout produced a commemorative volume of photographs. Clearly, the Victorian message laid emphasis on the patience and passivity of Elaine's love for Lancelot, rather than on that of the adulterous Queen Guinevere.

43. Gleeson White, *English Illustration*, London, 1906, p. 153.

44. Mss. Eng. Lett. E118, Bodleian Library, Oxford; letter to Alexander Wedderburn dated 19 October 1874.

45. Numerous prints produced by the Autotype Company for Colnaghi's, still mounted on the original cards, may be seen at the Royal Photographic Society. Many are carbon rather than silver copies, hence the customer's choice as to whether they should be tinted brown or grey.

46. Letter dated 23 January 1866, Gernsheim Collection.

47. Pamphlet in the Royal Photographic Society collection, k/n 1073, dated 1873.

48. Harry Cooper, *The Centenary of the Royal Photographic Society of Great Britain*, London, 1953, p. 12.

49. W. Allingham, *A Diary*, London, 1907; entry for 7 February 1868.

50. *Photographische Mitteilungen*, Berlin, 1865, p. 128.

51. See *Photographic Journal*, October 1865.

52. *Photographische Mitteilungen*, Berlin, 1865, p. 73.

53. Marie A. Belloc, 'The Art of Photography', *The Woman at Home*, London, 1897, Vol. IV.

54. Taken from the catalogue of an exhibition held in the Musée de la Ville de Paris, November–December 1980. Entitled 'Hommage de Julia Margaret Cameron à Victor Hugo', it was written by J.-M. Bruson (translated by the present author).

55. *Annals of my Glass House*.

56. A. & H. Gernsheim, *Queen Victoria*, London, 1959.

57. Lewis Carroll, 'Photography Extraordinary', *Complete Works*, Glasgow, 1939, p. 1109.

58. 'A Photographer's Day Out', ibid., pp. 980, 982.

PICTURE LOCATIONS

By far the largest collection of Julia Margaret Cameron's work in Britain is housed in the Royal Photographic Society at The Octagon, Milsom Street, Bath. Some five hundred prints are carefully catalogued and stored there in an air-conditioned room, and are available for inspection by Society members and guests.

The National Museum of Photography, Film and Television at Princes View, Bradford, houses a selection of the Sinhalese prints and the Herschel album. This is displayed every day at a new page, so in order to inspect each page one either has to reside in Bradford for 45 consecutive days or become an accredited researcher, in which case the staff allow access outside normal opening hours.

In London, the largest collection is in the Print Room of the Victoria & Albert Museum, South Kensington. Access is open to all, but woe betide anyone who attempts to make sense of the 'catalogue' of copy prints! The substance of the National Portrait Gallery's collection went to Bradford, but a few prints are kept in the Registry beside the main gallery. A vast quantity of copy prints and an excellent library are housed in the gallery annexe, at 15 Carlton House Terrace, SW1. A dozen or so prints are in the Science Museum, South Kensington, where they are rendered remarkably inaccessible through some very determined efforts; seven more are likewise well incarcerated in the royal archives at The Round Tower, Windsor Castle (including two unusual prints of Sir John Simeon and Clinton Parry). The Ashmolean Museum in Oxford also houses a small collection.

Those in private hands are listed in the *Directory of British Photographic Collections* (compiled by John Wall, published in 1977 by the Royal Photographic Society). Each collector states in it whether he or she is prepared to be visited, and under what conditions. In addition, the catalogues of the major salerooms quite often feature Camerons which come up for sale.

The considerably longer lists of Camerons in American university collections make this distribution seem very eccentric. Surely it is time for a single, national, Cameron collection in Britain.

SELECT BIBLIOGRAPHY

Recent Books on Julia Margaret Cameron

Cecil, D., ed., *A Victorian Album*, London, 1975
Ford, C., ed., *The Cameron Collection*, London, 1975
Gernsheim, H., *Julia Margaret Cameron, her Life and Photographic Work*,
 London, 1948; rev. edn., Aperture, London, 1975
Harker, M., *Julia Margaret Cameron*, London, 1983
*Hill, B., *Julia Margaret Cameron, A Victorian Family Portrait*, London,
 1973
Weaver, M., *Julia Margaret Cameron 1815–1879*, London, 1984

Books by Julia Margaret's Relatives and Contemporaries

Allingham, W., *A Diary*, London, 1907
Cotton, H., *Indian and Home Memories*, London, 1911
Liddell, A., *Notes from the Life of an Ordinary Mortal*, London, 1911
North, M., *Recollections of a Happy Life*, London, 1892
Taylor, H., *Autobiography*, Vol. II, London, 1885
Taylor, H., *Correspondence*, London, 1888
Taylor, H., *Notes from Life*, Boston, 1853
Thackeray Fuller, H., *Freshwater Friends*, Dublin, 1933
Thackeray Ritchie, A. (Lady Ritchie), *Alfred, Lord Tennyson and his
 Friends* (with introduction by Henry Herschel Hay Cameron), Lon-
 don, 1893
Thackeray Ritchie, A., *From Friend to Friend*, London, 1919
Thackeray Ritchie, A., *From the Porch*, London, 1913
Thackeray Ritchie, A., *Records of Tennyson, Ruskin and Browning*,
 London, 1892
Troubridge, L., *Memories and Reflections*, London, 1925

*The only book to supply any information on Julia Margaret's life before she lived
in England.

Woolf, V. and Fry, R., intro., *Victorian Photographs of Famous Men and Fair Women*, London, 1926

Contemporary Material

Cameron, C. H., *Two Essays. On the sublime and the beautiful, and On duelling*, privately printed, 1835
Emerson, P. H., *Naturalistic Photography*, London, 1884
Emerson, P. H., *Death of Naturalistic Photography*, London, 1890
Emerson, P. H., *Mrs Cameron, Sun Artists*, Number 5, 1890
Robinson, H. P., *Pictorial Effect in Photography*, London, 1869
Robinson, H. P., *Picture-Making by Photography*, London, 1884
British Journal of Photography and *Photographic News* for the relevant period 1865–1875

By Julia Margaret Cameron

Translation of *Gottfried August Bürger: Leonora*, London, 1847
Illustrations to Alfred, Lord Tennyson, *Idylls of the King and Other Poems*, London, Vol. I, 1874; Vol. II, 1875

Manuscript material:

Annals of my Glass House, and letters to Miss Moseley (Royal Photographic Society)
Letters, fragments and notes (Bodleian Library, Oxford): Mss. Authogr. C24, fols. 327–30; Mss. Don, d. 129 (papers of Mrs L. Wood); Mss. Don. E58; Mss. Eng. Lett. C1; Mss. Eng. Lett. c. 457, fols. 64–73; Mss. Eng. Lett. d. 12, 13, 17, 178, 293
Cameron–Coleman Collection Tracts (British Library, London)

Background on Julia Margaret's Circle

Barrington, G. I., *Reminiscences*, London, 1905
Campbell, Rev. J. A., *Idylls of the King*, Dublin, 1896
Chapman, R., *The Laurel and the Thorn*, London, 1945
Gernsheim, H., *Lewis Carroll, Photographer*, London, 1949
Nicholson, H., *Tennyson*, London, 1923
Ricks, C., ed., *Tennyson's Poems*, London, 1968

Background to the Photography of the Period

Coe, B. and Haworth-Booth, M., *A History of the Photographic Processes*, London, 1983

Ford, C., *A Hundred Years Ago*, London, 1983

Gernsheim, H., *A Concise History of Photography*, London, 1965

Harker, M., *Victorian and Edwardian Photographs*, London, 1975

Scharf, A., *Art and Photography*, London, 1968

INDEX

Numbers in italics refer to plates